Palgrave Studies in Literature, Culture and Human Rights

Series Editor
Alexandra S. Moore
Binghamton University
New York, NY, USA

This series demonstrates how cultural critique can inform understandings of human rights as normative instruments that may at once express forms of human flourishing and be complicit with violence and inequality. The series investigates the role of genre and the aesthetic in shaping cultures of both rights and harm. Essential to this work is an understanding of human rights as at once normative and dynamic, encompassing egregious violations as well as forms of immiseration that have not always registered in human rights terms.

Alexandra S. Moore • Elizabeth Swanson
Editors

The Guantánamo Artwork and Testimony of Moath al-Alwi

Deaf Walls Speak

palgrave
macmillan

Editors
Alexandra S. Moore
Binghamton University
Binghamton, NY, USA

Elizabeth Swanson
Babson College
Babson Park, MA, USA

ISSN 2524-8820 ISSN 2524-8839 (electronic)
Palgrave Studies in Literature, Culture and Human Rights
ISBN 978-3-031-37655-9 ISBN 978-3-031-37656-6 (eBook)
https://doi.org/10.1007/978-3-031-37656-6

This Palgrave Macmillan imprint is published by the registered company Springer Nature Switzerland AG.
The registered company address is: Gewerbestrasse 11, 6330 Cham, Switzerland

For Moath Hamza Ahmed al-Alwi, the voice and inspiration of this book, and to Chloë, Samantha, and Marcelle, always

PREFACE

This volume presents and engages the testimony and artwork of Moath Hamza Ahmed al-Alwi, a Yemeni citizen who has been detained *without charge* at the Guantánamo Bay Naval Detention Center (Cuba) since 2002 and who has become an extraordinary artist over the course of this decades-long imprisonment. This Preface discloses parts of the process of bringing Moath's work to a public audience, and we begin by noting that only two of the contributors here have ever met or spoken with him directly: Beth Jacob, one of his attorneys, and Mansoor Adayfi, a former fellow detainee and Yemeni citizen, whose detention without charge lasted more than fourteen years before he was transferred to a precarious existence in Serbia. Only Mansoor is a native Arabic speaker. This volume then emerges from complex processes of clearance, translation, editing, and arranging all (except the clearance review by the privilege teams operating under the Departments of Justice and Defense) undertaken with the imperative of fostering Moath's self-representation.

Throughout this volume, we follow Beth's suggestion to refer to Moath by his first name, rather than the geographical al-Alwi. And in keeping with the language preferred by former detainees, including Mansoor, we use "detainees" and "prisoners" interchangeably. Whereas the US government has insisted that the 779 men and boys held at Guantánamo were and are detainees and therefore not subject to the protections afforded to prisoners of war in the Third Geneva Convention, those who have been released and now speak more freely reject the term "detainee" as a euphemism used to mask the conditions of their confinement: often in cells and cellblocks built to the specifications of maximum security facilities in the

US Federal Bureau of Prisons and in conditions that include solitary confinement, force feedings, violent interrogation, and cruel, inhuman, and degrading treatment, all without access to meaningful legal review and, in the case of Moath, Mansoor, and the vast majority of prisoners, without ever having been charged with a crime.

Those conditions also influence the use of the word "torture" in this volume. We reject the government's term "enhanced interrogation" and test each invocation of the terms "torture" and "cruel, inhuman, or degrading treatment" against the standards in the UN Convention of the same name, the work of victim advocate organizations such as the Center for Victims of Torture (CVT), and detainees' own understanding of their experience. Although there is now widespread agreement that techniques such as waterboarding, prolonged use of stress positions, cramped confinement, and "walling," to name but a few, constitute torture, we follow the lead of the CVT and others in understanding the conditions of extremity such as indefinite detention without charge that now enters its third decade as also meeting those standards of torture or cruel, inhuman, or degrading treatment or punishment.

Out of such conditions of extremity, Moath's work provides vital representation of his experience, his voice, and his creative energy. The story of how we've come to engage with his artwork and testimony begins below and continues throughout the chapters of this book.

RELEASING ART AND TESTIMONY FROM GUANTÁNAMO

Beth D. Jacob

To put the process for taking art out of Guantánamo into context, one must look first at the rules for disclosing anything communicated by a detainee. Every written or spoken word is presumed to be classified secret, and therefore cannot be disclosed until it has been reviewed to determine its classification level and whether disclosure would harm the national security of the United States. This approach, devised in the first years after the courts ruled that the men could have lawyers, has not substantially changed.

In practice, this means that when I meet with Moath, I cannot disclose anything he says until it has been reviewed—even something as bland as his preference for one kind of coffee, a memory of his childhood, or a request for art supplies. I am permitted to take paper and pens into the meeting room—although since no metal is allowed, the paper cannot be a pad that is held together by staples (such as a legal pad) or a notebook with a metal coil. In the beginning, the pen could not have a spring, but

now I can bring in any pen that I like (although I have not tried fountain pens yet). After the meeting, my notes are placed in a sealed envelope and taken by my military escort (because we are not allowed in the detention camp areas without an escort). The escort gives them to the "privilege team" which puts them in another sealed envelope and arranges for them to be couriered to a secure facility[1] where I can access them. If I wish, I then can submit them to the "privilege team"[2] to review and determine whether they are unclassified. If they are marked unclassified, I can share them outside of a secure setting.

The same process is followed when I receive a letter from Moath. The letter is delivered to the secure facility. At my option, I can submit it to the privilege team for classification review. If they find it to be unclassified, I can read it outside the facility and share the contents.

And this is how Moath's chapter describing his art at Guantánamo and his creation of his ship models made it out of prison. Our meetings take place in bare, ugly rooms, containing a metal table and several chairs (generally mismatched and somewhat the worse for wear). The walls are unpainted and undecorated, except for the cameras so that we can be watched at all times by the guards and a clock (that may or may not be working). Ostensibly, although we are monitored visually, our conversations are not overheard because they are privileged attorney-client communications. Moath himself sits at one side of the table, shackled to the floor by one leg, and I and the translator sit at the other side of the table.

I first met Moath in 2016, about a decade after I began representing men imprisoned at Guantánamo. From the beginning, we talked about art. Moath brought his ship model *Gondola* to our first meeting as a gift, and so we began our relationship by my asking how he made it and him describing how he converted found items and trash into art. He described cutting up a sponge to make the seat, adding reassuringly that he used a clean sponge. And so all of our meetings included talking about art—how he created his models, what he was painting, and the meanings of his

[1] A "secure facility" is a location, provided by the government, where classified documents and information can be accessed and stored. Often, as is the case with the Guantánamo secure facility, its location is supposed to be kept secret.

[2] The privilege team is the group designated to review our notes and letters from our clients to determine their classification status. By court order, the attorney-client privilege survives sharing this information with them, and they are not allowed to disclose anything they learn to anyone else, including the government (with the exception of an imminent danger). The privilege team also monitors our telephone calls to ensure that the discussion over an open line does not stray into classified topics.

works. He was permitted to bring his models and his paintings into the meetings and we would talk about why he painted a particular scene, its significance, what colors he used, and what it meant to him to be able to create. When he talks about art, Moath speaks in poetry. And so I would scribble as fast as I could and as close to verbatim as possible, trying to record his turns of phrase and patterns of speech.[3] These notes were duly submitted to the privilege review team and were designated "unclassified."

Moath and I also exchanged letters about art. Especially as the idea for this book began to develop, I would send him questions (sometimes the result of conversations with Professors Moore and Swanson) and he would write answers. His letters to me would be reviewed by the privilege team. At that time, writings about art were deemed unclassified. During our telephone calls, we also discussed art, which (at that time) was allowed by the monitors. And again, I would write (or type) as fast as I could to capture Moath's words as accurately as possible.

At the end of 2017, Professor Erin Thompson at John Jay College curated a small exhibition of art by Guantánamo detainees that connected to the sea, which included Moath's three ship models. Apparently in response, the Department of Defense decided that art would no longer be allowed to leave Guantánamo. Over the next few years, these restrictions grew to bar photographs of the art, then to bar descriptions of the art which went from being "unclassified" to being "secret."

While this crackdown on Guantánamo art was developing, we collected my notes of meetings and telephone calls, as well as Moath's letters, and I talked with Moath about what he wanted to say in his chapter. The editors of this volume put together a draft based on these materials, and the students helped to organize the draft according to the timelines they were constructing. That initial draft was translated back into Arabic, and we sent it to Moath for his review.

Moath is meticulous in his art, and also in his writing, which can make working with him challenging. He had many comments about the draft, about its organization, and about its content, which we tried to incorporate. And then the pandemic came, so I no longer could visit Moath in

[3] Moath spoke Arabic, so we were speaking through Felice Bezri, an extremely skilled interpreter, who captured the essence and flavor of Moath's words. Mr. Bezri also translated Moath's letters to me and helped with the early drafts of Moath's chapter. Although the beauty and power of the language is Moath's, it is Mr. Bezri (and then Ureib Qassis) who allow us English speakers to access it.

person. Fortunately, we were still able to exchange letters and have telephone calls, and Moath gave me many more comments and revisions. My first post-pandemic visit to Guantánamo was in July 2021 (my previous visit had been December 2019). I showed up with the Arabic and English drafts of his chapter, and Moath brought his copy to our meetings. We sat down at the table, spread out the pages, and got to work going over it line by line. More reorganization, more revisions of language, more additions and deletions!

We discussed the next revision with Moath during my October 2021 trip, but by the time my notes of these meetings reached the secure facility, discussions about art were considered "secret" instead of "unclassified." So several of Moath's insertions could not be included in the final version of the chapter, although fortunately the draft was almost complete.[4] All of this took a long time, including the delays inherent in sending and receiving letters and notes to and from Guantánamo. But finally, Moath read and approved the Arabic final version, which we then translated one last time into English. You will find it here.

But how did the art itself get out? When I first began taking paintings out of Guantánamo, they were treated similarly to my notes. I would bring the paintings out of the meetings with me and hand them over to the military escort. The difference was that the paintings then were reviewed not by the privilege team, but by someone designated by Joint Task Force-Guantánamo, the military unit responsible for the prisoners. If they were "cleared," the paintings would be given back to me and stamped "Approved by US Forces, JTF/JDG S-2, Guantánamo Bay, Cuba." No further review was required, and I could pack them in my suitcase and they would travel with me back to New York City. After a while, the camp administration assigned a tracking number to each piece of art, and a special form was created for the lawyers to fill out, asking permission to take the artwork with us.

At first, at least for me, it was only paintings, but then Moath began creating bas reliefs and other three-dimensional pieces. And, of course, there were the ship models. They could not be put in my suitcase, even carefully packed, because they were so fragile. Moath built cases for them, but he was limited to cardboard.

[4] Ureib Qassis, another excellent interpreter, now was working with me and she handled the translations of the final versions of the chapter and Moath's final comments, ensuring that Moath's words and ideas were communicated precisely and accurately.

At that time, we habeas lawyers would take a small commercial plane from Guantánamo to Fort Lauderdale; this was a charter company which had a contract with the Navy permitting it to fly into and out of Guantánamo, and the flight was fairly informal. (The identity of the company changed several times over the years.) I then would take a regular commercial flight from Fort Lauderdale. I had anticipated and expected challenges at Guantánamo, but not once I was merely another traveler on another routine commercial flight. But I was wrong.

The gondola was relatively easy. It was small enough to fit under the seat on the commercial airplane, so I could carry it carefully with me in a small bag. It was inspected, returned to me, and I carried it home. The first of the tall ships, *The Ark*, was a different story. It was too big for standard carry-on and too fragile to check, so I figured that I would have to buy a seat for the ship model. As I made my travel arrangements, we phoned the airline to ensure that the ship, in its case, would be allowed on the plane. Getting an affirmative response, I purchased two seats, the window seat for the ship and the middle seat for me.

At Guantánamo, I was told that the ship model had been X-rayed before it was approved to leave. The approval stamp was on one of the sails, clearly visible. Boarding the small charter plane was not too much of a problem. Although the ship would not fit through the X-ray scanner, the JTF approval was enough to allow it on the plane, where it sat at my feet for the flight to Florida. In Fort Lauderdale, TSA similarly peered at the ship, saw the JTF/JDG stamp, and allowed it through. I boarded the plane and strapped the ship model into the seat next to me, but then my luck ran out. The flight attendants asked what it was and where it came from; they left and returned to tell me that the pilot had decided that I could not take the ship model on the plane. I found myself escorted off the plane with the ship model in hand (it is surprisingly humiliating to be kicked off a plane). And there I was at the gate as the plane left, trying to figure out how to get back to New York City in time for my father's 89th birthday dinner that evening. (I did not make it.) Much discussion with a very sympathetic gate agent, and about five hours later, the ship model and I were on another airplane flown by a courageous pilot who was willing to allow us on his flight.

So when the time came to bring *GIANT* to New York, flying with it clearly was not a good plan. First, it was larger than *The Ark*, so trying to put it on the seat probably would not have worked. But this time, I was not going to try. Once again, it was X-rayed and examined at Guantánamo, and approved to leave. Once again, the personnel on the small charter

from Guantánamo to Fort Lauderdale allowed it to sit in the cabin. But this time, *GIANT* and I took a cab to my daughter's small studio apartment in Miami Beach, where she was working with the New World Symphony Orchestra. We wrapped it carefully in blankets and towels and plastic garbage bags, and it resided for months in her apartment, taking up much needed floor space and providing a comfortable perch for her two cats. Finally, a musician in the orchestra—an Israeli clarinetist—was driving north and agreed to take the ship model, still wrapped in its blankets and plastic bags. He knew what he was carrying of course, and when he reached me in the Bronx, he asked if I would unwrap it so he could see it.

When Moath started working on his next ship model, *Eagle King*, even bigger and more elaborate than *GIANT*, I wondered how I would manage to get it safely to shore on the mainland. But then the Department of Defense, apparently spooked by the fact that people were interested in looking at art created by prisoners whom they had hoped to suppress and demonize, decided that artwork would no longer be approved to leave Guantánamo.[5]

And so as I write this in 2023, Moath himself languishes in prison—without charges, without trial, years after the US government concluded there was no longer any reason to keep him there. His art is imprisoned with him.

NOTES ON PROCESS: VOICE, TIMELINE, AND TRANSLATION

Olivia Vinson and Maya Gamer

We were introduced to the role of Guantánamo in the War on Terror in our two-semester human rights research seminar in the Source Project our first year in college, when we chose to work with Alexandra Moore on projects related to the legal and cultural representations of the detention center. The attacks of September 11, 2001, took place before we were born, and Guantánamo was not something we had ever learned about before this course. After doing extensive secondary source research on the Central Intelligence Agency's Rendition, Detention, and Interrogation program (which began scooping up suspected terrorists and disappearing and interrogating them in black sites around the world just months after the attacks), additional prison transfers by the US Department of Defense, the use of torture, and the lack of legal due process, we read Mohamedou Ould Slahi's *Guantánamo Diary* and had the chance to speak directly with him, his former guard Steve Wood, and Beth D. Jacob.

[5] That policy was recently changed, with a grudging allowance that a "practicable amount" of art could leave with a detainee when he himself was released.

From this foundation, we chose our individual research topics. Olivia decided to test the US government's claim that the 2500+ redactions of Slahi's memoir that appear in the first published version in 2015 were necessary to protect national security. Researching the government's security and FOIA provisions and working from the restored version of the text which Slahi published in 2017 after his release from Guantánamo, where the redactions have become translucent and Slahi has reinserted the missing text, she coded each redaction for whether it met the government's own standards for state secrets. Readers familiar with attempts to control information from and about Guantánamo will not be surprised that her research showed the redactions were capricious and irregular and largely failed to meet those standards. Maya also focused on the manipulations of language in her work on the terminology—specifically the use of the term "unlawful combatant"—used to classify detainees in legal documents (and circumvent the requirements of the Third Geneva Convention) as it relates to their right to own the artwork they create in Guantánamo.

Our research required us to look closely at law and policy statements and to think about how the US government has shaped the public understanding of Guantánamo and of the men who were and are held there. It also made us committed to unearthing the stories the government sought to suppress. Working on this project, which is coming to completion as we approach our college graduations, has given us the opportunity to participate directly in that process by helping to bring forward Moath's testimony and artwork. Throughout our time working on this book, we have thought deeply about how to do justice to the voice of someone we have never met and can't speak with directly and who has been detained without charge by our government since before we were born.

When this project began, the publicly available documentation of the rendition and detention of Moath was extremely sparse and provided little insight into his perspective. We knew the Wikileaked documentation from JTF-GTMO on him (available in the *New York Times* Guantánamo docket) could not be verified, and there were few of Moath's own statements in mainstream media. We began by attempting to compile a timeline of Moath's life using a variety of sources, so that we as contributors would have a better sense of his background. These sources included transcripts of government hearings, investigative reports by journalists, and op-eds by Moath working with Ramzi Kassem, his independent counsel. We added to the timeline details from Moath's own writing to develop a better understanding of his beginnings as an artist and his status as a detainee of the War on Terror.

We discussed our timeline in broad terms with Beth in hopes that her professional relationship with Moath would provide insight into the viability of the information released by the US government and allow us to make revisions. Beth's security clearance provides her with access to otherwise unavailable information but prevented her from sharing this information through comments on the timeline; in addition, she was unable to review information we might have included from unauthorized sources. However, even this limited feedback revealed critical weaknesses in the publicly accessible documentation of Moath's life. Olivia undertook a similar process in assisting with the compilation of "A Very Incomplete Chronology of Moath al-Alwi's Artwork" based on publicly available information and the spreadsheet of artworks maintained by art professor, curator, and contributor Erin L. Thompson. Ultimately, any representation of Moath, either through his writing or through his artwork, has been shaped or limited by the same government that has justified the violation of his human rights as "necessary and appropriate" to preserve national security. It is due to those restrictions that there is no timeline of his life included in this volume. Instead, we place Moath's testimony of his art-making process as the centerpiece of the book. And we include the "very incomplete chronology" of artwork to gesture however partially toward the huge range of his artwork that still awaits a larger audience.

Working from the draft of the testimonial chapter the editors had created from Moath's writing and Beth's notes, we reorganized the essay based upon the timeline we built, some of which his essay revisions corrected, as well as Moath's own wishes that the essay be organized chronologically. Yet we faced the problem of never having heard him speak and of not reading and speaking Arabic ourselves. We had long conversations all together about what could be ethically understood as Moath's accurate self-representation given these limitations. In one particularly useful drafting session, Beth shared with us translations of Moath's writing (all cleared, of course, by the privilege team) done by three different translators. In combing through those passages sentence by sentence with her, we learned more about his cadences when he describes his artwork, how poetic he is in discussions of his work and what it means to him, and which parts of each translation seemed to best reflect to her the experience of talking with him directly (where a translator is present but they can also have limited conversations in English).

The editors shared with us their process, developed in their extensive experience with testimonials from torture survivors from around the

world, for working ethically with the text we had culled from notes, inter-
views, and feedback from Moath, so as to preserve as closely as possible
the narrative voice as it was received in those original notes. That method
follows two basic principles: first, never add any words or phrases; instead,
cut away any words or phrases that interfere with sense-making by readers,
keeping a close record of those changes should the need ever arise for
comparison; and second, edit strictly for written grammatical accuracy
unless inaccuracy is central to the tone of a specific phrase or sentence. The
editors painstakingly made those initial edits, and we maintained the pro-
cess in making the chronology as close to Moath's intention as possible.
Despite the careful work of the translators, portions of Moath's writings
were nonetheless difficult for us to understand. Although we tried to
maintain the nuances of his writing, there remained our inexorable dis-
tance from Moath that required us to make inferences regarding his
intended meaning. This challenge presented itself in the original draft of
the narrative, which contained chronological and translational inaccura-
cies Moath of course recognized. That process of review also returned us
all to the first principle in the editing process, and the recognition that
an exact word in the initial translation might not be the best representation
of Moath's meaning. In her meetings with Moath and Ureib the transla-
tor, Beth was often able to add a layer of precision to the initial translation.
Through Moath's feedback, which was again filtered through a translator,
we collectively continued to revise and cross-check to create another draft
Beth and Moath could work on sentence by sentence with the pages spread
out before them on the table in their meeting room in Guantánamo, as she
describes above. The challenges faced in the publication of this narrative as
well as Moath's larger effort to publicly display his art are representative of
the common barriers faced by Guantánamo Bay detainees who seek to
express themselves in a public forum. Beth notes that Moath had additions
and revisions of the final draft that were not cleared for release and thus do
not appear in his chapter. We eagerly await the opportunity to work directly
with him to ensure the text holds his full intention.

Binghamton, NY	Alexandra S. Moore
Babson Park, MA	Elizabeth Swanson
Washington, DC	Beth D. Jacob
New York, NY	Olivia Vinson
Ann Arbor, MI	Maya Gamer

A Very Incomplete Chronology of Moath al-Alwi's Artwork

Moath al-Alwi has completed well over 100 works of art, including paintings of different sizes, bas-reliefs, and at least two additional ship models with another in progress beyond what is listed here. Each entry only reflects what has been transferred out of Guantánamo or what he or others have discussed before the 2021 ban on descriptions of current artwork. He designed and constructed numerous works of furniture in the period detainees term the Cardboard Renaissance. Moath has completed many paintings, most of which are still held at Guantánamo, including dozens completed since 2016.

2009

- Statue of Liberty (wall drawings and paintings)

2010

- Water wheel (3D mixed media)

2012

- Window (3D mixed media)
- Bookshelves and other furniture (cardboard)

2015

- *The Ark* (model ship with case) (mixed media sculpture)

2016

- *Gondola* (model ship with case, mixed media sculpture)
- House on a beach under palms (acrylic paint on folded and cut paper)
- Sailing ship (acrylic paint on folded and cut paper)

2017

- *GIANT* (model ship with case) (begun in 2015) (mixed media sculpture)
- Rose growing from a crack near water (mixed media—cardboard, fabric, plastic elements, acrylic paint)
- Sailing ship (paint)
- Roses with broken watch (paint)
- River flowing over broken steps (paint)
- Sailing ship under moon (paint)
- Path leading from beach hut to sea (paint)
- Treasure on bottom of sea (paint)
- Bridge over stream (mixed media—cardboard, plastic elements, acrylic paint)
- Sunflower growing from brick wall (mixed media—cardboard, plastic elements, acrylic paint)
- Roses in a vase with winged hearts (mixed media—cardboard, plastic elements, acrylic paint)
- Waterfall with a bridge (mixed media—cardboard, acrylic paint)
- Rose in a rope-covered vase (mixed media—cardboard, plastic elements, acrylic paint)
- Rose in a gold case (mixed media—cardboard, plastic elements, acrylic paint)
- Rose in a vase with a heart (mixed media—cardboard, plastic elements, acrylic paint)
- Rose in a rope-covered case (6-sided frame) (mixed media—cardboard, plastic elements, acrylic paint)
- Sailing boat with sun (mixed media—cardboard, acrylic paint)
- White rose in a case with a heart (mixed media—cardboard, plastic elements, acrylic paint)
- Bouquet of flowers with a bow (mixed media—cardboard, twine, acrylic paint)

- Interior with fireplace (mixed media—cardboard, plastic elements, fabric, acrylic paint)
- Sunflower in a case with a heart (mixed media—cardboard, plastic elements, fabric, acrylic paint)
- Tree with sparkling fruits (acrylic paint on paper)
- Ocean floor with shipwreck, shark, and candle in a bottle (acrylic paint on paper)

2018

- *Eagle King* (begun in 2017) (model ship with case, mixed media sculpture)

2019

- Castle with the flag of justice (3D mixed media) (approx. date)

2020

- Castle of justice with small Eagle King ship (3D mixed media) (approx. date)
- *The Story of My Imprisonment* (series of four paintings) (approx. date)

2021

- Ban on the description of prisoners' artwork

ACKNOWLEDGMENTS

Our deepest gratitude goes to Moath al-Alwi for sharing his experiences and his artwork. The volume also would not be possible without the support of his attorney, Beth D. Jacob. Beyond his contribution to this volume, Mansoor Adayfi, Moath's former fellow detainee, has also been an important interlocutor for understanding artwork and conditions of confinement at Guantánamo.

We express our gratitude to the Human Rights Institute at Binghamton University (State University of New York), Binghamton, NY, and The Mandell Family Foundation Senior Term Chair, Babson College, Wellesley, MA, for support for this volume.

Praise for *The Guantánamo Artwork and Testimony of Moath al-Alwi*

"Moath al-Alwi's artworks from Guantánamo, created under the harshest conditions of abduction, confinement, and torture, appear nothing short of miraculous. This pioneering volume, blending firsthand testimonies with meticulous, careful and multidisciplinary scholarship, tells the story of its creation, censorship, and eventual exhibition. It demonstrates the profound significance artmaking holds for Moath al-Alwi in testifying to his torture as well as his humanity, while compelling us to reflect its potential meaning for us as a public."

—Dr. Sebastian Köthe, *Zurich University of the Arts*

CONTENTS

NOTES ON CONTRIBUTORS

Mansoor Adayfi originally from Yemen, is a writer and former detainee in the Guantánamo Bay Prison Camp who was held for over fourteen years without charge before being transferred to Serbia. His essays have appeared in *The New York Times'* "Modern Love" column and Op-Ed pages and the edited collection, *Witnessing Torture: Perspectives of Torture Survivors and Human Rights Workers* (Palgrave Macmillan 2018), and the "Ode to the Sea" art exhibition catalogue. He also contributed to radio documentaries which aired on BBC radio, a CBC podcast, and NPR. In 2019 he was awarded the Richard J. Margolis Award for nonfiction writing that illuminates issues of social justice. His memoir of his time at Guantánamo, *Don't Forget Us Here*, was published in 2021.

Moath al-Alwi is a Yemeni citizen who has been detained without charge at the Guantánamo Bay Naval Base prison since 2002. At Guantánamo, he has created a significant archive of paintings, bas-reliefs, and sculptures from scraps of refuse and found objects and the camp's limited art supplies. Initially creating artwork as gifts for his family and lawyers, his work has also been featured in the art exhibit, *Ode to the Sea: Art from Guantánamo Bay* (2017–2018) and in "A Ship from Guantánamo," an Op-Doc video, published in *The New York Times*.

Maya Gamer expects to receive her B.A. in History from the University of Michigan in May 2024. She has previously worked on projects about the Guantánamo Bay Detention Facility, and is currently studying Marxism, feminism, and the experiences of women in small socialist communities.

Beth D. Jacob is a lawyer whose practice now focuses on human rights. She holds a B.A. (*magna cum laude*) from Radcliffe College, Harvard University, and J.D. from Yale Law School. She is a member of the bars of New York, Georgia, and Alabama. She served as Assistant District Attorney in the New York County District Attorney's Office and was a law partner at several law firms in New York City, where her practice focused on pharmaceutical patent litigation. Most recently she was a Senior Supervising Attorney at the Southern Poverty Law Center. She has provided pro bono representation for Guantánamo detainees since 2005: seven have been released and she now represents four men who are still imprisoned. She has made more than three dozen visits to her clients at Guantánamo. She is also a founder and president of the non-profit organization Healing and Recovery After Trauma, which provides support and representation to survivors of torture from Guantánamo and elsewhere and promotes exhibition and publication of their artwork and writings.

Alexandra S. Moore is Professor of English and co-director of the Human Rights Institute at Binghamton University, USA. Her publications include two monographs, most recently *Vulnerability and Security in Human Rights Literature and Visual Culture* (2015), and seven edited collections, including *Writing Beyond the State: Post-Sovereign Approaches to Human Rights to Literature and Culture* (with Samantha Pinto, 2020), *Witnessing Torture: Perspectives of Survivors and Human Rights Workers* (with Elizabeth Swanson, 2018), and *The Routledge Companion to Literature and Human Rights* (with Sophia A. McClennen, 2015). She writes widely on representations of human rights violations in contemporary literature and film. Her current research is on cultural renditions of Guantánamo in the War on Terror.

Joshua O. Reno is Professor of Anthropology at Binghamton University, USA. He has written two books—*Waste Away* (2016) and *Military Waste* (2019)—on the politics of different senses of discard in North America. He has more recently written on a wider array of subjects including, with Britt Halvorson, *Imagining the Heartland* (2022), about historical ideas of whiteness that shape global white supremacy, and *Home Signs*, a forthcoming book on semiotics and non-verbal communication expected in 2024.

Safiyah Rochelle holds a Ph.D. in Legal Studies from Carleton University, Canada, and is Assistant Professor in the Department of Social Science at

York University. Her research focuses on contemporary political and legal theory, critical race and visual studies, state violence, and violence and the body. Her award-winning dissertation, funded by the Social Sciences and Humanities Research Council (SSHRC), centered on an analysis of photographs of Guantánamo Bay detainees and theorized the political and legal capital of these images; the relationship between visual practices, law, and racialized bodies; and the role of state-produced photography and visual evidence in practices of state violence. She received the 2022 Early Career Essay Award from *Humanity: An International Journal of Human Rights, Humanitarianism, and Development.*

Gail Rothschild is a Brooklyn-based artist who collaborates with museums internationally, creating paintings that breathe new life into archeological fragments of textiles. After graduating from Yale, she embarked on a peripatetic career creating site-specific installations—many of found materials—that commented on lesser-known local histories. Considering her role in the construction and destruction of these political sculptures, and her interest in the ancient world led Rothschild to the Odyssey and Penelope's cycle of weaving and un-weaving. By utilizing archaic fabric as the subject of her *Portrait of Ancient Linen* series, Rothschild alludes to her affinity with Penelope's struggle. She recently opened two exhibitions in Germany featuring a total of twelve monumental paintings inspired by objects in the collections of the Bode Museum in Berlin and the German Textile Museum in Krefeld.

Elizabeth Swanson is Professor of English and Mandell Family Foundation Senior Term Chair in Literature and Human Rights at Babson College, Wellesley, MA, USA. Author of *Beyond Terror: Gender, Narrative, Human Rights* (2007), Swanson has co-edited, with Alexandra S. Moore, *Witnessing Torture: Perspectives from Torture Survivors and Human Rights Workers* (2018), *Teaching Human Rights in Literary and Cultural Studies* (2015), and *Theoretical Perspectives on Human Rights and Literature* (2011). Author of numerous articles and book chapters on human rights and literature, she also recently co-edited *Human Bondage and Abolition: New Histories of Past and Present Slaveries* (2018) with James Brewer Stewart. Swanson's NGO work operates on a parallel track with her scholarship: currently directing the Babson College Venturing Out Prison Education Initiative, she also led the Board of Made BySurvivors (now Her Future Coalition) from 2008 to 2016, working directly with survivors of brothel slavery in India and Nepal, with torture survivors and

asylees in the US, and with incarcerated people in Massachusetts. A Commissioner for the Barnstable County (Cape Cod) Human Rights Commission from 2010 to 2015, Swanson is committed to working directly with and centering the voices of survivors regarding our most pressing global human rights concerns.

Erin L. Thompson obtained her B.A. (*magna cum laude*, Phi Beta Kappa) from Barnard College, her Ph.D. in Art History from Columbia University, and her J.D. from Columbia Law School, along with a certificate in Global Business Law from the Institut d'Eìtudes Politiques and Paris I (Sorbonne). After working as a lawyer for Hogan Lovells and the Conflicts of Interest Board of the City of New York, she is Associate Professor of Art Crime at John Jay College, City University of New York (CUNY). She studies the damage done to humanity's shared heritage through looting, theft, and deliberate destruction of art, including during the current conflicts in Syria. She is also interested in the legalities and ethics of digital reproductions of cultural heritage, as well as art made by detainees at the United States military prison camp known as Guantánamo Bay; she curated an exhibit of this artwork in New York in 2017–2018. Besides traditional scholarly publications, she has written on the above topics in publications including *The New York Times*, *Paris Review Daily*, *Kenyon Review*, and *The Nation*, and has spoken at many universities as well as on CNN, NPR, BBC, two TEDx conferences, and the Freakonomics podcast. She was a fellow at the Rice University Humanities Research Center from 2017 to 2018 and a Public Scholar of the New York Council for the Humanities from 2015 to 2018. Her book, *Possession: The Curious History of Private Collectors*, was named an NPR Best Book of 2016.

Olivia Vinson is a recent graduate from Binghamton University, USA, with a major in English and minors in human rights and Spanish. She has done extensive research on refugee rights and on Guantánamo Bay through censorship and the narratives of former detainees. She is currently pursuing her Master's in Human Rights at Columbia University, where she hopes to focus on international law and continue her work with Guantánamo Bay detainees and asylum seekers.

Mira Rai Waits is Associate Professor of Art History at Appalachian State University, USA. Her research has addressed the development of fingerprinting in colonial India, the architectural history of British colonial prisons, and the role that remunerative labor played in the production of

colonial Indian penology. Her research has been funded by the American Council of Learned Societies and University of California President's Program. She has held postdoctoral fellowships with the Mahindra Humanities Center at Harvard University and the Interdisciplinary Humanities Center at the University of California, Santa Barbara.

Belinda Walzer is Assistant Professor of Rhetoric and Writing Studies in the Department of Department at Appalachian State University, USA. Her research focuses on rhetorics of resistance and human rights through a temporal lens, and issues of diversity, equity, and inclusion in writing studies and pedagogy. Her work has been published in edited collections from the Ohio State Press, Routledge, and MLA, as well as in journals including *Philosophy and Rhetoric, College Literature,* and *Comparative Literature Studies.* She teaches graduate and undergraduate courses in writing, transnational gender studies, advocacy writing and rhetorics of resistance, human rights and rhetoric, and literature and mass violence.

LIST OF FIGURES

Introduction: The Guantánamo Artwork of Moath al-Alwi: Art as Expression, Witness, Evidence

Alexandra S. Moore and Elizabeth Swanson

Deaf Walls Speak presents an insider's view of artmaking in the Guantánamo Bay naval detention center as self-expression and protest, staging a fundamental human rights claim that has been denied by law and politics: the right to be recognized as human. This is a book about works of art made under conditions of extremity by Moath Hamza Ahmed al-Alwi, deprived of the totality of his civil and human rights as part of the War on Terror. It is also about the person, the artist who made the works, both as he represents that class of persons whose rights have been denied at Guantánamo, and, strictly and perhaps more significantly,

A. S. Moore (✉)
Binghamton University, Binghamton, NY, USA
e-mail: amoore@binghamton.edu

E. Swanson
Babson College, Babson Park, MA, USA
e-mail: eswanson@babson.edu

© The Author(s), under exclusive license to Springer Nature Switzerland AG 2024
A. S. Moore, E. Swanson (eds.), *The Guantánamo Artwork and Testimony of Moath al-Alwi*, Palgrave Studies in Literature, Culture and Human Rights,
https://doi.org/10.1007/978-3-031-37656-6_1

1

himself. Across a range of disciplines and in conversation with Moath's testimony, our contributors argue that artwork at Guantánamo constitutes important forms of material and aesthetic witnessing to human rights abuses perpetrated and denied by the US government: the art objects themselves bear witness to the violation of the artist and other Guantánamo prisoners' human rights. Indeed, the artwork we examine represents one of the very few forms of self-expression by Guantánamo detainees available in the public sphere—albeit within ever-shifting constraints. Equally important, this is a book of witness to Moath, a Yemeni citizen who arrived on the first transport to Guantánamo when it began holding so-called War on Terror detainees in 2002, and who remains there today, *without ever having been charged with a crime*, and although he was cleared for release on December 27, 2021.

The book juxtaposes detainee artist Moath's testimony and artwork with chapters that situate his work within legal, political, aesthetic, and material contexts, and that consider his conditions of imprisonment, the materials with which he creates, and how his artwork resonates within and beyond prison walls. Foregrounding Moath's process, intentions, and the work's reception both within and beyond Guantánamo's walls, the project situates his artwork in the prison's particular legal, bureaucratic, and geopolitical context to explain the significance of his creative process. The artwork opens larger critical conversations explored throughout this book about the tension between evidentiary and aesthetic modes of witnessing, that is, about artwork as *evidence* or as *creative representation* of Moath's imagination and experiences in Guantánamo. It is also about artmaking in the context of egregious, ongoing human rights violations, and how art as evidentiary and/or aesthetic witness circulates in public spheres the US government has sought vigorously to control.

In her foundational *Marking Time: Art in the Age of Mass Incarceration*, Nicole Fleetwood defines carceral aesthetics as "the production of art under the conditions of unfreedom; it involves the creative use of penal space, time, and matter ... [where i]mmobility, invisibility, stigmatization, lack of access, and premature death govern the lives of the imprisoned and their expressive capacities" (2020, 25). In this volume, guided by Moath's testimony in Chap. 2, we examine his carceral aesthetics in specific artworks, most notably in the model ships he constructs from the prison camp detritus. Building on Fleetwood's work, we attend closely to the specific conditions of his imprisonment that inform his artwork to consider its *evidentiary aesthetics*: how his artwork at once exposes human

rights abuses at Guantánamo ("evidence") and provides a means with which to construct a viable subject position, to reclaim his own humanity within the very system that seeks to deny him. If the value of evidence depends in part on its source, then Moath's artwork not only reflects and is, indeed, made from the very conditions of his imprisonment; it also helps to construct him as a viable witness. In the absence of charges or a trial through which to answer them, art—visual, written, and material—is the vehicle for Moath's self-representation. As noted in the Preface, we strive throughout this volume to include Moath in the discussion of his work and prison art and human rights more broadly, despite the many barriers to accessing him. Although at this writing, he remains virtually incommunicado at Guantánamo, accessible only to his legal counsel in pre-approved visits, to his family in monthly monitored phone calls, and via reviewed mail correspondence (which can be censored), we are grateful for the opportunity to work with him on this book and look forward to the day he can talk directly with scholars and the wider public about his work.

We begin with a deeper look into his "conditions of unfreedom" and the struggles over their representation. Moath's simultaneous invisibility and recognition as an accomplished artist is typical of the government's manipulation of secrecy and access to control representations of Guantánamo in the public sphere since the naval base detention center first began receiving War on Terror detainees, including Moath, on January 11, 2002. Despite the long history of the base as a gatekeeper of US imperial interests and site of prior detainee abuse, it offered (through ambiguity about legal jurisdiction and its remoteness) "legal flexibility and a low-risk security environment" for holding and interrogating suspects in the War in Terror (Greenberg 2009, 15; see also, e.g., Paik 2016, Braziel 2006, Lipman 2008). The US government has consistently and closely guarded information about the prison and detainees, often in violation of the Geneva Conventions and legal due process. For example, it only released names of the initial 558 detainees (including to their families) in 2006, four years after the prison opened, in response to a leak, Freedom of Information Act (FOIA) request, and legal pressure; and the men and boys held there, the vast majority without charge, only gained access to legal counsel following the US Supreme Court's decision in *Rasul v. Bush* in 2004. Those small gains have been challenged, however, by Congressional legislation, such as the Military Commissions Acts of 2006 and 2009, and the ongoing struggle within the flawed Military

Commissions over whether they can consider evidence obtained through torture (legally inadmissible according to Article 15 of the UN Convention Against Torture and Other Cruel, Inhuman or Degrading Treatment or Punishment) in the trials of those few detainees who do face charges.

In place of legal representation through US courts, the government has offered carefully orchestrated press access and photographs in an attempt to control public perception of the detention center. Remembering her initial trip to Guantánamo, when Moath arrived on that first transport, renowned journalist Carol Rosenberg offers the account she and other selected civilian journalists shared with the Pentagon press pool:

> 2:55: First prisoner comes off. He is wearing a fluorescent orange jumpsuit, a shiny turquoise face mask, goggles, similar colored orange socks over white footwear, a brighter orange head cover that appeared to be a knit cap. His hands were manacled in front of him, and he limped. He was frisked and led, by at least two Marines, to the awaiting bus. (Rosenberg 2021)

The government also quickly discovered, however, the difficulty of controlling the story and the visual archive. That difficulty is perhaps best represented by the controversy following the Department of Defense's release of images taken that first day by US Navy Combat Unit photographer Shane T. McCoy—the now iconic images of the captives goggled, chained, dressed in orange jumpsuits, and kneeling in outdoor cages. Images the Pentagon projected as "showing the care and concern with which we treated the detainees" appeared largely to the global public as representations of abuse and cruel, inhuman, and degrading treatment (Rosenberg, "20 Years Later," 2022a; see also, e.g., Van Veeren 2011). More than two decades later, and after *The New York Times* filed a successful FOIA request for additional military photographs of that first day, Rosenberg's annotations of the images reveal striking details omitted from the first press filing: a detainee with duct tape around his goggles and head, the chains around their ankles, marines in jungle fatigues and combat dress (Rosenberg, "Secret Pentagon Photos," 2022b). Readers now might turn to films like *The Report* (2019) and *The Mauritanian* (2021) to understand the use of torture before and during flights to Guantánamo as perhaps root cause of the "limp" initially noted by Rosenberg; at the time, however, it remained for journalists, human rights advocates, and lawyers to unearth details of detainee treatment during this "extraordinary rendition" (i.e., abduction and transfer outside the law) to Guantánamo

(see Sadat 2006). The ongoing struggle over image, representation, witnessing, and interpretations reverberates in the treatment of detainee artwork.

Without the capacity to represent themselves or, at least initially, to have meaningful representation in any legal or political forum, the detainees turned to prayer, song, poetry, dance, and eventually visual art to express themselves individually and to forge a shared culture across their forty-eight different nations and eighteen languages (Adayfi 2022). Those efforts were largely invisible beyond the confines of the prison until the publication of lawyer Marc Falkoff's edited collection, *Poems from Guantánamo* (2007). Prisoners had been writing and sharing poems since their arrival. Before they gained access to pen and paper after the first year, they would use pebbles and apple stems to impress poems and designs on the Styrofoam cups they received with their meals, circulating the poem cups through the cells before the cups were collected as trash. A collection of twenty-two poems either cleared for release by the military or reconstructed from memory by detainees who had been transferred, the book, Falkoff writes, "represents another step in our struggle to allow our clients' voices to be heard" (Falkoff 2007, 2).

And yet here, too, the military misread the poems. Whereas the military feared poetry's "content and format ... presents a special risk" to national security, the poems focused on their author's despair, suffering, and intrinsic humanity and, as Falkoff has recollected recently, have "worked to reframe our understanding of what it means to be human and what it means to be a citizen in a country with an increasingly tenuous dedication to the rule of law" (Falkoff 2007, 4; Falkoff 2023, 138). His framing of *Poems from Guantánamo* also draws attention to how public access to the cultural work of detainees is conditioned by a wide range of mediators, each with a different purpose: the Pentagon's privilege team that reviews items for declassification; lawyers representing their clients in legal and public forums; translators, curators, and editors like ourselves. In the Preface and through our attention to carceral and evidentiary aesthetics, we try to be as explicit as possible about the process of engaging with Moath's work in this project (in the context of lack of direct communication with him) and to consider the conditions of his artistic production.

Just as prisoners improvised with Styrofoam cups to write poetry, they drew and painted with the resources at hand in the absence of art supplies. Mansoor Adayfi has described how they would try to hold onto pens from the International Committee of the Red Cross to draw on toilet paper and

discovered they could use tea bags in the Meals Ready to Eat they were served to create ink: detainees "would mix it with a little water and then fold the tea bag to use as a pen to write or draw on their toilet paper" (Adayfi 2018, 234). In his chapter here, Moath describes his own processes from drawing on cell walls to creating paintings, bas-reliefs, and sculpture. Conditions changed when President Obama took office, and in 2009, the administration of the prison camp, Joint Task Force-Guantánamo (JTF-GTMO), initiated art classes. Whether a public relations tool "to send a message to the world by trying to humanize Guantánamo" or an attempt to occupy and rehabilitate men who had been violently incarcerated and tortured in years of detention, the program provided an art teacher and two forty-five minute classes a week for detainees approved for participation and willing to undergo the invasive searches to and from class in order to have the opportunity to paint and draw while shackled to the floor (Adayfi 2023, 268). A number of detainees in addition to Moath discovered or honed their artistic skill, among them Djamel Ameziane, Abd Almalik, Muhammed Ansi, Ammar al-Baluchi, Ghaleb al-Bihani, Khalid Qasim, Sabri al-Qurashi, and Ahmed Rabbani, some creating dozens and dozens of works.

Prisoners' artwork became a staple on Guantánamo media tours and often illustrated journalistic reports from the base, but it first gained collective widespread exposure beyond prison walls in 2017–18, when John Jay College of Criminal Justice hosted an exhibition of eight artists' work, including Moath's, in a small gallery hall outside the President's office. When Erin L. Thompson agreed to curate "Ode to the Sea", she could not have imagined the range and intensity of responses it would garner. Few visitors arrived at first; Guantánamo was, she feared, a "forgotten issue" (61)—until media reports made their way to the Department of Defense, which immediately halted any additional release of artwork and threatened to destroy any pieces that remained at the facility. Given the previous display of artwork at Guantánamo, the military-sponsored art program from which it arose, and the fact that all the pieces in the "Ode to the Sea" exhibit had been cleared for release, the subsequent ban seemed to acknowledge the works' evidentiary aesthetics—their capacity to present the artists' imaginations as well as aspects of their conditions of confinement to diverse publics—rather than their threat to national security. Like the release of McCoy's photographs, the government's attempt to control the public visual archive of Guantánamo and its reception had unintended consequences. As news of the ban on releasing the artwork

reached the public, the exhibit became a cause célèbre, with reactions ranging from outrage at the idea of government censorship of detainee art to condemnation of the exhibit for "humanizing the enemy" in the US-led War on Terror. The idea of "terrorists" being willing and able to appreciate—much less to create—art is anathema to the cultural narratives that surround them, as the detainees well know—hence, their intense desire for their artwork to be seen. As Rosalyn Deutsche assesses (in words similar to Falkoff's) in her *Art Forum* review, "Of course, self-expression is a crucial aspect of the detainees' artmaking. ... Yet everyone, artists and commentators alike, agrees that the exhibition of the Guantánamo works has a broader purpose: to show the world, especially Americans, that the works' creators are human beings. That they are might seem obvious, but, given the massive dehumanization detainees have suffered at the camp and in Western media and propaganda, it is a significant goal." Because the detainees have been denied full personhood or legal standing, the creation of alternative human rights fora through the assertion and recognition of their humanity becomes all the more crucial.

This book contributes to that goal by centering the testimony and artwork of Moath, who survives Guantánamo in part through realizing the artistic talents he has discovered during his imprisonment. Most significant among his works are the large, dynamic sculptures of ships constructed from found objects, prison trash, and limited art supplies. As reviewers point out, these sculptures demonstrate artistic talent plus a determined vision all the more remarkable given the conditions under which Moath works and the fact that he has never been on a boat himself.

We place Moath's creative process in the context of indefinite, often violent detention, itself a form of cruel and degrading treatment, in order to develop three main facets of its evidentiary aesthetics. First, the book details how his artwork provides a mode of self-expression both within and beyond the flawed bureaucratic and legal systems designed to deny him a voice. Drawing on Fleetwood's insights regarding the measurement of prison labor in time, we situate Moath's narration of his creative process in the context of his indefinite detention in order to demonstrate how he constructs alternative spaces and times to those that confine him. Second, the project ties Moath's testimony on *why* he creates art at Guantánamo to his ingenuity of fashioning exacting model ships from the heavily regulated detritus of a prison camp as well as the aesthetic, imaginative, and technical sophistication of crafting multimedia works with moving parts powered by the air from within his prison cell. Moath's repurposing of

military refuse and his allotted "comfort items" provides unique insight into the ideological and material tenets of the military prison system, especially in the context of force feedings determined to deny his right to freedom of expression through hunger-striking. Finally, this project—in its content and form—demonstrates how his creative expression invokes multiple contexts and communities (theoretical, carceral, historical, aesthetic) and calls forth responses from diverse audiences that are unscripted from narratives that keep Moath at Guantánamo despite having been cleared for release. In this way, the project engages contemporary critical conversations about cultural representation as a form of aesthetic and evidentiary witnessing in the bid for accountability for atrocity.

CARCERAL AND EVIDENTIARY AESTHETICS

To trace the path by which Moath's voice and art is made available to us is to trace the machinations of the carceral state that imprisons and oppresses him. Over and over, Moath describes his experience of detention, particularly solitary confinement, as a grave, a dead space at the bottom of the sea, an exile on another planet. A total removal not only from the voices and touch of others, but a disconnection from the self itself via a distortion of the senses, which are limited, diminished, and twisted by lack of or overexposure to stimuli and connection. Moath's testimony to the conditions of his imprisonment, especially how indefinite detention without charge amplifies conditions of solitary confinement, resonates with Lisa Guenther's exploration of the ontological condition of solitary, "[t]he feeling of being buried alive, reduced to a ghost in one's own life" ("Beyond Dehumanization" 50), and with Stephen Dillon, who suggests that "[t]he centrality of death to incarceration undoes normative modes of temporality so that the prisoner is subjected to a space that is timeless. Indeed, the carceral state's dream of the prisoner's future is one of incapacitation, slow death, and nothingness" (qtd. in Fleetwood 39). So too, Moath, who, if given the choice between his own release and that of his artwork, answers "without any hesitation": "I would choose the release of my artwork because as far as I am concerned, I am done, both my life and my dreams have been shattered, whereas if my artwork is released, it would be my sole witness for prosperity" (44). As the chapters in this volume elaborate, Moath's artwork offers a powerful symbology that acts as evidence to the conditions he endures, especially the all-pervasive violence of torture and abuse (including indefinite detention as well as "no-touch

torture" via sensory deprivation or hyper-exposure; stress and duress; and other "advanced" techniques). Other techniques of coercion and control of the penal regime include force-feeding (another form of torture and humiliation) and solitary confinement, all of which form an "ocean of suffering" from which Moath seeks, through his art, to rescue himself: "The ships I make talk about violence of the ocean. The ocean is violent; it does not know any mercy. The ocean where we are now is always violent. We are suffering here" (33-4).

We understand, then, that Moath builds ships and creates other artworks not only to express the rescue he so desperately desires, but also to call into consideration the forcefield of total domination and violence under which he lives: "the ocean," the carceral regime. Several authors in this collection address how Moath, in the act of building his ships, reveled in the visceral and, as he puts it, magical ability to save himself: "I felt as if I were in the middle of the ocean, I felt waves hitting the ship from every direction, and I felt I was rescuing myself" (29). We highlight several of our contributors' attraction to this line as a point of theoretical significance. It captures the ineffable transformation of forms made possible by the creative act of making art, the restoration from silence, pain, and exile to voice and being. In other words, art as material witness.

Considering this function as witness, we return to Elaine Scarry's generative *The Body in Pain*, and more specifically to her less well-known subtitle, *The Making and Unmaking of the World*, to consider the foundational relationship between torture and the inner and external worlds of the tortured. Scarry's thesis is deceptively simple: that the deliberate infliction of pain *un-makes* the voice and world of the prisoner while the prisoner's testimony or other creative expression in the aftermath *re-makes* their voice and world.

We say "deceptively" simple because beneath the neat equation lies a theory of the relationship between pain and imagination that precedes and grounds the act of artmaking as antidote to the desubjectification of torture, isolation, and indefinite detention—the perpetrators' attacks on the prisoner's humanity, personhood, and social and corporeal life. Reading scores of testimonials to torture from Amnesty International and other sources, Scarry identifies the pain of torture as "world-destroying" because, in her view, eventually the external world falls from the prisoner's view entirely, diminishing and contracting in proportion to the increase and expansion of pain until the interior state of the body, "the body in pain," is the only verifiable reality. As the prisoner's world is destroyed and

replaced with the world of the prison, their pain and subjugation, indeed, their very bodies, according to Scarry, are converted into signs of the regime's power, and remain trapped in this state of disarticulation until the power of voice to testify to one's own experience is restored, often with the help of a committed witness. She asserts:

> The failure to express pain—whether the failure to objectify its attributes or instead the failure, once those attributes are objectified, to refer them to their original site in the human body—will always work to allow its appropriation and conflation with debased forms of power; conversely, the successful expression of pain will always work to expose and make impossible that appropriation and conflation. (14)

We pause here to consider important limitations to Scarry's thesis. First, implicit in her thesis is the separation between the torture chamber and "the world." In this book, we insist on the Guantánamo Bay prison complex and the network of black sites, airports, hotel rooms, office buildings, and other infrastructures upon which the War on Terror detention and interrogation program depended as wholly of "the world." Indeed, Moath's evidentiary aesthetics provide one form of access for those outside its walls precisely because it is constructed out of the matter of that world. Second, "the body in pain" for Scarry appears to be an abject body, for whom subjectivity has been replaced by the sensate experience of pain, and who might be resuscitated by narration. While we acknowledge the prevalence of this model as described in the testimonies of many survivors, we make no such claims. Rather, we are attentive to the ways in which Guantánamo detainees express themselves and communicate with one another, the prison staff, and those beyond through social practices and creative expression. Finally, it's unclear in Scarry's writing the extent to which the failure of language to capture the pain of torture might tell us more about language and the limitations of witnessing as representation than about pain's destruction of the subject per se. Here, too, we wish to avoid the claim that language—or in this case, artwork—re-makes the subject, and we focus instead on how carceral and evidentiary aesthetics offer a valuable approach to better understanding the violent abuses of the prison and Moath's own creative imagination and production from within it. With those significant caveats in mind, we nonetheless appreciate Scarry's groundbreaking work for posing the question of how torture, embodied subjectivity or selfhood, and representation are intertwined,

and for prompting us to ask how self-making (as an ongoing, dynamic process) takes place in conditions of extremity designed to deny or to control it.

In his chapter in this volume, we learn more about Moath's struggle against the forms of power designed to silence him and to convert his pain into a sign of the power and legitimacy of those inflicting it, and we witness his immediate turn to both imaginative and material expression in order to survive (Fig. 1.1): "I paused in the middle of the cell, confused, thinking about what I could do to get life moving inside the dungeon. I thought of home, the old life: agriculture, greenery, plowing, and the old mill. Old, beautiful things, especially arts and crafts, attract me to meditate and to think without feeling—an essential skill in this place" (23).

To think without feeling is essential to Scarry's understanding of the power of imagining and making as antidotes to the destructive capacities of torture: "[S]hould it happen that the world fails to provide an object [as in the deprivation of Moath's solitary confinement], the imagination is there, almost on an emergency stand-by basis, as a last resource for the

Fig. 1.1 Moath al-Alwi, interior with fireplace, mixed media (cardboard, plastic elements, fabric, acrylic paint), 2017. Courtesy of artist.

generation of objects" (166). Moath's imagining of greenery, a plow, a water wheel, a hearth inside what he characterizes as the dead space and deaf walls of his isolation cell contains echoes of other acts of creative imagination in testimonials to torture across time and place (e.g., Jacobo Timerman's intricate description of building an entire house and a library full of books in his mind while disappeared and tortured by Argentinean dictators in his acclaimed testimonial, *Prisoner Without a Name, Cell Without a Number* [1984]).

After imagining, or "making-up," Scarry identifies making, or "making-real" (endowing the mental object with a material or verbal form), as the final stage of world-making, a return to the ability to express or represent oneself from the state of total dominion over voice and body that is torture (21). Scarry uses the word "work" to describe this act of making-real, whether material or aesthetic or both, as an expression of humans' "expansive possibility, the movement out into the world that is the opposite of pain's contractual potential" (169), and she notes another conversion of pain through the act whereby "the wholly passive and acute suffering of physical pain becomes the self-regulated and modest suffering of work" (171). As discussed above, we depart from the trajectory Scarry traces from selfhood in the world to destruction by torture to material or verbal reconstruction. We understand subjectivity or selfhood as a perpetual, dynamic, "worldly" process, and the torture and cruel, inhuman, and degrading treatment at Guantánamo to refer to ongoing, if fluctuating, conditions. If we think of torture as a condition rather than as a discrete "moment when pain causes a reversion to pre-language" or "specific acts of inflicting pain" (6, 27), this, too, demands a different set of terms, which we posit here in terms of evidentiary aesthetics, to describe creative expression emerging from or with rather than after torture and abuse. Still, we find Scarry's focus on the materiality and labor of imaginative expression and its expansiveness helpful in situating this volume's concern with matter and the contexts of production and reception. We follow Scarry in wanting to understand how the labor and materiality of creating calls forth ideas, affects, desires, and sensations beyond prison space and time; and we emphasize that the power of this work as witness (just one of several ways of reading it, as the contributors to this volume demonstrate) is tied to Moath's specific circumstances and materials.

This focus on the material conditions of carceral aesthetics also calls to mind recent work on forensic and investigative aesthetics. Forensic Architecture's Eyal Weizman has developed a concept of aesthetics that

focuses on "the sensorial capacity of matter itself," how matter holds traces of and interacts dynamically with the ecologies in which it exists (14, 9). In *Investigative Aesthetics*, Matthew Fuller and Weizman emphasize the "sensing capacities of entities" which are themselves assemblages "emerging out of relational forces inherent to matter in various forms," and, thus, which can form the basis for "sense-making" about those forms and relationships (51, 45). The Forensic Architecture team collects sensorial data from both human and nonhuman sources or witnesses to build human rights cases though advanced digital modeling and visualization techniques. Noting that aesthetics calls into being diverse audiences, the team also exhibits its visualizations in dedicated art spaces. Our invocation of carceral and evidentiary aesthetics shares this attention to how materiality bears witness to the conditions of its making, its maker, and its context or ecology. However, our approach reverses the terms of analysis in crucial ways. Rather than abstracting the work into the art world to form another audience for it, this book begins with Moath's aesthetic (in the more traditional sense of pertaining artistically to the senses) imagination, intention, and production. In subsequent chapters, contributors examine, first, how his artwork as such tells new or different stories about conditions in Guantánamo, human rights violations, and solidarity than those scripted by the US government or conveyed by other means; and second, how his work resonates in a wide range of other contexts, such as prison art, Islamic art, model ships, and assemblage or bricolage. Wary of the ways in which Forensic Architecture's museum installations run the risk of substituting the aesthetic prowess of its team's data visualization techniques for the stories and experiences of those whom these human rights cases represent, we offer a range of contributions, each of which explicitly addresses how its approach reconsiders Moath's life and work in Guantánamo.

We are fortunate to have Moath's description of his artistic process as the centerpiece of this book—both for his extraordinary testimony and as a foundation for the chapters that follow. While we might have imagined the labor it took to make the ships and other artworks, we have instead his testimonial, which allows us to witness his perspective on his work. He describes imagining and making as intertwined in terms that echo Scarry's comments about the "expansive possibility" of the work—"I thought, how can I open a window in my windowless cell? Of course, I could not, but that did not stop me (26)"—and he shares that the intensity of his effort is inscribed in the object itself: "If *GIANT* [one of his model ships] could talk, it would answer your questions about how I suffered and

stayed up exhausted until I created it from nothing" (37). It is in this bodily sense that Moath's artwork acts not only as aesthetic, but also as evidentiary witness. As he reflects, the two forms are irrevocably intertwined: "Artwork is part of the artist's life; it is one of his organs. All of my artworks are produced with hard work, by staying up late at night, through exhaustion and sickness. In my case, the beauty of an artwork reflects the amount of suffering and pain that the artist experiences" (40).

In this sense, Moath's ships bear witness to the multiple forms of pain inflicted upon him—body, mind, and spirit—by the military industrial complex of Guantánamo. They are *evidence* of it, inlaid in the riggings and masts, the decks and hulls, as the artist's hands once worked to make them in that place of deprivation and suffering. They are *expression* of it in their extensive symbology of ship, ocean, eagle, and the implied figure of a "shore" to which they may someday return. And they are *aesthetic objects* made from it, in his words, "to bring culture to people, to educate them, and to illustrate the beauty of this life which is filled with love and compassion" (41). As chapters in this volume analyze and discuss, even as the ships bear the traces of suffering in the materials, prison time, and labor from which they are constructed, they also make a statement about the creativity and humanity of their maker. The power of the ships lies at once in their ingenuity and skill and in their rebuttal, both through the process of making and their material/aesthetic existence, of the narratives used to imprison him. His artwork convenes an alternative forum to the legal processes which have failed him and other detainees, as his repetition of sentence structure—subject, verb, object—reveals:

> We are interested in culture, we have feelings, we have sentiments, we can create beautiful things. We feel for others; we share sorrow, sadness, joy, and happiness with others. We rejoice for their joy and mourn for their grief. We don't discriminate against color, gender, or race. We wish happiness for all even if they disagree with our ideas and opinions. ... I would like people who are biased against us, I would ask them before judging us to take a look at our artwork." (44)

CALLING FORTH A PUBLIC

The emphatic assertion of self in the testimonial above resonates with scholarship on carceral aesthetics as well as critical response to prison art, which collectively explores how "artmaking [is] crucial to maintaining a

relationship with self"; "to creating a subject position that defie[s] the extreme deprivation of isolation units"; and to "creat[ing] a community and sense of belonging" for the artist (Fleetwood 18). We note Moath's construction of a collective self, above, in his use of the pronoun "we," precisely the position of the *testimonio* genre, born in mid-twentieth-century Latin America as a response to the "dirty wars" which swept the continent, in which the author is called to share their story not only as a story of self but also as a story of the collective who have suffered similarly without being heard, especially those who did not survive. Perhaps the most famous example is the opening line of the Nobel Prize winning *testimonio, I, Rigoberta Menchū: An Indian Woman in Guatemala* (1984), which describes her experience of the Guatemalan civil war in which over 200,000 people are estimated to have been killed or disappeared, 70,000 of whom were indigenous (Center for Accountability and Justice): "My name is Rigoberta Menchū. I am twenty-three years old. This is my testimony. I didn't learn it from a book and I didn't learn it alone. I'd like to stress that it's not only *my* life, it's also the testimony of my people. ... My personal experience is the reality of a whole people" (1).

So too, Moath, who rejects the narrative spun by the United States government of Guantánamo detainees as brutal, savage, terrorists; breeders of destruction; haters of "civilization," "the worst of the worst," and who speaks not only for himself, but for the men at Guantánamo who have become "brothers" over the course of his 21-year detention. Former detainee Mansoor Adayfi's contribution to this volume, "My Brother, the Artist," also testifies to the collective dimensions of Moath's narrative as well as to his individual creativity and position within the brotherhood of prisoners. In this way, both Moath and Adayfi create the community and sense of belonging cited by Fleetwood, above, which returns us to where we started in our discussion of the dominant narrative about detainees crafted and controlled by US officials, who were so displeased with the circulation of artworks from Guantánamo that they instituted a years-long ban on the release of detainee art, as several of our authors explore in this volume. The Department of Defense only lifted that ban in February 2023 in response to domestic and international pressure, including by UN Special Rapporteurs Alexandra Xanthaki and Fionnuala Ní Aoláin, and with the caveat that detainees transferred from Guantánamo would be able to take "a practicable quantity of their art" with them (Rosenberg 2023).

For Moath, who vehemently protests his ongoing detention, as well as the larger undemocratic context of Guantánamo itself, even if the ban had

not been recently reversed, his work is out there in the public sphere, available for display, its digital imprint irreversible and beyond control of any government: in "A Ship from Guantánamo," a July 2021 *New York Times* Op-Doc; in editorials published by *Al Jazeera* in July and October 2013; in the many images and reviews of "Ode to the Sea," the 2017 show of detainee artwork at John Jay College, described by curator Erin L. Thompson in Chap. 4; and now, in this volume. And as Fleetwood affirms, this conjuring of community is one of the most significant strengths of carceral aesthetics: "Carceral aesthetics challenge the isolated confinement enforced by penal architecture. Prison art practices foster an alternative formation of 'the public' in which the imprisoned, those under various forms of surveillance, and the seemingly free are viewers and participants" (38). Our focus on evidentiary aesthetics offers an added dimension to carceral aesthetics that focuses on how the materiality of his work and artistic practice provide evidence of prison conditions otherwise barred from consideration by a larger forum.

Indeed, we consider the collective of contributors to this volume to be one such "public," a community convened with the shared goal of studying, researching, and reflecting on Moath's artistic production from multiple points of view and disciplinary angles and as dedicated witnesses to his testimony. From first-person testimonials to scholarly essays, the volume represents the work of a group of people who share a set of materials—Moath's art, public archives of his work, the chapter he wrote for this book, scholarly work on Guantánamo—and a set of approaches (human rights, art history, carceral aesthetics, material rhetorics and witness, evidentiary aesthetics)—from which, in keeping with the methods of Moath's own work, an assemblage has been made. The volume stages a conversation, then, about the same artworks, often referencing the same key passages in Moath's testimony, that advances a broad range of interpretations and conclusions about the meaning and value of this work, from this place, by this person, in this time.

Moath's testimony in Chap. 2, "Artmaking at Guantánamo: A Ship Expresses Rescue," written over the past several years, provides the necessary starting point for this work. In this extraordinary chapter, he bears witness to and reflects on the specific ways the conditions of extremity at Guantánamo have spurred his creative work as necessary for self-expression and self-sustenance. Detailing the methods and labor involved in transforming objects and scenes in his imagination into artwork while in a state of severe deprivation, his chapter gives voice to the power of creative

impulse and ingenuity in carceral aesthetics and to the inseparability of the suffering body and mind and the art they produce. We also invite readers to consider the process we describe in the Preface of bringing this chapter to publication not only in reading Moath's words, but also in reflecting upon the means by which testimony must be constituted when the government withholds direct access to the prisoner. Together, Mansoor Adayfi's "The Beautiful Guantánamo" (2022), Mohamedou Ould Slahi's "My Guantánamo Writing Seminar" (2022), and Moath's "Artmaking at Guantánamo" form an important archive unto themselves: a set of testimonials from individuals who have survived or are still surviving torture and indefinite detention at Guantánamo, offered in the critical context of their reflections upon the processes, struggles, and triumphs of becoming and being writers/artists, their stories of survival and cultural production irrevocably enmeshed.

Deepening our understanding of life at Guantánamo for prisoners, former detainee Mansoor Adayfi offers a personal reflection on shared incarceration with Moath and his artmaking process in Chap. 3, "My Brother, the Artist." Imprisoned without charge and tortured for fourteen years before his transfer to Serbia, where he continues to suffer economic and political precarity and social isolation, Adayfi, author of *Don't Forget Us Here: Lost and Found at Guantánamo* (2021), describes how creative expression forged a community among prisoners (and sometimes guards) built on the demonstration of shared humanity that was life-sustaining, and situates Moath in that community.

Erin L. Thompson's chapter (Chap. 3), "'APPROVED BY US FORCES': Showing and Hiding Art from Guantánamo," examines the artwork outside prison walls. Reflecting upon the process of curating "Ode to the Sea," the first exhibit of Guantánamo prison artwork, she details the complex narratives about creative expression, national security, and justice that formed and were mobilized in reaction to the exhibition. The chapter draws upon her experience with artists, attorneys, her university, and the public as the curator and her research as a scholar of criminality and art.

The remaining chapters situate Moath's testimony and artwork in distinct artistic, cultural, political, and human rights contexts. In Chap. 5, "From Wasting Away to a Way with Waste: The Visibility of Moath al-Alwi's Hunger and Sculpture," anthropologist Joshua O. Reno compares hunger-striking and prison art as different but related forms of material practice and political resistance associated with incarceration. While hunger-striking and prison art can be connected on that general level,

these themes emerge even more starkly, he argues, in the context of wrongful and inhumane imprisonment at Guantánamo Bay. Drawing on Hannah Arendt's ideas about worldliness and transcendence, as well as Moath's art and activism, Reno relates wasting away through hunger-striking as continuous with "having a way with waste," that is, reusing discarded materials as prison art. Through both his creative process and hunger strikes, Reno shows, Moath "challenge[s] his erasure, his planned social death" by transforming the materials available to him into forms of presence and self-expression.

Art historian Mira Rai Waits extends the interpretation of Moath's work beyond Guantánamo by situating it within an Islamic visual tradition and a longer history of model ship making that has taken place in prisons around the world over the last few hundred years. A reading that acknowledges these additional lenses demonstrates the importance of Moath's work as a complex testament of one man's expression of faith, survival, and creativity. It also provides an indication of the multiple fora and audiences for Moath's work, only some of which this volume can address. Chapter 6, "Ships of Scraps: Moath's Model Ships in Islamic Art and Prison Histories," also insists that Moath, the artist and prisoner, is himself situated in diverse, sometimes overlapping contexts unexamined by those who confine him—a "brother" (as Adayfi explains); a Yemeni, as Moath's own testimony reflects; a prison artist; and an artist working in recognizable Islamic traditions.

We return to the specific conditions of imprisonment, censorship, and control at Guantánamo in Chaps. 7 and 8. Belinda Walzer, a scholar of rhetoric and social justice, brings a material rhetorics approach, looking at the rhetorical power and processes of material objects and at discourse's material effects, to the discussion of Moath's work in her chapter, "Guantánamo Bay Ensigns: Material Rhetorics and Moath al-Alwi's Ships." She examines the ways in which the art, produced out of the material conditions of detention, is simultaneously an archive of state violence—each piece is marked with the stamp "Approved by the US Forces"—as well as testimony and resistance to that violence. As Saidiya Hartman asks in writing about the archive of slave ships crossing the Atlantic, "How does one revisit the scene of subjection without replicating the grammar of violence?" (Hartman 2008, 4). Walzer argues that, through the US Forces property stamp, the scene of resistance that these ships manifest is also the scene of subjection to the very violence it represents. The fact that the process of attempting to assemble an imagined

alternative is still subject to the US government's ensign signals the difficulty of claiming rights out of the impossible rhetorical situation of indefinite detention and forever war.

In Chap. 8, "A Sea Without a Shore: Towards Building an Alternative Visual Archive of Guantánamo Bay," critical legal scholar Safiyah Rochelle moves the conversation from the specificity of the ensign on individual ships to how Moath's work fits within the larger visual archive of the prison that the US government seeks to curate and contain. She asks, how can art made under the conditions Moath and other detainees and investigators have described both reveal and challenge the conditions of possibility that form and sustain the camp? Drawing on theories of the archive, visuality, and counter-visuality, she argues that Moath's artwork offers moments of counter-visualization that disrupt the ways in which state power has relied on visual representation (often with unexpected effects as we detail above) as a means of control. In doing so, Moath's work creates the means through which he stages an alternative human rights claim: a right to see and to be seen in terms he, at least partially, constructs.

The volume concludes with a focus on artistic practice in Chap. 9, "Assemblage by Necessity: The Maritime Sculpture of Moath al-Alwi," by artist Gail Rothschild. An early advocate for Guantánamo's artists, Rothschild was involved in the formational years of the art program in the prison by sending art materials to detainees to further their work. Through the eyes of a fellow artist, she situates Moath's ship sculptures in the context of artistic genres and movements (including prison art, maritime art, intuitive or "outsider" art, and mixed-media assemblage) from a range of diverse cultures and time periods, finding synergies from many quarters with his practice, aesthetic, and artistic forms.

That final chapter refocuses attention upon Moath's imagination, that faculty that allows our making and thereby our extension into the world of which we are part. Our aim throughout this project is to preserve the vision, creativity, and life force of a casualty of the undemocratic practices of the world's proudest democracy, sharing his experience as an artist, a human being, and a detainee in the context of the War on Terror. In this way, the book contributes to the body of global literature by incarcerated authors and, much more specifically, to the archive of cultural production from the network of black sites and detention centers employed in what has come to be known as the forever war. We must continue to gather, preserve, and make public archives that bear witness to these alternative prison and black sites even as we engage in ongoing struggle for human rights, the rule of law, and the freedom of creative expression.

WORKS CITED

Adayfi, Mansoor. 2018. Did We Survive Torture? In *Witnessing Torture: Perspectives of Torture Survivors and Human Rights Workers*, ed. Alexandra S. Moore and Elizabeth Swanson, 231–236. Palgrave Macmillan.

———. 2022. The Beautiful Guantánamo. *Humanity Journal*, dossier on Cultural Renditions of Guantánamo and the War on Terror, edited by Alexandra S. Moore, vol. 13 (3) (Winter), pp. 334–342.

———. 2023. Making Art in Guantánamo. In *Breaking the Exceptional: Tea, Torture and Reparations Chicago to Guantánamo*, ed. Amber Ginsburg, Aaron Hughes, Aliya Hussain, and Audrey Petty, 261–274. DePaul Art Museum.

al-Alwi, Moath Hamza. 2013a. My Life at Guantanamo. *Al Jazeera*, July 7.

———. 2013b. We Will Remain on Hunger Strike. *Al Jazeera America*, October 15. http://america.aljazeera.com/articles/2013/10/15/hunger-strike-guantanamo.html.

Braziel, Jana Evans. 2006. Haiti, Guantánamo, and the 'One Indivisible Nation': U.S. Imperialism, 'Apparent States,' and the Postcolonial Problematic of Sovereignty. *Cultural Critique* 60 (Autumn): 127–160.

Center for Justice and Accountability. n.d. Guatemala. https://cja.org/where-we-work/guatemala/#:~:text=During%20that%20time%2C%20the%20Guatemalan,70%2C000%20were%20killed%20or%20disappeared.

Deutsche, Rosalyn. 2020. Staking Claim: 'Ode to the Sea' from Guantánamo Bay. *ARTFORUM*, September. https://www.artforum.com/print/202007/rosalyn-deutsche-on-ode-to-the-sea-art-from-guantanamo-bay-83687.

Falkoff, Marc, ed. 2007. *Poems from Guantánamo*. University of Iowa Press.

——— (ed.). 2023. Reflections on *Poems from Guantánamo*. In *Breaking the Exceptional: Tea, Torture and Reparations Chicago to Guantánamo*, edited by Amber Ginsburg, Aaron Hughes, Aliya Hussain, and Audrey Petty, pp. 133–138. DePaul Art Museum.

Fleetwood, Nicole R. 2020. *Marking Time: Art in the Age of Mass Incarceration*. Harvard University Press.

Fuller, Matthew, and Eyal Weizman. 2021. *Investigative Aesthetics: Conflicts and Commons in the Politics of Truth*. Verso.

Greenberg, Karen. 2009. *The Least Worst Place: Guantánamo's First 100 Days*. Oxford University Press.

Hartman, Saidiya V. 2008. Venus in Two Acts. *Small Axe: A Caribbean Journal of Criticism* 26: 1–14.

Lipman, Jana K. 2008. *Guantánamo: A Working-Class History Between Empire and Revolution*. University of California Press.

Paik, A. Naomi. 2016. *Rightlessness: Testimony and Redress in U.S. Prison Camps since World War II*. University of North Carolina at Chapel Hill.

Rosenberg, Carol. 2021. Recalling the First Guantánamo Detainees. *The New York Times*, May 3 (Updated July 20, 2021).

———. 2022a. 20 Years Later, the Story behind the Guantánamo Photo That Won't Go Away. *The New York Times*, January 10.

———. 2022b. The Secret Pentagon Photos of the First Prisoners at Guantánamo Bay. *The New York Times*, January 10.

———. 2023. Pentagon Lifts Trump-Era Ban on Release of Guantánamo Prisoners' Art. *The New York Times*, February 7.

Sadat, Leyla Nadia. 2006. Ghost Prisoners and Black Sites: Extraordinary Rendition Under International Law. *Case Western Reserve Journal of International Law* 37 (2 & 3): 309–342.

Scarry, Elaine. 1985. *The Body in Pain*. Oxford University Press.

Slahi, Mohamedou Ould. 2022. My Guantánamo Writing Seminar. *Humanity Journal*, dossier on Cultural Renditions of Guantánamo and the War on Terror, edited by Alexandra S. Moore, vol. 13, no. 3 (Winter), pp. 402–410.

Van Veeren, Elspeth. 2011. Captured by the Camera's Eye: Guantánamo and the Shifting Frame of the Global War on Terror. *Review of International Studies* 37 (4): 1721–1749.

———. 2014. Materializing US Security: Guantanamo's Object Lessons and Concrete Messages. *International Political Sociology* 8 (1): 20–42. https://doi.org/10.1111/ips.12038.

Weizman, Eyal. 2014. Introduction: Forensis. *Forensis: The Architecture of Public Truth*. Sternberg Press and Forensic Architecture.

Artmaking at Guantánamo:
A Ship Expresses Rescue

Moath al-Alwi

The first thing I noticed when I entered the cell in 2010 were its deaf walls, with no window for air or sunlight. No way to know if you are under or above ground, or to distinguish between day and night, as if you were in a grave and everything alive got disconnected. I paused in the middle of the cell, confused, thinking about what I could do to get life moving inside the dungeon. I thought of home, the old life: agriculture, greenery, plowing, and all the tools that recall our ancient heritage—the axe, the sickle, the water wheel, and the old mill. Old, beautiful things, especially arts and crafts, attract me to meditate and to think without feeling—an essential skill in this place.

I have to make these deaf walls speak.

I had started my artistic work a year earlier, when I was in solitary confinement and on hunger strike. That was not the first strike because strikes

M. al-Alwi (✉)
Guantánamo Bay Naval Detention Center, Guantánamo, Cuba
e-mail: bdjacob@hrtlaw.org

© The Author(s), under exclusive license to Springer Nature
Switzerland AG 2024
A. S. Moore, E. Swanson (eds.), *The Guantánamo Artwork and Testimony of Moath al-Alwi*, Palgrave Studies in Literature, Culture and Human Rights,
https://doi.org/10.1007/978-3-031-37656-6_2

23

and struggle have no beginning and no end in this place; as long as there is injustice and oppression, there is hunger and struggle.

The most difficult thing that I faced in my days in solitary confinement was when I was on a hunger strike in 2009 and the camp administration responded by forcibly humiliating me. The Immediate Reaction Force (IRF) team took me out for force feedings. I used to write and draw on the walls of the cell to send my message to those among the guards and officials who had a conscience. Some of them still have a conscience and try to help, and some of them are like robots—they hurt and do not help. When they took me out to be force fed, they would record and take pictures of my paintings and my words, then wash the wall and wait for the new message the next day. I always painted the Statue of Liberty, the United States' proud symbol of freedom. Around the image, I wrote slogans calling for freedom and justice to show the contradiction between the statue and the oppression under which we lived in these graves in solitary confinement.

This was the beginning of a journey that was full of thorns. At Guantánamo, my beginning was not that of an artist who establishes his artwork with brushes and paint and a natural vision. It was bitter and difficult, and the main reason I started was because I could make others hear my voice and my pain in this place, this exile in which you feel that you are imprisoned on another planet or at the bottom of the ocean. In complete darkness, where no one can see or hear you. Loneliness. Estrangement. Sickness. Pain. All in a place where conscience is absent, where everything is outside the law in the country of law and freedom!

The beginning of my artistic journey was an expression of the oppression, injustice, deprivation, and despair that we live with in this place. As a young child, when I first attended school, I enjoyed art but did not give it too much importance. I had a touch, but I didn't have the desire. When my parents brought me a toy, I enjoyed dismantling it and seeing how it was made. I always liked to work with wood, nails, and hammer. If something broke in the house, I always liked to fix it. My mother sent me a letter recently: "Do you remember that door you fixed? It's still there."

I used to walk for hours on end to relieve my hunger and thirst. I was pacing and watching the very slow and tedious movement of the clock. It felt like breathing through the neck of a bottle. They force fed me, so my soul couldn't taste or smell a breeze of freedom. They tried so hard to prevent your soul and even your body from getting freedom, when you are inside the two-meter-long room. But outside there are people who

defend you, seek your freedom, and suffer for you, and there are other people who fight for the wickedness to deprive you of the air of freedom. No matter what challenges and struggles I faced, death wasn't allowed to get near me at this time. They rushed to keep me away from death and make it harder for me to liberate my soul and give it a taste of freedom. This was how my difficult days passed while I was waiting for death, and every day I saw death watching me from afar, although it was not allowed to approach me.

The worst injustice and oppression is to keep a person in solitary confinement because it is against human nature. In solitary confinement, you are restricted from all freedom; you can't get your food except through the guards, you can't go to the yard to walk except through the guards, even a drink of water can only be obtained through the guards. You become like a bird in a cage. You have no control over yourself, but you have determination and will to achieve your goal, which is freedom. One of my brothers told me about his experience in solitary confinement. He said he became friends with a fly. He enjoyed watching it every day. But one day, the fly disappeared, and he became very sad and didn't know where that fly went. He worried it might have gotten stuck in a spider's web and needed someone to save it. Another brother told me he became friends with an ant, and every day he would share his food with that ant to keep it interested in visiting him. Some became friends with birds, and another became friends with an iguana.

In solitary confinement, there is nothing that helps you practice your artistic skills. You don't have paints or anything related to art. Perhaps you can use your food to draw on the walls or to write some slogans so they can photograph it and show it to officials. The only way you can create anything is by walking long hours, because moving allows you to paint beautiful paintings in your imagination. When you get tired of walking, you feel like a person running behind a mirage. You know that tomorrow will be no different from today which is no different from yesterday. You live like a dead person in a grave waiting for Doomsday and for judgment to come, when you will have relief from loneliness and brutal alienation. There is no one to comfort you, to share your dreams, worries, and sorrows. Most of my brothers who died, died inside solitary confinement because in communal living we pay attention to each other's lives.

I like nature, I like to use nature and to do something creative with it. I like old things, old ships. I like gardens and waterfalls. In my new dead cell in 2010, I started to think, and the first thing that came to mind was

the spinning water wheel. So, I started with that. But this place is different from the rest of the world. You don't have the most basic materials, not even wooden and plastic sticks, but there were things that came with the food, like syrup containers, cans, and cardboard. Even these things were not readily available and obtaining them required an unbelievable effort. I asked my detained brothers not to throw cans and cartons in the garbage because I needed them for my artwork. They would laugh and wonder what I was thinking about, especially when I told them about the water wheel and that I would make it circulate 24 hours, nonstop. They teased me and laughed, which made me accept the challenge.

I refused to know hopelessness, so I started working on my experiment, my water wheel. Every time I failed, I became more determined to work until the project was completely finished. I put different natural scenes on each box so that the water wheel would give me different views while turning. The real challenge came after I finished my project: how could I make it spin when I didn't have any materials? After a lot of thought, I made glue from soap until it became like dough, then I used it to place the water wheel on the wall. I shut the air conditioner vent except for one corner that pushed the air toward the wheel, and now my plan worked! The water wheel didn't twirl at first, but then I used a pen. I found a way to control speed! A small house with a water wheel on top that circulates on air, and instead of carrying water, these water wheel boxes showed natural scenes. The pictures were from small cards the Red Cross sent us. I tore them out and put the scenes on the front of the boxes. Even though they were very small, they created an oasis in the desert that lifted the depression inside the cell. The water wheel started spinning, and the guards were surprised and astonished because no one expected to see a piece of art that circulates nonstop made out of nothing. Everybody started visiting my cell to see the water wheel glued to the wall, moving nonstop, with beautiful images from nature. This was the beginning of my exciting and daunting artistic journey.

I thought, how can I open a window in my windowless cell? Of course, I could not, but that did not stop me. After the water wheel, my second idea was to build a window, a real three-dimensional window on the wall, to delude myself that I'm living a normal life, not inside a cell…or a grave. I was collecting nature magazines and I cut out the pictures by rubbing their edges—I couldn't have scissors, they were forbidden—so this is how I was able to cut out pictures of the sky, the mountains, the trees. Then I

assembled these pieces and turned them into a three-dimensional model window. I enjoyed building artwork that felt closest to reality.

This is how I started creating things. My brothers started, too. I made bookshelves, big bookshelves, although these were lost in the 2013 raids. I made a trash basket you could open with your foot, and I kept it for about two years. It was made of rods and ropes. The teacher liked it. He said the ones made of metal break, but not this one. Sometimes I used plastic material from shampoo bottles, sometimes cartons and cardboard. We used soap because there was no glue available, but after the camp administration saw our crafts and our furniture, they were stunned by the design and workmanship and they allowed us to use glue. I could give you a warranty on the wardrobe I made or on any of my crafts. I could give you a warranty for several years on the things I made with just the few resources I had.

I created my window to the world. It was a large window, almost 140 centimeters high and 100 centimeters wide. It was a mighty work and it stunned everyone. Even I could not believe I had accomplished it! My only mistake is that I did not get a picture of my work, of my window overlooking an island with a house and three or four palm and coconut trees, two lifeboats, and some columns with banners that had prayers written all over them. I fixed this window to the wall with a big base. After that, my room looked like a museum inside the prison, intended for visitors. My detained brothers started visiting me in my cell, lying down on my bed to enjoy the view. No one knows the loss of beauty and freedom except for those who lose it to prison, sickness, or blindness. Those small, beautiful scenes meant a lot to us. We used to steal a look at the outside world through small holes, smaller than one centimeter, in the fences that surround us. Even birds: you can hear them but not see them, as if they are telling you, you're in the cage and I'm outside enjoying my freedom. One day is for you and the next day is against you, and happiness will not last for anyone.

Whenever I remember this window, my heart burns from within because it is one of the most beautiful pieces of art I have ever made. I love having three-dimensional shapes in my art, because they are tangible and closer to real things. They invite you to look at them deeply and with pleasure. Even when I draw, I try to make my drawings look three-dimensional. My window was like a resort, as if you were on an island in the Caribbean! What I did was to cut pictures from magazines—mountains, trees—and mount them over each other so that there was depth

when you looked out my window. I made the painting with palm trees because there was nothing inside my cell. I also drew an island, a sea, a house with windows, and made doors that open and close. I drew small boats on the sea. The palm trees were in relief, made from ropes and stiffened stems as if they were really shaking with the wind. Street signs were written in English. Once one of the teachers went to the US for vacation and brought back phosphorous Muslim signs, and I put one on the window.

It was the catastrophe, the raid by the guards on our cells in 2013, that destroyed much of our art. When they attacked, I was outside my cell. My body was bloody from the bullets that hit me. Despite the fact that I was bleeding and in much pain, when I saw my brothers from the other cells, I worried about my paintings, my window, and the rest of my artwork. I asked if the guards had ruined them or if they had survived. Most of my brothers did not have an answer, but one told me, "I saw as they dragged me to this cell, your window was outside on the path. They did not break it or do anything to it. It was outside." I did not give up. I kept asking because it took me a long time to finish that work. In 2014, I saw my art teacher and I asked him about my window. I said it took me a long time to finish, it has sentimental value, and the art teacher told me, "We have it. We have it." When I saw the instructor again, I asked him where my window was and he said, "I have no idea." I said, "But you told me you knew where it was." The window had disappeared, and I just gave up at that point. I don't know where it is. But I think it still exists because some brothers said they saw it on the side, not with the things that were thrown away. But I have lost hope, I will not get it back. It was a beautiful piece, and every time I think of it my heart is broken.

I would like you to feel as if you were the maker of this piece of art. How would you feel if your father took it away from you? And how would you feel knowing that he was the one who provided the paper and the paints, and you drew your life and your memories on these papers? How would you feel if your father took them away? You would certainly be saddened and feel depressed and in pain, as if you had lost both your eyes or the dearest person to you. You would give your father a sorrowful look because he had taken away from you your sleep, your late nights, your exhaustion, your pain, and the house that you had built and in which you hoped to live and build a future. To see it destroyed in a blink, becoming like a dream after which you woke up to find yourself facing a bitter and hopeless reality—how would you feel after all of this?

There were a lot of difficulties after the raid. Getting materials was like extracting water from a rock. What I mean is, I don't have the tools; there is nothing here. Everything I need I have to improvise myself: ropes, sails, all. There are some things that are missing. I ask my brothers, does anyone have a prayer cap he no longer needs? Does anyone have a shirt he no longer needs? I ask other detainees for materials, and sometimes I get them, sometimes not. I used the Islamic prayer cap and beads, plastic pieces from the shampoo caps, paints, brooms and floor mops, shirts, cardboard pieces, worn out painting tools, even the trees we have here. I tried to use it all. I used it all, but I tried to clean and disinfect it and remove any marks that indicate that this raw material is trash or scrap. Every piece of wood, plastic, cloth, cardboard or string, even if it has no value, I keep in order to use in my artwork. Everything in detention is of high value due to its scarcity. Almost everything is forbidden, even litter. Your thinking is constrained; you are not even allowed to express yourself through art and try to rid yourself of that inner feeling of oppression, because if you tried to do it, it would be misconstrued as an inciting message which would pose a threat to the camp security. There is room for neither freedom, nor justice, nor democracy.

A Ship Expresses Rescue: *The Ark*

I have never been on a ship, but everyone knows its shape. Our Prophet Noah was able to rescue people and animals with a ship when the earth was flooded, so a ship expresses rescue—and that is why I love to build ships. The other thing that attracts me about ships, sailing ships, is tradition and heritage. Each ship contains art and creativity. The most beautiful thing happened the first time I made the sails and tied the ropes. I felt as if I were in the middle of the ocean, I felt waves hitting the ship from every direction, and I felt I was rescuing myself. One day I was tired and lay down on the floor next to the ship. The fan blew air onto the sails and the ship started moving! Yes, the ship itself is the rescue.

The Ark was the first ship I ever made; this was in 2015 (Fig. 2.1). Lack of resources was the first challenge I encountered with *The Ark*, followed by lack of experience, since I'd never made any ship in my life nor even stepped foot on a ship or a boat. Despite all of the challenges, I started my project from scratch and worked so hard on it, even while I was on a hunger strike in Camp V. Unlike in communal living in 2010, where I could ask my brothers if I needed more supplies, in 2015 it was hard to get help

Fig. 2.1 Moath al-Alwi, *The Ark* (Model of a Ship), mixed media sculpture, 2015. Courtesy of artist

from anybody. If I needed ropes, sails, or other things to make the ship, I wasn't able to get them. I started planning the model of the ship. I imagined the shape of the ship and sketched the pieces I was going to use. I readied all the parts I needed. When I wanted to put it together, though, I still did not have access to glue and had to work with soap. I couldn't have any glue or adhesive, but the next day I went to the school and the instructor, surreptitiously and unbeknownst to the guards, slipped some adhesive on a piece of plastic so that I could finish building my ship. In fact, he took a risk, but he couldn't help it when he became aware of my suffering, my weariness, and the lack of materials—he felt sorry for me and was willing to jeopardize his job.

I will never forget the night I gathered all the parts and started my battle to assemble *The Ark*. I didn't have tape, so I tied it with the blanket that I used to keep me warm and the laundry bag. As soon as I put two parts together, other parts fell apart. I got frustrated and tired. I was so tired I did not recognize I was fighting the ship, instead it was as if I was battling the whole night with a real person until finally we both fell asleep

from exhaustion. I did not realize when I fell asleep that I had succeeded, but when I woke in the morning, I found the ship tied to one side of the bed. I won that battle and ended up putting all the parts together. It was in that moment that I found energy to continue the journey I started.

I used threads from my prayer cap for rigging, my shirts for sails and side ladders, and I also used the mesh laundry bag in addition to the envelopes from the letters I received from the lawyers, which I covered with paint until no one believed *The Ark* was made out of cardboard boxes painted with acrylic paint.

When I took *The Ark* out to walk during recreation, I had the sails up, but it was not stable. I was tired, I felt anxious, but then the wind started hitting the sails. When the wind blew, the ship started shaking as if it were ready to fly in the sky. I shouted from joy and told my brothers, "Look at my ship shaking from the wind! The ship is flying!" It made me forget my fatigue. I finished my project by adding my symbol, the eagle's wings.

This was my first artwork with my symbol. When I would get frustrated in solitary confinement, I would stand against the wall of my cell in Camp V, reflecting and looking out at the sky through the little window. I could see an eagle freely flying up high. My mind would wander away far from prison and the narrow cell. The wings on the figurehead of my ship symbolize flying, which is freedom. When I saw an eagle flying, I felt it was me flying. I wished the eagle could pick me up and carry me away, as in the old stories.

When I finished the model, I built a case for *The Ark*. Everybody was fascinated, even the guards. My art teacher was very happy to see it. He didn't expect me to succeed and make something out of nothing. The Colonel was happy about it, too. He even took it along to show to his bosses. That is when the camp administration started changing their attitude toward me from negative to positive, asking the art teacher to support me and give me the materials I needed. The art teacher told me from that point not to make anything without telling him; that way he could provide me with all I needed. When he realized officers enjoyed the pieces, he wanted to be part of it. Even a higher officer talked to me—he was a very good guy. He said, I hope you will stay here longer so you can produce more artwork.

Gondola

Next I started working on *Gondola* as a gift for my lawyer since it was my first time meeting her (Fig. 2.2). Out of respect, I did my best to give her that small gift to make her happy. I started with the design, working day and night to finish it. Just as I started making the gondola, I realized I needed other things. I looked around...I looked around...and the only material I could find to build a seat in the gondola was a dishwashing sponge. So, I painted it with acrylic paint and thus improvised a seat for the gondola. When I told my lawyer how I created this model, I reassured her that the sponge was clean, it had not been used. It was better than I expected and even better still when I made the case for it. Despite the lack of time, I finished it before the lawyer's meeting by one or two days, and I was so happy because I made my lawyer happy with this gift.

Fig. 2.2 Moath al-Alwi, *Gondola*, mixed media sculpture, 2016. Courtesy of Artist

GIANT

After finishing the gondola, I worked on *GIANT*, which was my fourth sculpture (Fig. 2.3). I had pictures in my mind from a program I had watched in Guantánamo about a ship called *Ghost*, an old ship that sank in the ocean and became inhabited by ghosts. It appeared that next to the ship was a woman working on it, and she seemed to be talking to the ghosts. She was communicating with them, asking them to move the rope or line, and the rope moved! This surprised people, and they began to believe the ship was haunted.

We feel the same here in Guantánamo. We are ghosts here. You can see us, but you cannot talk to us. We used to look at the horizon from a window in the camp. We could see ships from far away and we wished we were on board those ships. We stole glances at the ocean when they moved us from camp to camp, but now I can see the ocean from my cell. The ships I make talk about the violence of the ocean. The ocean is violent; it does not know any mercy. The ocean where we are now is always violent. We

Fig. 2.3 Moath al-Alwi, *GIANT*, mixed media sculpture, 2017. Courtesy of artist

are suffering here. We are on board that ship, and we are fighting and challenging the waves. We are on the ship, but we hope to reach the shore.

I started building *GIANT* before *Gondola*. I threw my first effort in the garbage bag where I kept my art scraps and supplies when I realized that I had not enough experience building ships. I felt desperate and frustrated. But once I was done with the gondola, I took the ship model out of the garbage bag. But I was still feeling frustrated because I didn't have the necessary materials to finish my work. It needed sails, wood, and ropes, and I had to find them with the help of my instructor, who had promised to support me with all my artwork. That support was mainly his encouragement of my work, but it also meant providing paint, skewers and glue. I was allowed only scissors, nail clippers and hair clippers—which the guards would give me to use and then take back—and if they broke, it would have been very difficult for me to replace them. I took the body of the ship and tried another time to fix it. I started working on the hardest part, which was the bow, because I thought to myself, "If I succeed in building the bow, I'll then be able to build the rest of the ship." And after several failed attempts, I was finally able gradually to move from the bow to the rest of the hull.

In the ship's portholes, there are pictures of Jerusalem, Mecca, Medina, but you can't see them unless you look closely. I didn't have the right material for the anchor, so I found a plastic lid from a spray can and as usual had to try more than once until I was able to make it. These small details are the substance of my art. I used prayer beads and a wooden skewer; I put the wood through the hole in the bead and it became like a nail, so I could use it to affix the ropes. The biggest obstacle was twisting the ropes to make them strong. If it weren't for my hair clippers, this would have taken me two days; instead, in 15 minutes I was able to roll all the ropes I needed. I was so happy! I used the motor of the clipper to twist the ropes, and my brothers were stunned with my improvisation: "How could you have thought of it!!??" But as they say, "Necessity is the mother of invention."

When I had finished the ropes and sails, I tried to make the sails look as if they were filled with air by taking fabric and gluing it to paper. Then I started making bridges, and I was battling a whole day to finish. I started in the morning and worked on it till night, when I started feeling very tired, but I completed the work and did a good job. Then I started working on the masts, using skewers and envelopes together to make it stronger and harder, just like wood. Once I was done with all the parts from

ropes to sails to columns to bridges, I put it all together without any technical errors. I painted this ship using a color called the blood of the deer. For the flags, I chose the color green. I had a reason: green represents nature and life. When I was done with everything, I made the figurehead from plastic covers, wood, and ropes, and I made it look real. The bow has the shape of an eagle's beak, and the figurehead, which was made of ropes from a mop, had the shape of a serpent—the idea was of a predator eagle preying on the serpent. I also placed the eagle's wings, my symbol, on the prow (Fig. 2.4).

The eagle built its nest on top of the masts, just like when eagles build their nests on top of the mountains. The crow's nests at the tops of the masts were very hard to make. More than once, I couldn't make them

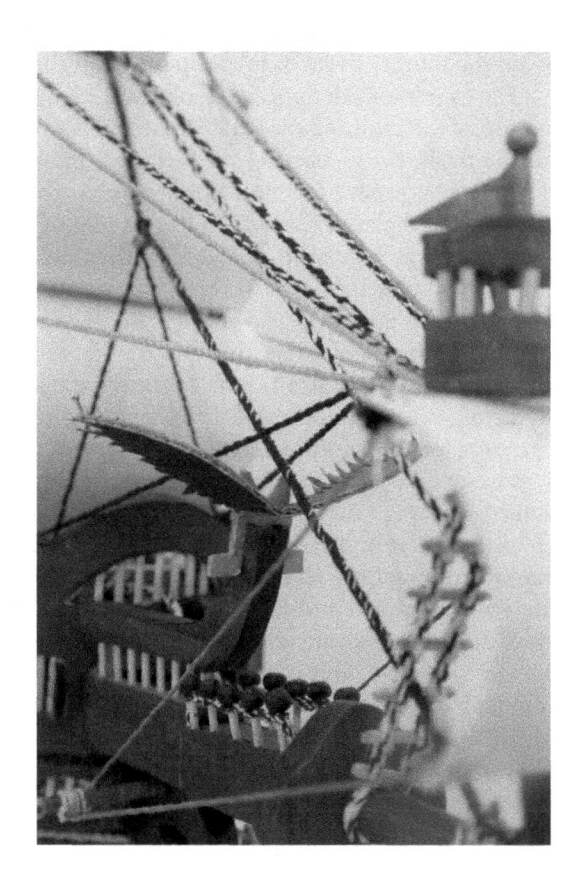

Fig. 2.4 Moath al-Alwi, *GIANT*, mixed media sculpture, 2017. Detail of eagle's wings. Courtesy of artist

properly. They broke. I tried again and again for an entire day. It was very difficult. Every single detail was difficult. Despite all of this, I persisted in finishing the design that was in my head, a design that did not exist physically on paper. It was even harder to make the mechanical movement in the helm, so when the wheel turns the rudder moves. Not every kind of rope gives the same result. I tried and tried and tried until I found that dental floss is stronger and smoother, has light friction, and could make the helm turn the rudder.

I hated when people told me that working on my ship was a waste of time. These opinions made me lose focus on my imagination. Even the hunger strike was not an obstacle to me. I was focused on accuracy and elegance, imagining the design in my head and then translating it into the body of the ship. I was ecstatic when I realized that everybody was admiring my artwork, which encouraged me to build even better-looking pieces. Even the hunger strike didn't stop me from that.

The case itself I designed to look like a cage for the eagle. I put the ship on top of the cage and placed it in the middle of my cell after I cleaned up all the trash: boxes, acrylic colors, fabric, plastic bags, wood, and ropes. There was no space for me to pray or even to sleep, so I cleaned all the wreckage and placed the ship in the middle of the cell and passed out on my bed. I was very tired. I was back then on a hunger strike, and I felt hungry and very sick from working long nights on the ship. But as soon as I would wake up, my eyes would see the ship and I remembered the long nights and the sheer exhaustion and the starving, along with all the obstacles that I had to confront. I felt I was in the middle of the ocean being hit by strong waves, all but dead. I was trying to rescue myself. My only concern was for the ship to reach the shore safely.

I woke up the next the morning and the ship filled my sight. When the sun rose, it was a new day for me. The news spread all over the camp, and the administration heard that I had finished *GIANT*. That's when visitors started coming from all over to see my art. I asked my instructor to evaluate the ship model and he told me that it was priceless. He added, "If it were up to me, I would display it in the best place in my house because this artwork was made out of nothing. It is close to magic because it is almost impossible here to get any material." Still, I wished at the time I had more ability to make something that looked even better than *GIANT*. The Colonel asked my instructor how I was able to make this ship despite the lack of resources, but the instructor did not have an answer. He told the Colonel that I did everything on my own; he had not helped me. After

that, they moved me to communal living in Camp VI, but the ship stayed in Camp V.

If *GIANT* could talk, it would answer your questions about how I suffered and stayed up exhausted until I created it from nothing. Every part of this ship has a story and a challenge that comes with it. After I finished this ship, I got sick for two weeks or even more, and if you don't believe me, look at the ship, its parts, and think about the lack of resources I faced. Despite all of that, I did not give up and I started making the next ship, *Eagle King*.

Eagle King

This ship started sailing before the raging sea, and before storms and hurricanes occurred. This ship started sailing in the hope that it would reach safety. This ship is *Eagle King*. This ship began to sail when the sea was still and the sky was clear. There was nothing alarming on the horizon about what would happen. However, as soon as the ship started sailing, frightening clouds filled the sky, thunder started shaking the sea, and storms and hurricanes surrounded the ship from all sides. Despite all these disasters, the ship kept sailing with full force and confidence that one day it would reach safety while swimming on the surface of the water—just like the king of the sky, the eagle, swims in the sky.

I began making *Eagle King*, which I named after the king of the sky, back in November 2017 with leftover materials that I had from my ship, *GIANT*. Since then many things have changed, and even the instructor has been replaced. I started preparing some materials and equipment that could help me build the body of the ship. I started collecting things (some from my brothers, some from the teacher, and some from my private belongings), and I started the process of manufacturing and constructing the body of this ship. I was almost halfway, in the middle of the sea, when the water started raging and storming and the sky was filled with thunder and lightning. Harassment began: artwork was not allowed to leave the camp, the guards focused specifically on me, and there were frequent inspections and surveillance. I was in a race against time until the ship and I were saved. But fate was stronger and faster than everything, and despite all these difficult circumstances, I accepted the challenge and steered the ship through the high waves and storms. I didn't care about obstacles, nor did they affect my motivation and determination to reach my goal.

After I completed the ship, I gave it to the art instructor to stamp, document, and photograph. Unfortunately, then it disappeared, and I thought it was gone forever. The reason behind its disappearance is unknown, just like the ghost ship and many ships that made the bottom of the ocean their home. Every time I asked my instructor about it, he said, it's in a safe place where no one can reach it. I didn't give up searching for it, but I didn't tell anyone so they wouldn't change the place it was hidden, until I received confirmed information from an eyewitness who said he saw it inside a locked cell with a note on the door that said, Do Not Enter, and with closed windows so no one could see it. The ship, *Eagle King*, had become a prisoner like us.

When I received the information about its location, I carefully considered how to get it, but days and weeks passed until I met with some of the senior officials who had influence and the power to make decisions. I gave them the pictures of the ship, and I told them that I wanted it back because it needed to be adjusted and fixed, but I didn't tell them about its place so that they wouldn't move it to someplace else. The official ordered the guards to bring *Eagle King* to my cell. A couple of minutes later while I was still waiting by the door, a guard arrived carrying the box of the ship. I started jumping with joy. I remember staying up late at night, restless to complete it, but the joy was greater than everything because artwork at Guantánamo Bay is different than at any other place. You make something out of nothing.

I took the ship to my cell and started working on it right away, I reworked it and made the box sturdier to protect the ship inside. I put a base on top of the box for the ship to sit on and to protect it from falling. I put a safety knob on the base to prevent it from moving until I turned the knob. Also, I put a safety latch on the door for the ship to go in and out safely and for no one to get injured taking it out because this box is like a house for *Eagle King*. Next, I started working on the ship. I changed everything in it but the body of the ship. I changed the sails and drew the symbol of the ship on the new ones, the two wings and the crown, which dazzled everyone. I also changed the ladders and the lifeboats and added lanterns with some shiny plastic inside that made them shine every time you got closer. These additions were difficult, and it took me longer this time to improve the ship than it took me to make it the first time because I was trying to be precise with my work and trying to get the most significant pieces, even if I had to make them myself with great effort and time.

After I completed the lanterns, the instructor told me it is like turning lead into gold.

When I put everything together and completed it, I took it out for my brothers and the guards to see, and they all said it was a great piece of art and some of them said it's beyond great and flawless. Some of the guards said they would love to take a picture of it, but they couldn't. They said they would tell people about it if it ever made it to the United States, so I was very proud and happy because I brought joy and happiness to many others. This time they sent a photographer to take pictures of it. Once the photographer was finished, I asked him to show me the pictures. There were more than 20 pictures from different sides and angles.

I took *Eagle King* back with me to my cell while my heart was at ease. Every time I get tired or upset, I look at it and it takes away my worry and sadness. Every time a new group of soldiers comes to the island, the old soldiers ask me to bring the ship and show it to the new ones. This artwork—the ship and others—influences their opinion about us, and contradicts the rumors that they were hearing before. *Eagle King* impresses everyone who sees it, and the new guards all ask me, how did I do this? How did I do it and how long did it take me to finish it? And that's always the beginning of a new page, when the questions start and a good relationship begins.

WITNESSES

The Qur'an teaches you self-discipline, it soothes your soul, it removes anxiety, discomfort and tension; it also improves memory. And each time I neglected my habitual reading of the Qur'an, I found myself unable to create any type of art; I was unable to focus. But reading the Qur'an gives me energy, it changes my mood and it eliminates my sadness and my distress.

Many of us have memorized the Qur'an in prison despite the suffering and the psychological warfare that makes us lose our minds. The Qur'an is one of the greatest stabilizing factors because the Qur'an has endless meanings. You read through the verses of the Qur'an and every time it is as if you were reading it for the first time. In the stories, the prophets who experienced suffering in this world faced the most harm from evil demons and mankind, but the harm coming from humans was uglier than the harm from demons. Satan has many faces, personalities, and colors. Satan comes in the shape of a soldier who harms you; or even of a leader who

orders people, commands wickedness, and opposes good deeds. Satan comes in the shape of a doctor who kills and hurts others. Satan comes in the shape of a lawyer who defends wrong and criminals, or a judge who rules for injustice. Every prisoner who has encountered injustice in this world will receive his full fairness and justice at Doomsday where no one can deceive anyone.

The first ship I built was named after our prophet Noah, whose story is in the holy Qur'an. It describes how his ark rescued people and animals on earth and that is why we, and all the creatures that we see today, still exist. I named it *The Ark*. And the person who gave me the idea was an ICRC staff, a Moroccan by the name of Naufal who asked me, "Why don't you call it *Ark*?" And that was when I remembered the story of our Prophet Noah and his ark that saved all humanity. So, I was delighted to call it *The Ark*. Its name made me feel optimistic and made me think that it might also rescue me and save me from this raging, dark and wild ocean that could almost kill you. And yet, he who is fortunate enough to reach the safe shore and survive will feel as if born anew.

I was so bored here. I had so much empty time, so I started making things, making progress as an artist. I realized this was a way to fill the time, but also to enjoy the time passing by. When I start an artwork, I forget that I am in prison. When I start an artwork, I forget myself, especially when I have an idea in my mind that I can express and draw. Despite being in prison, I try as much as I can to get my soul out of prison. I live a different life when I am making art; it makes me live within my soul. It makes me feel free.

Artwork is part of the artist's life; it is one of his organs. All of my art is produced with hard work, by staying up late at night, through exhaustion and sickness. In my case, the beauty of a piece of art reflects the amount of suffering and pain that the artist experiences. When I make something nice, I put it next to my bed and keep looking at it until I go to sleep. It makes me happy. It becomes a part of my life. Each piece, each painting, the sculptures I have made, all have had an impact on me. Every time I finish a piece, I prepare to make another. My prayer rug is stained with paint. Every time I finish, I give my room a thorough cleaning and then I start working on a new piece.

All you have to do is ask an artist this question, "what is the importance of this artwork to you? And what is its value in your life?" And he will answer promptly, "Artwork is like my little child and it is my most valuable possession. Making art is part of my life and an account of my memories."

Many artists have died and their bodies disappeared under the soil, yet their artwork remains alive to bring culture to people, to educate them, and to illustrate the beauty of this life which is filled with love and compassion.

Many ask why so many of my paintings give the impression that something wants to get out of the painting. When the English teacher saw it, he said everything in your paintings is trying to escape. I said, because this is the reality. But it's not always what they think. For instance, in the case of my sculpture of a brick wall, with two small hands reaching through a crack and pushing the crack apart. You can see an eye through the crack. A small heart on a chain is dangling from the hands. In this case, the government refused to approve it for release with other pieces because it "gives an impression someone wants to escape." And though I have spent all my time thinking about how to escape this prison, I made this sculpture after watching the news and seeing how wars wreak havoc across the world and displace a tremendous number of children, depriving them of the childhood and innocence felt by children who live in a stable and safe world. These are, in fact, the hands of a child wanting to get away from a bitter reality to a better reality. It represents a broken wall with a little girl looking from behind the wall, asking for help because of poverty and deprivation. Through the crack she is trying to reach out to the world outside, to ask for help so she can live like other children her age. She is expressing her poverty, her childhood, her innocence, and her little heart through this crack. The crack represents her love for life, her love for happiness and freedom. The heart is made of plastic and the chain represents her poverty.

After I completed *Eagle King*, I made a three-dimensional painting of a castle flying the flag of justice. There is a ship full of pirates who want to demolish this castle, but there is a second ship carrying the flag of justice and defending this castle. For the sake of this castle many people sacrifice, because people need justice, but justice doesn't need people. This castle is surrounded by palms bearing the fruit of justice. There is a sign pointing to the sea, with the words DANGER—HELPLESSNESS—DOOM—DESPAIR—LOSS on it, and a second sign pointing toward the castle with HOPE—JUSTICE—SURVIVAL—FREEDOM written on it. The castle carries on one of its towers a cannon, which is the voice of justice and freedom that suppresses injustice and supports the weak, and this cannon will remain until the Day of the Resurrection. If this voice disappears, it will be replaced by thousands calling for freedom, justice, and equality.

Justice does not differentiate between the strong and the weak, nor the rich and the poor. This castle flies the flag of justice.

Then I made a second three-dimensional artwork of the castle of justice. In this second work, the castle is bigger and stronger, and around this big castle are more palm trees than around the first castle. There is also a small ship, *Eagle King*. I thought about making a three-dimensional model with the castle of justice standing against the raging sea and, in the middle of this sea, *Eagle King* is carrying the flags of justice on its top. This ship splits the sea and resists the waves, heading toward the castle of justice. I started with this idea, defying all odds and knowing what effort and material it would require to finish this detailed and precise work, since the smaller the artwork is, the harder it is to complete. I began diligently day and night without boredom, and every time I achieved something, I got more encouraged for the next step until I finished the task to its fullest and most beautiful shape.

I can spend a lot of time looking at it, with its accuracy of details and clear meaning. This ship passes by a mountain to the left, and on top of that mountain are banners. Written on the banner pointing toward the castle is CASTLE OF PEACE—GO THIS WAY. The second banner points toward the sea, and it says TO UNKNOWN. To the right of the ship is the castle with a cannon on it that represents the voice of justice. On the castle tower flies the flag of justice, and on its wall is a big banner with a scale, a gavel, and a key. To the left of the ship is a mountain with a waterfall pouring from its top to the bottom, and around the castle are fruitful palm and coconut trees. I chose white fruit to indicate good deeds. These white fruits are the fruits of justice. At the bottom of the castle to the right of the ship are signs. Those with the words JUSTICE—EQUALITY—HOPE—RELIEF are pointing toward the castle, and other signs with the words HORROR—ENDLESS DARKNESS—HELPLESSNESS—DANGER, along with drawings of two crossbones and a skull, are pointing toward the sea.

The ship is making its way to the castle, and waves hit the ship and the castle from all directions as if the sea is angry and wants to separate the ship from the castle. But the steady and mighty ship makes its way towards the castle firmly and with confidence, knowing that the path of justice is difficult, arduous, and requires sacrifice. Many shipwrecks are under the sea, sacrificed for the sake of the oppressed and vulnerable. Whenever a ship was destroyed, it was replaced by thousands of stronger ships, and the high waves indicate the injustice and the suppression of the oppressed.

The raging sea hides the oppression beneath. The loud sea waves indicate the voice of injustice and the voice of falsehood. No matter how loud the voice of injustice and falsehood is, it remains small in the end without resonance in front of the voice of justice and the voice of truth and freedom.

I look to see what progress I have made by comparing my old work with my new work. My first works were not as good. I taught myself without an instructor. I tried to teach myself. Everyone came to enjoy the work; they hadn't seen anything like it before. Sometimes I asked the teacher, what if I try this or that? Sometimes I experiment, gaining from previous experience. If I do something wrong, I try a better way to get a better result. Often I have an idea in my mind, but certain pieces are hard to make, like the flower. My nature is, I don't despair easily. If I don't succeed in creating something, I try again and again.

Every drawing and artwork expresses something, either joy, sadness, struggle, or tragedy. My artwork talks to others, asks them questions and waits for answers. I like to be very accurate to express myself clearly, so that the person who will look at the painting will understand immediately what is being expressed. Every human being when they create something beautiful appreciates when people see it. I want to use art to express my emotions and to convey a message to every person who is feeling lonely and desperate and empty.

In the beginning I said to myself, I am here doing nothing, empty handed. I spent my time thinking, thinking about being released. This is the situation of every person who feels destroyed: if you are not able to occupy yourself with something useful and interesting, you will be a prisoner of thinking, sorrow, despair, and emptiness. I said, I am not going to give up. I said, I am going to start. There is a saying that if you want it, you can do it, so I started looking for something to fill this emptiness. I realized the most beautiful thing is to improvise and create. In this way I discovered, at times, I could liberate myself from all restraints. So maybe I thank the Periodic Review Board for not clearing me for release and transfer from Guantánamo, for I have developed so many artistic skills and also improved my skills in building ships, three-dimensional models, and painting. I learned how to do sculpture. You don't know when good things will happen. You don't know what life will bring. I did not know how to do sculpture or build ships in the early days. When I started sculpture lessons, I didn't like it. I said I need to liberate myself and do it my way. Now I realize how beautiful sculpture is.

I am asked, what is the fate of these artworks and what will you do with them? I tell them, God willing, I will be released, and our fate will be the same because creating them took a part of my life. My brothers ask me, "If you had the choice between your own release and your artwork's, which one would you pick?" And without any hesitation I answer: "I would choose the release of my artwork because as far as I am concerned, I am done, both my life and my dreams have been shattered, whereas if my artwork is released, it would be the sole witness for posterity." And when future generations discuss these artworks, they will wonder how in spite of the bitter and harsh reality that had been inflicted on us, we fought, we struggled, and we surmounted all the challenges in order to achieve our goals and build these beautiful pieces which helped us change that dark, vicious, and macabre image they made of us when they depicted us as a bunch of savages who have no taste for art, for beauty, or for creativity. Our artwork will be the testimony of who we are, our work, and our thoughts. As a matter of fact, many people have already met these witnesses and have believed the messages that they conveyed: "We are indeed people, and we do have a sense of art. We come from an old civilization and history and we enjoy building beautiful things that bring joy to people's souls." The proof is our art. I wanted the prison stamp to be clear on the sails of all of my ships, so people would know the ships come from Guantánamo.

I want people to change their mind about people here. The widespread idea is we are criminals, we cannot create anything beautiful, we are enemies of cultural heritage. People think we know nothing of art and know nothing about life and are not productive; that we have nothing to show. I created my art to change people's minds.

I am asking you to look at my art before you judge me. I hope you can look at the ships I have made to see my artistic sense in the little details and also to look at my sculptures and paintings. I want to make beautiful things to give a beautiful idea of people here. I would like to change the black image created by a blind man who does not distinguish between ugly and beautiful and between right and wrong, and who sees only through the eye of ugliness, misery, and hatred for others. This artwork expresses our character, who we are. What people hear about us on the outside is not true. We are interested in culture, we have feelings, we have sentiments, we can create beautiful things. We feel for others; we share sorrow, sadness, joy, and happiness with others. We rejoice for their joy and mourn for their grief. We don't discriminate against color, gender, or

race. We wish happiness for all even if they disagree with our ideas and opinions. We human beings all have the same forefather, Adam, and the same foremother, Eve. So I painted a tree symbolizing the original father and the original mother. And the different, colorful fruits symbolize the various human races: white, black, brown, red, for they are all brothers with one mother and one father. I would like people who are biased against us, I would ask them before judging us to take a look at our art.

I've been searching for justice and freedom for the past 20 years. I am over 40 years old, and half of these years I have spent in prison without ever being charged with a crime. More than twenty years have passed, generations have died and new generations have been born. Every day passes, and I remember hearing the voices of children, the new generation, and I hope to see them and sit with them.

A few years ago, I finished four paintings. I call the series, *The Story of My Imprisonment*. In the first one, a youth is waiting on the beach. He's holding a stick and has his belongings tied to his back. This drawing shows the moon, the full moon, and the painting has green colors. The second drawing has the same person on the beach, but he's older. It also has the same stick, but instead of holding it over his shoulder, the man is leaning on it as a cane, for he has become an old man. The moon is now half gone, and the colors are gray. The third drawing has rose colors, but the man, that old man who was waiting, has died. It shows his tomb, with his cane facing the tombstone and his belongings next to it. He is already dead but before he died, he wrote a note, "If hope dies, life ends," and he hung it with a nail on the tree before he entered his tomb and died, leaving behind his cane and his hat on top of his grave and all his belongings next to it. There is very little light from the moon, and there is a ship coming from afar. It is flying the flag of justice. The fourth painting shows the tree close to the beach, where the man was standing and waiting for the ship to come and rescue him when he died. The ship has left and the moon is in the middle of the sky. The colors are beige and brown. When the ship arrived, it did not find the man, but they found his tomb and put some flowers next to it. They left a note that it is too late, time has passed.

These four paintings tell the story of suffering, the story of waiting and longing, the story of people waiting for justice to be done and freedom to be restored. It is the story of people who have been imprisoned for 20 years and who have been waiting for justice. And this was how I started my first painting depicting a young man in his twenties waiting while everything around him was aging. And the tree he is leaning on also has been aging,

and its roots were starting to grow through the cracked rocks. It grew and expanded while he was still waiting. Then he turned into an old man. So he placed his belongings on the ground and felt that he could no longer stand on his feet; so he leaned on the cane that also served as a stick for his bundle. Then a ship came, and it was flying the symbols of justice. But it was already too late. A long time had gone by, and the man died leaving no trace but his bundle of belongings and a hat. So I gave his belongings to his family and those who loved him, who put them on top of his grave along with flowers and the note on the tree that said: "It was already too late."

So this is the beginning and the end of Guantánamo, summarized in four paintings that depict the story of the injustice that was endured by the prisoners for the last twenty years. They are all yelling in unison, What ever happened to freedom and justice? The other detainees tell me they like the drawings. They say, this is our reality.

My Brother, the Artist

Mansoor Adayfi

2002 Camp Delta—I heard beautiful singing from a neighboring block. We all stopped and listened when we heard it. "Who is the singer?" I asked. A brother replied, "This is Moath al-Alwi from Yemen." In the early years at Guantánamo, singers were either moved to other blocks or punished with solitary confinement. I first met Moath in Echo Block. He was older than me (I had just turned 19), and we grew up together in prison. He was in his early 20s and liked to tease people and sing for them, too. Singers at Guantánamo were in high demand. Their voices brought happiness to our hearts and transported us beyond the prison cages.

Moath has a thin, loud voice, and when he teased people, friendly teasing, he would laugh so loudly. In the early years, Moath would try to use humor to diffuse the situation, and the guards punished him many times for teasing and laughing at them. Sometimes prisoners would strike a deal with him, trading a sweet to avoid his friendly sarcasm. This was part of our survival in Guantánamo.

In the early days, art wasn't allowed at Guantánamo. We weren't allowed to have pen and paper, and no books were allowed, except in the

M. Adayfi (✉)
Belgrade, Serbia

A. S. Moore, E. Swanson (eds.), *The Guantánamo Artwork and Testimony of Moath al-Alwi*, Palgrave Studies in Literature, Culture and Human Rights,
https://doi.org/10.1007/978-3-031-37656-6_3

blocks for highly compliant prisoners. In our blocks, though, everything had to be approved by interrogators; they didn't want to see us happy or having some good moments. Still, we found ways to communicate and share our culture and talents with each other.

From 2002 to 2010, we moved in and out of solitary confinement. The prison distanced us from who we are and from our memories of our previous lives. Art helped us to connect to ourselves and to the world beyond Guantánamo. During those years, we sang, danced, and composed poems and memorized them by heart. Moath memorized many poems in different languages. He would sing for all prisoners in their languages, and that made him even more popular.

In addition to memorizing and reciting poems, we used whatever we had to make art and to write. We had nothing except the Styrofoam cups and clamshell containers for our meals, powdered tea, toilet paper, and soap. We used pebbles to engrave the sink or bed, to scratch on the cell's bars, and count days and months. We pressed designs and poems into the Styrofoam cups and passed them through the bars to our neighbors. We added a little water to the tea bags we received and used the corner of the tea bag to write on toilet paper. We learned to rub the soap into glue to put things together and hang things on our cell walls. Guards confiscated our work and punished us.

Moath took part in many hunger strikes to protest our living conditions, the torture, and our detention in the camp. While we were shackled and strapped into the force-feeding chairs, Moath always sang for us. Even guards took note and loved listening to his voice. I remember a young female guard would ask Moath and a few of the other brothers to sing. The rhythms and tones transferred the guards out of Guantánamo, just like us.

The hunger strike lasted for years, and some of us, including Moath, had been on force feeding throughout that time. Eventually in 2010, most of us stopped the hunger strike when the camp administration started to make changes in the camp. When President Obama failed to close the military prison, we negotiated with the camp administration to improve our living conditions and to allow classes. Art was one of those classes. The first art teacher was an Arabic translator with no knowledge about art or painting, so again we protested to demand an art teacher and art supplies.

The art revolution started when the teacher Adam, an Iraqi artist with a Ph.D., arrived in Guantánamo. The class was full, and there was no room for everyone. The art teacher was very supportive, kind, and sincere in his

teaching; he wanted to teach everyone. For the prisoners who had talent but couldn't attend due to the strict procedures for moving to and from the classroom, Adam would secretly send art supplies to their block.

Yesterday, we were hiding our art, protecting it, and were punished for making it. Today (2010) we have an art class. Suddenly, we didn't have to hide part of ourselves. Art was our child, born from the ordeal we lived in.

Even with the art class, however, there were still many restrictions on making art in Guantánamo. At first, we were only allowed to make art in the classroom, where we were chained and shackled to the floor and only had one hand free. The guards would watch the art teacher very closely, and he had to translate into English for them every word he spoke to us. Cameras were everywhere. We were only allowed 45-minute classes twice a week, and we had to leave our artworks in the classroom at the end of each class, where sometimes they were stolen or disappeared.

Painting was another story. Some of you who paint might have your own studio, a nice coffee by your side, music. You are free to move, to stand up and walk around or step outside. You don't have to race with time or worry about whether your painting will be approved or not. This is not "approved" as in whether someone will like it but "approved" in terms of not confiscated and destroyed. But in our world, we had to fight with the guards—some of whom are lazy—just to move us to the art class. We had to endure four to six searches going back and forth to class, and when we were in the classroom our movements were limited, time was limited, art supplies were limited, and we weren't allowed to paint about our detention. If we did, we would be either punished or suspended. Each painting would take weeks, months, a year to finish. And while painting we were not sure if our work would be approved or rejected. There was always uncertainty. Even if the painting was approved by the military group currently running the camp, the next group might confiscate our work, because we had no rights.

We painted what we missed: the beautiful blue sky, the sea, stars. We painted our fear, hope, and dreams.

In no time, art started to move around the camp. We shared our artworks with each other, and the camp administration created an art gallery to exhibit copies of our artworks to journalists, visitors, and delegations. Our artworks were used by the military to improve Americans' image of Guantánamo.

Even with classes, we were limited in terms of what we could have and our living conditions. We wanted to change the scary naked walls of Camp

6 and our windowless cells. We started making shelves for books and for our kitchen and cabinets for our clothes and other belongings. Everything was made of cardboard held together with soap.

Moath's work was the best of all, and all of us wanted him to work for us. He made windows of cardboard in his cell. I describe them in my book, *Don't Forget Us Here*: "One opened east to Makkah and the sun rose over a vast blue sea dotted with ships and palm trees swaying gently in the morning light. The other window opened west to the most beautiful sunset, palm trees so close you could touch them, birds flying freely, and the sea a deep and mysterious blue" (Adayfi 2021, 288). The windows had shutters that could be opened and closed. He also made a windmill and placed it in front of the AC opening where the air kept it spinning. Then he made a small box and placed it over the AC opening to control the air flow and direction. The box was controlled by string he could use while lying on his bed.

Moath's cell didn't look a cell anymore. We all started following his lead and changing our cells. He would make the plans and do the final touches. Measuring with a piece of cloth marked with centimeters, Moath would do the design and tell people what to cut and what materials they needed. We used the concrete floor for sanding and shaping, and then Moath would put the pieces together. Initially we used soap as glue, but later we had real glue and Velcro. The cardboard would be naked until he put on the last touches: adding handles from bottle caps or other trash and painting the cardboard with different decorations or so it looks like wood.

We made covers for the toilet from either the ISO mat or cardboard. Each cell now had a bookshelf, cabinet for clothes, mirror cover, and holder for toiletries. We were allowed to have carpets in our cells, and although the light bulbs were always on, they were reduced to one instead of three.

He also made beautiful vests and caps from shirts and laundry bags, all with just scissors and a needle. During the golden age of Guantánamo, guards were allowed to cut things like cardboard and pictures for us, and some good guards brought us our own scissors and needles which were contraband items. Especially for the guards who stayed longer during that time, watching the prisoners eat, sleep, and make art conflicted with what they were told by the camp administration about who we are. Guards don't live with their superiors 24/7, and, as human beings, sometimes they trusted their own judgment. Guards are normal people, and they recognized that most of the prisoners are innocent. When they saw our

artwork and the abuse, like force-feedings, they sometimes wanted to pro-tect their own humanity and tried to help. Sometimes guard artists would teach detainees and vice versa. It was mutual. We brothers formed our own family, and if guards chose to be part of that family, they could be.

In communal living in Camp 6, we were allowed to have a microwave and refrigerator, the food was better, we were given ice cream twice a week and candies, and families and lawyers were allowed to send us spices, sweets, and sealed food. Prisoners started cooking and sharing their knowledge about the best ways to cook. I was one of those who ate and cleaned. Moath surprised us by the sweet he made. He would collect dif-ferent candies, nuts, dates, honey, olive oil, ice cream, and spices, and would make his own unique sweet with its own flavor. It was so delicious. Some prisoners would go to the fridge and eat it, and that drove Moath mad. But he is a very forgiving brother, which is why we sometimes teased him by eating his sweet like he teased us with his words. Guards also loved his sweet, and he always set some aside for those who were his friends.

Our art and cardboard industry flourished in Guantánamo's golden age, what I call the Cardboard Renaissance, from 2010 until the end of 2012. In 2012 the Army came to replace the Navy. The Army didn't like the life in the camp. They returned to the strict Standard Operating Procedures of the camp, confiscating our belongings, and harassing us daily. We went on hunger strike to protest the new policies, but the Army was determined to close communal living in Camp 6.

In April 2013, the Cardboard Renaissance was destroyed when the Army raided Camp 6 and closed the communal living camp. This was the end of the golden age. Groups of guards stormed each block, searching and confiscating our stuff. Artworks were the first target, and many of them were destroyed.

Just like the work of the rest of the prisoners, all of Moath's work was destroyed or confiscated. He joined the hunger strike in protest and was moved to Camp 5, where he had to start to work again, challenging hard-ship, hunger, and force-feedings. The camp's new policy was even worse than our first days at Guantánamo, and all classes were canceled.

Some of the brothers continued the hunger strike, but some of us stopped. I stopped because I wanted to focus on education and learning. Moath continued his hunger strike, and since we both were in Camp 5, which was the disciplinary camp and where the hunger strikers were force-fed, we usually met in the rec yard.

Despite everything, Moath continued collecting cardboard and trash and art supplies, and he would ask the guards to bring a black garbage bag to other blocks to collect trash he could use. He made it into a joke so they would do it. This time he started working on ships and the gondola, and the Camp 5 administration allowed him to continue.

I watched him living in a different world. Making art was his life and freedom in a place where we felt that we weren't alive or dead, and where our freedom was caged. All of us always watched him, waiting to see the next stage of his work. Every time it would get better and more astonishing. Moath puts his soul in his work.

When the guards would come to move him for force-feeding, he would give instructions of what to do and what not even to think to touch. He would rush back after the force-feeding to continue his work. He wasn't allowed to use the scissors, but the guards were instructed to cut for him, so we called him "The Boss." We all were working for him.

Moath's clothes, hands, and prayer rugs were full of paint, and he had two trash bags full of pieces of cardboard, plastic, Styrofoam, string, torn prayer caps, t-shirts, torn shoes, and bottles. He also had two plastic boxes full of art supplies.

We were in different blocks in Camp 5, but he always would send good guards in the middle of the night to ask for stuff he needed or things he needed someone to do for him in the morning. Guards would knock on my door, "Hey 441! Your brother 028 is asking if you have ... or ... he needs you to finish this in the morning." Not all guards cooperated with us, so it was a good chance to find nice guards.

In my last day in Camp 5, in 2016, we had a gathering of brothers from different blocks and we all spent the night together. Moath sang for me along with the others. He kept teasing me; it was his last time to do that. While giving me a goodbye hug, he said, "I will miss you, brother." They all asked me, "Brother, don't forget us here." I said, "I promise, I won't. I'm not free until you all are free."

●

WORKS CITED

Adayfi, Mansoor. 2021. *Don't Forget Us Here: Lost and Found at Guantánamo.* Hachette Books.

"APPROVED BY US FORCES": Showing and Hiding Art from Guantánamo

Erin L. Thompson

For months, Moath al-Alwi woke before dawn and worked all day on a model ship (Figs. 4.1, 4.2, and 4.3). He made planks from cardboard colored with coffee, sails from scraps of an old T-shirt, and constructed a bottle-cap wheel connected to a rudder carved from a shampoo bottle with cables of dental floss. Moath cut into his scavenged materials with a pair of nail scissors, as he is allowed nothing sharper in his cell at the Guantánamo Bay military prison camp.

Christening the model ship *GIANT,* Moath gave it to his defense lawyers. They, in turn, lent it to me. From October 16, 2017 to January 26, 2018, the ship stood in a display case in the President's Gallery of the John Jay College of Criminal Justice, City University of New York, along with 35 other paintings and sculptures made at Guantánamo. The works in the exhibition, "Ode to the Sea," which I curated, were made by eight

E. L. Thompson (✉)
John Jay College of Criminal Justice, New York, NY, USA
e-mail: ethompson@jjay.cuny.edu

© The Author(s), under exclusive license to Springer Nature
Switzerland AG 2024
A. S. Moore, E. Swanson (eds.), *The Guantánamo Artwork and Testimony of Moath al-Alwi*, Palgrave Studies in Literature, Culture and Human Rights,
https://doi.org/10.1007/978-3-031-37656-6_4

53

Fig. 4.1 Moath al-Alwi, *GIANT,* mixed media sculpture, 2017. Courtesy of artist

detainees: Moath, Muhammad Ansi, Ammar Al-Baluchi, Ghaleb Al-Bihani, Djamel Ameziane, Ahmed Rabbani, Khalid Qasim, and Abdualmalik Abud.

By the time of the exhibition, half these men had been released from Guantánamo without ever having been charged with a crime. Two were released during the exhibit's planning stages, on the day before the inauguration of President Donald Trump in January 2018. Their lawyers fought to make their transfers happen more quickly than usual, suspecting that the new administration would be reluctant to free anyone from Guantánamo. Ahmed Rabbani, who was cleared for release in 2021, was transferred to his home country, Pakistan, in March 2023. The other three men remain at Guantánamo, including Moath, who was cleared for release in January 2022. He might be detained for years until agreements with a host country can be finalized. Qasim's release has not yet been approved, although he has never had charges filed against him. The remaining man, Ammar al-Baluchi, is still in the preliminary hearings phase of his trial.

The art showed what the detainees who created it dreamt of in their cells: sunsets, meadows, cityscapes, and scenes, like the Statue of Liberty,

Fig. 4.2 Moath al-Alwi, *GIANT*, mixed media sculpture, 2017. Detail of ship's wheel. Courtesy of artist

that they would likely never see in reality (Fig. 4.4). Moath describes making art as a means to escape his prison:

> When I start an artwork, I forget I am in prison. When I start an artwork, I forget myself. Even the ship, when I started building it, cutting pieces, I forgot myself. The most beautiful thing was when I was cutting the ropes. I imagined myself on the ship in the middle of the ocean. (Jacob 2017)

Fig. 4.3 Moath al-Alwi, *GIANT*, mixed media sculpture, 2017. Detail. Courtesy of artist

Making art is a profoundly human urge, and this art conveyed the simple message that its makers are human beings—a message deeply at odds with the systematic dehumanization of the detainees. They have been stigmatized as monsters, animals, and, as then Secretary of Defense Donald Rumsfeld claimed in 2002, the "worst of the worst" (Seeyle 2002). These labels have allowed us to ignore their condition, to torture them, and to deny them basic human rights.

The penal and legal history of Guantánamo is well known, but its art history is not. "Ode to the Sea" was the first comprehensive exhibition of

Fig. 4.4 Muhammad Ansi, "Untitled (Statue of Liberty)," acrylic on paper, 2016. Courtesy of artist

Guantánamo art. The exhibition, with more artworks but a slightly different list of participating artists, has now traveled to the Baron and Ellin Gordon Art Galleries at Old Dominion University and the Catamount Arts Center in St. Johnsbury, Vermont. Artworks made by detainees have also been exhibited in a 2020 exhibition, "Guantánamo [Un]Censored: Art from Inside the Prison" at the CUNY School of Law in New York City, and a 2022 exhibition, "Remaking the Exceptional: Tea, Torture, & Reparations," at DePaul University in Chicago. A growing number of authors have written about the art, including me (Thompson 2017a, 2017b, 2017c, 2017d, 2019). Yet, the story of the detainees' artwork is still under threat.

Shortly after "Ode to the Sea" opened in 2017, a Pentagon spokesperson declared that all artwork made at Guantánamo is "property of the U.S. government," and a Guantánamo spokesperson confirmed to the

Miami Herald that the authorities had stopped allowing artwork to leave the camp (Rosenberg 2017). Moath reported that his latest model ship had been confiscated from his cell (Reiss 2017). It was years before he was permitted to work on his artworks again as he had before. Even now, his lawyers cannot freely describe the art he shows them when they visit. Their notes about the art are deemed classified and must be cleared by authorities before they can even acknowledge what they have seen. Moath told one of his lawyers that he thought that now even his ideas "are trapped in this prison with me" (Off and Douglas 2017).

The prohibition on the release of art was reversed only in February 2023 (Rosenberg 2023).

When the exhibition opened in late 2017, 41 prisoners remained of the roughly 780 men and boys who have been imprisoned at Guantánamo. Guantánamo is located on an American military base in Cuba. The captives from the Bush administration's Global War on Terror began to arrive in January 2002. The government labeled them "alien enemy combatants" and claimed they had no rights under either United States or international law.

Some detainees have been transferred to custody in other countries, but many others were released after convincing a military tribunal that they were no longer threats to the United States or that they had simply been arrested in error. President Barack Obama oversaw the release of 197 detainees during his years in office, but was unable to fulfill the promise he made on his first day to close the prison at Guantánamo. As of March 2023, 31 detainees remain at Guantánamo, only 11 of whom have ever been charged with crimes (New York Times 2023).

In early 2009, soon after President Obama took office, the Joint Task Force Guantánamo website boasted that a new art program had been established to provide "intellectual stimulation for the detainees" and "[allow] them to express their creativity" (Jacob et al. 2018). In 2010, some of their artwork went on display for visiting journalists. What they saw on their tours of the prison camp were not original works, but instead, color photocopies of detainee drawings and paintings. These were hung in the prison library—an area for the storage of books and other materials the detainees could request, but not a space that they themselves could enter. These photocopies had the artists' signatures and any other identifying details redacted. As scholar Rebecca Adelman pointed out, it is impossible to understand the truth of detainees' "emotional or cognitive situations"

by looking at the media tour's anonymized, decontextualized displays of artworks (Adelman 2018).

I learned about this artwork in mid-2016, when I received an email from a lawyer who knew me through a mutual friend. She was providing pro bono representation to Moath and several other Guantánamo detainees, and asked if I would be interested in curating a show of her clients' art. She also put me in touch with another of her clients, Mansoor Adayfi, who spent nearly 14 years detained at Guantánamo without being charged with a crime. The information below draws from my conversations with Adayfi and from reading the material he has written about art-making at Guantánamo, including his essay for the "Ode to the Sea" exhibition catalog (2017), sections of his 2021 memoir, *Don't Forget Us Here: Lost and Found at Guantánamo* (Adayfi 2021), and a longer, as-yet unpublished memoir specifically about art at Guantánamo.

The first years of the new art program were more meaningful to the authorities than to the detainees. Students were only given paper and crayons by a "teacher" who was not permitted to talk to them. The lengthy and humiliating strip searches the detainees had to undergo to reach the art classroom meant they rarely had much time to use even these few supplies. Adayfi describes years of protest by detainees, who asked camp authorities for more supplies and instruction and less obtrusive transfer procedures. By 2011, a new art teacher had arrived and was permitted to instruct the detainees on the use of oil pastels and acrylic paints. (He, like the other art teachers, was a civilian contractor known to the detainees only by a pseudonym.) More importantly, a new camp commander allowed detainees to keep their art and art supplies in their cells. This meant that art became important not just to those who could make it but to the entire community of detainees, as Moath also describes in this volume.

In his unpublished memoir as well as in his contribution to this volume, Adayfi describes conversations between detainees, guards, and camp administrations about this art, which included idyllic landscape paintings, caricatures of guards, satirical drawings about the ongoing War on Terror, and objects including stands for the Qur'an, bookshelves, tables, and other furnishings ingeniously constructed out of scraps of cardboard. Art became an opportunity for creating relationships between captives and captors.

Art was especially important when each new rotation of guards arrived. Adayfi explains that new guards came to Guantánamo convinced that the detainees were the "worse of the worst" and were prepared to treat them as such. Art began to change the guards' minds.

The camp imposed many rules on detainee art-making that are still in place today. Detainees are given only a few types of soft, non-toxic art supplies, like charcoal, acrylics, watercolors, and oil pastels, which cannot be used to harm themselves or others (Thompson 2017a). During some periods, detainees were allowed to use small scissors or nail clippers; at other times, they had to ask guards to cut materials for them.

The restrictions on content were less well defined and fluctuated over time. One former detainee reported that they were not allowed to draw or paint anything with a political or an ideological message or anything that had to do with camp security (Thompson 2017a). Since detainees are surrounded by security mechanisms, this would mean that they generally could not draw anything that they actually could see, such as their cells.

Each artwork that has left Guantánamo bears at least one stamp reading "APPROVED BY US FORCES" (Figs. 7.1, 8.1). These stamps show that military authorities scrutinized each piece before it left Guantánamo. The rules governing which pieces would be approved to leave also continually changed. At first, this scrutiny was fierce. Until around 2015, years after the art program began, only a few birthday cards or innocuous drawings of flowers were cleared for release, and then generally only via the International Committee of the Red Cross directly to detainees' families.

Eventually, the authorities seem to have decided that the detainees were not trying to hide messages in their art. In 2016, detainees and lawyers noticed that the approval process for lawyers to obtain permission to take artworks out of the camp had begun to go much faster (Thompson 2017a). Because of this, and because guards would confiscate and, presumably, destroy art during disciplinary crackdowns, as during a mass hunger strike in 2013, several detainees gave their lawyers hundreds of pieces of art, thinking they were safer outside the prison. Subsequent exhibitions have mainly featured these artworks, pulled from lawyers' filing cabinets.

Even with this new willingness to release more art, individual works were often denied release. For example, in 2017, Moath made a work showing hands reaching through a crack in a wall. A guard denied him permission even to show the work to his lawyer, much less give it to her. As Moath reported to the lawyer and describes in his contribution to this volume, the guard explained that the work suggested that Moath wanted to escape. Fruitlessly, Moath explained that the hands were not his, but those of a child, and that the work was not about Guantánamo, but about

a child trying to escape from the current famine and conflict in his home country, Yemen.

The opening symposium for "Ode to the Sea" was well-attended for an academic art exhibition, with about a hundred attendees. But after that, only a few visitors a day made their way to the exhibition space, a hallway outside of the office of the college's President. I had proposed the exhibition for this, the most modest of the college's exhibition spaces, because I had not expected there to be much public interest. Guantánamo seemed like a forgotten issue. And indeed, despite my attempts at publicity, at first there were only a few media reports on the exhibition.

But those few stories were read. By November, lawyers noticed that the authorities were taking longer and longer to clear artworks to leave Guantánamo. Detainees began to report that they had been told that any of their artwork deemed "excess" would be discarded and that any they left behind when released would be burned (Fortin 2017; Rosenberg 2017). In late November 2017, in response to questions from lawyers and journalists, Major Ben Sakrisson, a Pentagon spokesman, said that "media reporting" had "brought [the issue of art from Guantánamo] to the attention of the Department of Defense" and declared that "items produced by detainees at Guantánamo Bay remain the property of the U.S. government" (Fortin 2017). The Department of Defense suspended the release of art from Guantánamo, but stated that it did not intend to seize artworks that had already been released (Fortin 2017).

In January 2018, Commander Anne Leanos, a Guantánamo spokesperson, clarified that detainees could now keep only "a limited amount of artwork in their cell areas subject to our security protocols" (Welna 2018). She refused to answer questions about what would happen to artwork that exceeded those limits, since "that would be considered a security protocol, and we don't discuss specific security protocols" (Welna 2018).

At a press conference at Guantánamo in February 2018, Rear Admiral Edward Cashman responded to questions about the status of detainee art by reading a prepared statement, which said in part:

Detainees have the ability to maintain some of their art projects in containers in their cells. They have the ability to store some detainee art projects in storage facilities in the camps. I do not have the mission, the requirement, the direction or the capability to store every detainee art project forever. Detainees have a method to request which projects they want in their cell areas, which ones they want to have and store. ... They periodically turn in

completed projects, they turn in projects that they've lost interest in for disposal and destruction or objections when they exceed their capacity. I don't have a project to build a detainee art museum. I don't have a project to hire a detainee art curator. That's not part of my mission. (Rosenberg 2018a)

In response to follow-up questions about how the art is disposed of, Cashman said that this happens in the way that "most things are disposed of. Things are shredded, thrown away, whatever, if necessary" (Rosenberg 2018a).

As with so many policy decisions about Guantánamo, the justification for the ban on art exportation remains difficult to understand. No authorities claimed that the art posed a security threat or revealed classified information. Instead, any explanation given by spokespeople focused on the publicity received by the exhibition. Thus, Cashman said he was disappointed that "what's fundamentally a humanitarian program" had been sensationalized "to try to keep it in the news" (Rosenberg 2018a). Another Guantánamo representative told the *Miami Herald* that "everything was going fine until the lawyers decided to parade their artwork in New York City ... there is no need to parade it in the streets and to have people take pictures of it and show it. That's where the screw-up was" (Rosenberg 2018a). Ironically, if the authorities were indeed attempting to limit negative publicity, it was the ban itself that led to a wave of public interest and reporting on the exhibit. The authorities' desire to keep the art hidden resulted in more than 200 news reports, usually lavishly illustrated, in many languages, along with significant TV and radio coverage.

I spent most of my days in December 2017 and January 2018 conducting back-to-back interviews in the exhibition space. The film crews set up among crowds of visitors. The comments in the guest book made it clear that these visitors came to see the exhibit "before it's burnt by the USA"; one pleaded "PLEASE DO NOT DESTROY!" The controversy over the exhibition meant that millions of people saw either the artwork or images of it—a far cry from being hidden in lawyers' filing cabinets.

I stood in front of the art with veterans, former Guantánamo guards, and family members of victims of September 11, 2001, terrorist attacks. I discussed it with researchers from around the world who work on topics including political science, sociology, psychology and psychiatry, medicine, criminal justice, art therapy, terrorism, torture, detention, and human rights.

Many of these viewers had specific questions about who had created the art. The most intense reactions came to Al-Baluchi's piece in the exhibit, a swirl of dots and lines titled "Vertigo at Guantánamo" (Fig. 4.5). Al-Baluchi, originally from Kuwait, was held by the CIA for three and a half years before arriving at Guantánamo (Borger 2022). A Senate investigation found that Al-Baluchi had been tortured in the CIA prison. He drew this work in an effort to explain to his lawyers what it is like to have an attack of vertigo, which he believes is the result of a traumatic brain injury incurred during interrogation.

Al-Baluchi is currently facing a possible death sentence for making money transfers at the behest of his uncle, Khalid Sheikh Mohammed. Al-Baluchi confessed to making these transfers, which provided funds to carry out the 9/11 attacks, but it is unclear what, if anything, he knew about the purpose of the transfer. Additionally, his defense team is trying to have this confession invalidated, as it is the result of torture.

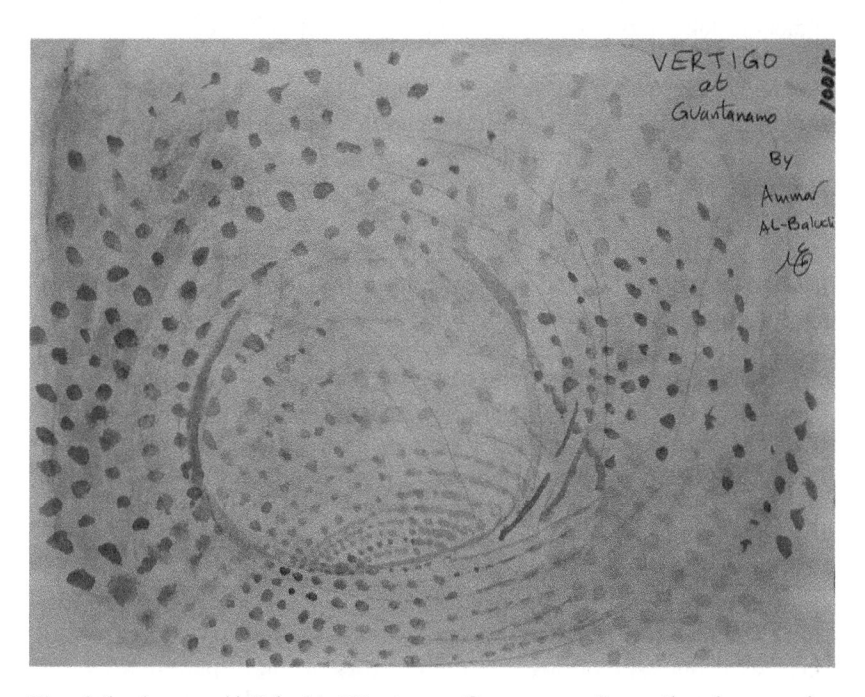

Fig. 4.5 Ammar Al-Baluchi, "Vertigo at Guantanamo," pencil and watercolor on paper, 2016. Courtesy of artist

As a "high value detainee," Al-Baluchi was held for years at Guantánamo's Camp 7, where security is even tighter than at the main camp (Rosenberg 2022). There, art-making is not officially sanctioned and detainees have only sporadic access to art supplies. Ironically, while Al-Baluchi has little ability to make art of his own, he is another artist's (unwilling) subject: a character named "Ammar," who is shown being tortured in the 2012 film *Zero Dark Thirty*, is based on information about Al-Baluchi given by the CIA to the filmmakers, but not to him or his lawyers (Borger 2019).

Critics of the exhibition, who regard Al-Baluchi as patently guilty, claimed that by displaying his drawing I was glorifying terrorism. The title of one blog post summarizes this strand of reaction: "Why is a College of Criminal Justice Celebrating Art by Guantanamo Jihadists?" (Wood 2017). Many journalists asked me to explain how it was possible for people who participate in horrific acts to also be able to appreciate beauty and art. Some asked if I was undermining America's ability to fight its war on terror by humanizing the enemy and thus making it more difficult for our soldiers to kill terrorists, now that they had been informed that terrorists could make art.

Veterans met the art with more complex reactions. For example, one student veteran came to the exhibition and said that he had expected to be angry at the artists, but he told me that he had found the works so beautiful that he was strangely angry at himself for appreciating them.

Another significant group of viewers were those who had lost family members in the 9/11 attacks. Lee Ielpi, whose firefighter son died, said that he was "shocked that John Jay would allow such a thing, it's disgusting and should be trashed. It is an absolute travesty to give credence to terrorists" (CBS News 2018). Maureen Santora, the mother of another deceased firefighter, called the exhibition "absolutely outrageous and reprehensible," because it is "giving them a forum which they should not have. They should have no voice, because they snuffed out the voices of almost 3,000 people on September 11" (CBS News 2018). Michael Burke, whose brother, a firefighter and alum of John Jay, said, "I can't understand how this college in particular would allow such a thing. Where's their decency? Where's their dignity? ... It's denying and softening what happened. What's next, hanging up the art of John Wayne Gacy?" (Vincent 2017). These reactions, although very understandable, were based on assumptions that the creators of the displayed works are indeed terrorists, guilty of murder, despite the lack of charges, much less convictions, for any of the artists.

After the first few media reports about the exhibition were published, before the controversy over the ban erupted, I received an email from the widow of a 9/11 victim. She asked me to give her a call. Reluctantly, expecting a negative reaction, I did—and was even more anxious when she immediately put me on hold so that she could conference in another 9/11 widow. But to my surprise, they said they had wanted to talk to me to thank me for curating the exhibition, and that it had given them hope. I eventually spoke to many more family members who also believed that the exhibition was important because it had drawn renewed attention to Guantánamo.

Some family members want the closure that trials and convictions will bring. Others do not want potentially innocent men to be detained indefinitely in their names. Some are even anti-death penalty advocates who carry their beliefs with them even as they mourn their losses. As Phyllis Rodriguez, whose son died in the World Trade Center, told a reporter who asked if she would hang one of the artworks from the exhibition in her home, "Oh, sure. They're done under circumstances that are very dehumanizing, and yet the human spirit comes up. ... To me, they give hope, because we all have these things in common" (CBS News 2018).

In April 2018, Al-Baluchi's defense team filed a motion protesting the new restrictions on the public dissemination of his artwork (Government Response 2018). In responding to this motion, which was eventually denied, the prosecution explained the ban by claiming that the Department of Defense "has determined that its captured enemies will not have a voice ... to spread their propaganda, in whatever form, to recruit more fighters to their lost cause" (3). To support this proposition, the prosecution quoted *Hirabayashi v. United States* (1943), in which decision the US Supreme Court declared that the "power to wage war is the power to wage war successfully" (3). The prosecution argued that the Department of Defense's restrictions on detainees' communications with the outside world, including artwork, "are a part of the successful war effort" (4).

It is characteristic of the confused swirl of attempted legal justifications of torture and indefinite detention that have long marked Guantánamo that this—the sole official rationale for banning detainee artwork I have seen—is based on a citation from *Hirabayashi*, a Japanese internment case.

Gordon Hirabayashi turned himself in for violating a newly declared curfew on Japanese Americans living on the West Coast. The curfew was one of the first restrictions on this population that followed Pearl Harbor— restrictions that would swiftly be followed by wholescale internment.

Hirabayashi, a conscientious objector, wished to test the legality of these new restrictions. In fact, he was so conscientious an objector that he had to hitchhike to the prison camp he was assigned to for violating the curfew, since all official prisoner transportation had been mobilized for the war effort.

Hirabayashi's conviction was overturned in 1987, when the US District Court in Seattle and the Federal Appeals Court determined that, during its arguments before the Supreme Court, the Solicitor General's office had cited examples of acts of sabotage carried out by Japanese Americans even though they had previously determined that none of these incidents had actually happened.

In 2011, the US Acting Solicitor General Neal Katyal delivered a speech to mark Asian American and Pacific Islander Heritage Month and referred to the Hirabayashi case both as a blot on the reputation of the Office of the Solicitor General and "an important reminder" of the need for absolute candor by the government when arguing cases (Savage 2011). It seems that the Guantánamo prosecutors have taken absolutely the wrong lesson from *Hirabayashi*.

Perhaps the rules about art will change yet again at Guantánamo. Ahmed al Darbi, an admitted al-Qaeda member who was released in 2018 to serve the remainder of his sentence in a rehabilitation center for returning jihadists in Saudi Arabia, was permitted to take dozens of pieces of his artwork with him when he left as a reward for working as an informant (Rosenberg 2018b), and Ahmed Rabbani was transferred in February 2023 with 130 kg of his artwork (Stafford Smith 2023).

Back at Guantánamo, Moath ruffles cardboard into feathers to create an eagle-shaped prow for each of his ships. As he spends months creating each one, he imagines that he himself is an eagle, soaring over the sea. But for now, he can no longer even launch his fragile creations into the world, to be free in his place.

WORKS CITED

Adayfi, Mansoor. 2017. In Our Prison by the Sea. In *Art from Guantanamo*, ed. Erin L. Thompson, 2–4. New York: np.

———. 2021. *Don't Forget Us Here: Lost and Found at Guantanamo*. New York: Hachette.

Adelman, Rebecca A. 2018. Fictive Intimacies of Detention: Affect, Imagination, and Anger in Art from Guantánamo Bay. *Cultural Studies* 32: 81–104. https://doi.org/10.1080/09502386.2017.1394343.

Borger, Julian. 2019. CIA Gave Details of 9/11 Suspect's Secret Torture to Film-Makers, Lawyers Say. *The Guardian*, February 22. https://www.theguardian.com/law/2019/feb/22/ammar-al-baluchi-pre-trial-911-cia-guantanamo-bay-torture. Accessed 20 June 2022.

———. 2022. CIA Black Site Detainee Served as Training Prop to Teach Interrogators Torture Techniques. *The Guardian*, March 14. https://www.theguardian.com/law/2022/mar/14/cia-black-site-detainee-training-prop-torture-techniques. Accessed 20 June 2022.

CBS News. 2018. Art from Behind the Walls of Guantanamo, January 21. https://www.cbsnews.com/news/art-from-behind-the-walls-of-guantanamo/. Accessed 20 June 2022.

Fortin, Jacey. 2017. Who Owns Art From Guantánamo Bay? Not Prisoners, U.S. Says. *New York Times*, November 27. https://www.nytimes.com/2017/11/27/us/guantanamo-bay-art-exhibit.html. Accessed 20 June 2022.

Government Response to Mr. Ali's Motion to Invalidate Restrictions on Public Dissemination of Mr. Ali's Artworks, *United States v. Mohammad et al.*, Military Commission No. AE563A (GOV) (April 13, 2018). https://www.mc.mil/Portals/0/pdfs/KSM2/KSM%20II%20(AE563A(Gov)).pdf. Accessed 20 June 2022.

Jacob, Beth D. 2017. Interview with Moath Moath, Guantánamo Bay, Cuba, May 15, 2017. In *Art from Guantanamo*, ed. Erin L. Thompson, 33–34. New York: np.

Jacob, Beth D., Ramzi Kassem, Pardiss Kebriaei, Aliya Hana Hussain, Shelby Sullivan-Bennis, and Katherine Taylor. 2018. Letter to DOD: The Review of Guantánamo Bay detainee art policy. https://ccrjustice.org/letter-dod-review-guant-namo-bay-detainee-art-policy. Accessed 20 June 2022.

New York Times. 2023. The Guantanamo Docket. *New York Times*, March 30. https://www.nytimes.com/interactive/2021/us/guantanamo-bay-detainees.html. Accessed 30 March 2023.

Off, Carol, and Jeff Douglas. 2017. Should Guantanamo Bay Prisoners Be Allowed to Display and Own Their Artwork?, As It Happens with Carol Off and Jeff Douglas. CBC Radio, November 29. https://www.cbc.ca/radio/asithappens/as-it-happens-wednesday-edition-1.4424587/should-guantanamo-bay-prisoners-be-allowed-to-display-and-own-their-artwork-1.4424653. Accessed 20 June 2022.

Reiss, Adam. 2017. Exhibit of Art by Guantanamo Detainees Draws Controversy. *NBC News*, November 28. https://www.nbcnews.com/news/us-news/exhibit-art-guantanamo-detainees-draws-controversy-n824726. Accessed 20 June 2022.

Rosenberg, Carol. 2017. After Years of Letting Captives Own Their Artwork, Pentagon Calls it U.S. Property. And May Burn It. *Miami Herald*, November 16. http://www.miamiherald.com/news/nation-world/world/americas/guantanamo/article185088673.html. Accessed 20 June 2022.

———. 2018a. Detainee Art? What Detainee Art? Popular Stop Vanishes from Prison Media Visit. *Miami Herald*, February 10. https://www.miamiherald.com/news/nation-world/world/americas/guantanamo/article199444279.html. Accessed 20 June 2022.

———. 2018b. Al-Qaida Terrorist Took His Guantánamo Art Home as a Reward for Trial Testimony. *Miami Herald*, May 10. https://www.miamiherald.com/news/nation-world/world/americas/guantanamo/article210730069.html. Accessed 20 June 2022.

———. 2022. Former C.I.A.-Run Prison Emerges as a New Front in Guantánamo's Legal Saga. *New York Times*, April 21. https://www.nytimes.com/2022/04/21/us/politics/cia-prison-gitmo.html. Accessed 20 June 2022.

———. 2023. Pentagon Lifts Trump-Era Ban on Release of Guantánamo Prisoners' Art. *New York Times*, February 7. https://www.nytimes.com/2023/02/07/us/politics/guantanamo-art.html. Accessed 30 March 2023.

Savage, David G. 2011. U.S. Official Cites Misconduct in Japanese American Internment Cases. *Los Angeles Times*, May 24. http://articles.latimes.com/2011/may/24/nation/la-na-japanese-americans-20110525. Accessed 20 June 2022.

Seeyle, Katharine Q. 2002. Threats and Responses: The Detainees. *New York Times*, October 23. https://www.nytimes.com/2002/10/23/world/threats-responses-detainees-some-guantanamo-prisoners-will-be-freed-rumsfeld.html. Accessed 20 June 2022.

Stafford Smith, Clive. 2023. Guantanamo: Freed After 20 Years Without Charge. A Beautiful Moment, a New Start. Opinion. *Middle East Eye*, February 27. https://www.middleeasteye.net/opinion/guantanamo-bay-detention-without-charge-long-road-recovery-begin?utm_source=twitter&utm_medium=social&utm_campaign=Social_Traffic&utm_content=ap_ite0og59kr. Accessed 1 April 2023.

Thompson, Erin L. 2017a. Interview with Aliya Hana Hussain, Djamel Ameziane, Alka Pradhan, and Shelby Sullivan-Bennis. In *Art from Guantanamo*, ed. Erin L. Thompson, 27–32. New York: np.

———. 2017b. Art Censorship at Guantánamo Bay. *New York Times*, November 27. https://www.nytimes.com/2017/11/27/opinion/guantanamo-art-prisoners.html?_r=0. Accessed 20 June 2022.

———. 2017c. The Art of Keeping Guantánamo Open. *Salon*, December 5. https://www.salon.com/2017/12/05/the-art-of-keeping-guantanamo-open_partner/. Accessed 20 June 2022.

———. 2017d. Art from Guantánamo. *Paris Review Daily*, October 2. https://www.theparisreview.org/blog/2017/10/02/art-from-guantanamo/. Accessed 20 June 2022.

———. 2019. The Guantánamo Spot: Exhibiting Detainee Art. *The Point*, Spring 2019. https://thepointmag.com/examined-life/the-guantanamo-spot/. Accessed 20 June 2022.

Vincent, Isabel. 2017. Pentagon Battles College Trying to Sell Art by "'Terrorists.'" *New York Post*, November 25. https://nypost.com/2017/11/25/pentagon-nyc-college-feud-over-gallery-of-artwork-made-by-suspected-terrorists/. Accessed 20 June 2022.

Welna, David. 2018. Controversy Over Guantanamo Prisoner's Art. NPR All Things Considered, January 1. https://www.npr.org/2018/01/01/574985923/controversey-over-guantanamo-prisoners-art. Accessed 20 June 2022.

Wood, Peter. 2017. Why Is a College of Criminal Justice Celebrating Art by Guantanamo Jihadists? December 3. https://www.mindingthecampus.org/2017/12/03/why-is-a-college-of-criminal-justice-celebrating-art-by-guantanamo-jihadists/. Accessed 20 June 2022.

From Wasting Away to a Way with Waste: The Visibility of Moath al-Alwi's Hunger and Sculpture

Joshua O. Reno

INTRODUCTION

It could be said that the entire point of prisons, detention centers, or other carceral sites is to subtract people from public life. Setting aside societal differences in penology, imprisonment is generally characterized by separation and erasure above all else.[1] Prisons literally separate us from one another. More than that, though, they also erase evidence of having done so. While prisons in general are subject to calls for reform, if not outright

[1] On this and what it means for the prison abolition movement, particularly in the United States, see Burns et al. (2020).

J. O. Reno (✉)
Binghamton University, Binghamton, NY, USA
e-mail: Jreno@binghamton.edu

71

abolition, some scholars and activists have documented the links between practices of erasure any prison may engage in (in terms of confinement and separation for instance) and the more profound erasure of one's humanity arguably characteristic of the American carceral state and empire (see Brown 2019). The latter has been formulated, following Saidiya Hartman (2008), as part of "the afterlife of slavery," where American incarceration employs the dehumanization of people as property, including stripping them of rights or subjecting them to indiscriminate torture and terror (Dillon 2012). And if this can be found in various forms in any American prison, the American carceral approach arguably reaches its apotheosis with the military detention center of Guantánamo Bay.

In this limited sense, prisons are somewhat like sanitary landfills. That is admittedly a subject I know much better, having worked at one in rural Michigan as part of my doctoral fieldwork in anthropology (Reno 2016). Both landfills and prisons, as physical facilities, are often built in out-of-the-way places. This is where the abundant land necessary to cordon off unwanted things and people from the rest can be acquired relatively cheaply (Schept 2022).[2] The difference between prisons and waste management, of course, is that no one's personal world is shattered when their discards are taken away and concealed under truckloads of dirt (except, maybe, out of guilt or shame for the harm it is likely doing to the surrounding environment or the Earth in general). By taking people far away from the places they come from, prisons sentence them to what sociologist Joshua Price calls "social death." Drawing on Orlando Patterson's influential analysis of slavery, Price suggests that like this founding institution of the United States, prisons "separate people from communities of support, and from their parents and children. … Natal alienation forces people in prison into a structure of vulnerability, subject to direct and indirect violence and humiliation" (2015, 5). If prisons warp and damage social relationships, they do so regardless of the extent to which they then go on to discipline and punish inmates in specific ways. By imprisoning people very far from the reach of their loved ones, they can both amplify a sense of isolation (and facilitate various forms of real and symbolic violence) and make the absence of the incarcerated more palpable for those people who lost them to the state.

[2] It is also where there would-be neighbors less likely to have the resources or wherewithal to prevent these, typically unpopular, developments from being built.

These are the generic, landfill-like qualities of all prisons. Landfills need waste, to fill air space, in order to make a profit. Prisons need "disposable people" in a similar way (Bales 2012). Both rely on social orders that encourage the devaluation of things and people, respectively, in order to justify the need for a location, elsewhere, where they can be gathered and kept separate. This common reliance upon relations of separation and absence are only more exaggerated in military-style detention centers like that of Guantánamo Bay. Scholars and activists have highlighted the relationship between Guantánamo Bay and the problem of absence in the legal loopholes that enable the US to incarcerate and torture "forever prisoners" on territory leased from Cuba (Ibrahim and Howarth 2019).[3] If an inmate's family and friends are from, for instance, New York City, that can feel very distant from Clinton Correctional, a large prison facility in Upstate New York several hours away by car. But that is nothing compared to the sheer geographic distance experienced by Guantánamo's War on Terror inmates, whose forty-eight nationalities do not include any Caribbean countries.[4] Obviously no one could visit them if they had been permanently kept instead as military prisoners in Durban or Dar es Salaam. At the same time, Guantánamo inmates cannot help but be aware in some sense of the vast geographic distance that alienates them from places and parts of the world more familiar to them—if not because of the very different natural surroundings they have (often quite limited) access to, then the distance they originally traveled to get there, in some cases thousands upon thousands of miles from places and people they know. This possibly accounts for at least some of the ways that Guantánamo prisoners have represented their incarceration, as if they were marooned on an island or lost at sea.

That real physical distance is compounded by the restrictions that come with being a military detention center, robbing inmates from many other sources of contact that they might otherwise use to feel close to the people and places they grew up around and now have been subtracted from. This includes legal policies surrounding the use of the facility, which successive US administrations have illegally used as a "black hole" to prevent

[3] The term "forever prisoner" comes from the documentary of the same name which aired on HBO in 2021 and focused on middle-aged, Palestinian prisoner Abu Zubaydah, whom the CIA admitted to torturing (Smith 2016).

[4] For insight into the rights violations accompanying the use of the base as refugee detention center for the region, see Paik (2016).

prisoners from exercising basic human rights, including a refusal to trans-
fer inmates to stand trial or in case of medical emergency. The earliest
incarnation, Camp X-Ray, was by all accounts the most restrictive, limiting
prayer and exercise and including routine torture and humiliation.
According to Asif Iqbal, a British man imprisoned for two years, guards
had been told to be afraid of the inmates, that "we would kill them with
our toothbrushes at the first opportunity, that we were all members of
Al-Qaeda and that we had killed women and children indiscriminately"
(Human Rights Watch 2004). After 2004, newer camps reportedly
allowed more freedoms of movement and religious observance, including,
as we will see, the ability to use art supplies, but they remained similarly
wedded to the notion of near-total separation from either social connec-
tion or political representation in the wider world.

The politics of absence in situations of what might be termed extreme
detention also mediate or transform the kinds of political resistance that
may be open to inmates. Such resistance comes in many forms (arguably
matching and exceeding any forms of discipline and punishment, at least
in creativity), but the one I consider in detail is the hunger strike. I will
compare this well-known form of prison resistance with what, on the face
of it, seems quite different: prison art. With both I attend to what Moath
al-Alwi, artist and long-term Guantánamo prisoner, said, did, and made
while unlawfully incarcerated there. Both his hunger striking and prison
art, I argue, draw upon and challenge processes of visibility and invisibility,
presence, and erasure in distinct but powerful ways.

And as these processes are part and parcel of the human rights violations
at Guantánamo, the concrete specificity, or what Hannah Arendt would
term the "worldliness," of those challenges, is worth attending to. Virtual
transcendence from one's material circumstances is something Arendt asso-
ciates with all art, and arguably political art especially, insofar as it lasts
"through the ages" in a way few material products succeed in doing:

> Nowhere else does the sheer durability of the world of things appear in such
> purity and clarity, nowhere else therefore does this thing-world reveal itself
> so spectacularly as the non-mortal home for mortal beings. It is as though
> worldly stability had become transparent in the permanence of art, so that a
> premonition of immortality, not the immortality of the soul or of life but of
> something immortal achieved by mortal hands, has become tangibly pres-
> ent, to shine and to be seen, to sound and to be heard, to speak and to be
> read. (Arendt 1958, 167–68)

Arendt's views on art thus might appear to see it as something of a romantic cure for human finitude, the inevitable constraints and limitations we face in this world (including oppression and eventually death).[5] At the same time, Kimberly Maslin makes clear that Arendt's views on art are part of what distinguish her more experiential ontology from the ontological project of Heidegger; whereas the latter is interested in the authenticity of an artwork, Arendt "values the potential for art to facilitate a rupture" (Maslin 2020, 29). Arendt is especially interested, for this reason, in the art of people who are marginalized or oppressed, whose voices and visions present a challenge to others in ways that both affirm and transform experience (Maslin 2020, 28).

If opportunities for creative transcendence are, paradoxically, only ever immanent to specific social situations, it is also clear that, for Arendt, artworks can be more or less *in and of the worlds they come from*. I describe such transcendence as "virtual," insofar as it can never actually manifest (setting religious beliefs aside) due to this-worldly immanence of human life. This paradox is something, I argue, that hunger striking and prison art both bring to light.

WASTING AWAY AS RESOURCE: THE HUNGER STRIKE

The hunger strike is a bodily form of resistance that involves, at its most basic, refusing food. A person needs to eat to live, and the hunger strike means publicly resisting that need in a performance, a display meant for others to witness. In the context of many carceral sites, eating may not only be an individual need but also an institutional demand, which in turn designates the target audience for the performance: those in power who want prisoners fed.

Theoretically speaking, if prisons separate prisoners from others and the outside world, they are meant to do that in perpetuity, that is, to continually or repeatedly separate. Thought of this way, separation presumes that prisoners should be kept alive, at least at minimum, not out of a commitment to human flourishing, but rather as a relegation to what following Hannah Arendt has called "bare life," a reduction of the human being from a creative, social, and free being to one that is merely alive (see Agamben 1995). While incarcerated, prisoners are meant to be alive and

[5] Thank you to the editors, Elizabeth Swanson and Alexandra Moore, for helping me clarify this.

separate or, put differently, it is only by being alive that their separation has any meaning either as punishment or as protection against recidivist crime. In moments of hunger striking, the inevitable violence of imprisonment comes to the fore. A long hunger striking prisoner cannot be allowed to waste away, since that would inevitably mean recognizing their political agency in excess of their bare life. This is why it tends to lead to a response that can only make the violence of the incarcerating state/empire more apparent, which is force-feeding.

Put differently, while most prisons deign to make people disappear, at least in the broader societal sense, they are meant to at least keep them alive, if only barely (see Ibrahim and Howarth 2019). This demand takes on new importance when a prison is not only incarcerating citizens, but people from other countries. Former Secretary of Defense Donald Rumsfeld made this clear, in a speech made in 2002, in his response to early criticism of the use of Guantánamo Bay Detention Center in the War on Terror:

> Whatever the detainees' legal status may ultimately be determined to be, the important fact from the standpoint of the Department of Defense is that the detainees are being treated humanely. They have been, they are being treated humanely today, and they will be in the future. I'm advised that, under the Geneva Convention, an unlawful combatant is entitled to humane treatment. Therefore, whatever one may conclude as to how the Geneva Convention may or may not apply, the United States is treating them—all detainees—consistently with the principles of the Geneva Convention. They are being treated humanely. (Rumsfeld 2002)

Importantly, Rumsfeld makes clear that there is ambiguity here, which the Bush administration and the three that have followed are all too happy to exploit; international law may or may not apply, he hints. Having said that, he also adds that the prisoners are being treated "humanely" without defining specifically what this means or who is to judge whether it is true.

Humane treatment, according to the Third Geneva Convention, includes a need for medical action to be taken if an incarcerated person is sick or wounded. That is why force-feeding hunger striking prisoners is better seen not as preventing them from dying, but rather as making them live, which would include insuring that they eat and do not starve. In the context of the United States, the rights of prisoners are partly shaped by interpretations of the Eighth Amendment and the right to avoid "cruel

and unusual punishment." For instance, the 1990 Supreme Court case *Cruzan v. Dir., Missouri Dep't of Health* gave competent adults the right to refuse food and, by extension, force-feeding. Yet, in another case the same year, *Washington v. Harper*, they decided a prisoner was not entitled to refuse medical treatment "if doing so is in his medical interest" (Dorf 2013). In practice, moreover, judges do not decide what happens in prisons; rather, prison administrators do. Outside of the context of the United States judiciary, there is a strong international consensus that force-feeding is a violation of human rights and that hunger striking should be considered a form of freedom of expression (see Reyes 2007).

At the same time, regardless of a given prison's approach to force-feeding, the demand to keep prisoners barely or "humanely" alive is enshrined in various ways in both international and American constitutional law; hence, in many contexts hunger striking becomes a useful tool of resistance, since it demands a response from the administration, one way or another. Price (2015, 154) describes two recent hunger strikes in American prisons in the last decade, both of which shared the goal of eliminating harmful practices. One of these practices that American prisoners sought to resist was the tendency to arbitrarily assign inmates to solitary confinement as a method of getting them to inform on one another. In other words, these prison staff were not satisfied with merely sentencing inmates to natal social death, through separation from their home communities and familiar worlds—they went further, and tried to create what could be called a *second social death* by fragmenting and attacking those social ties that develop within the prison itself. This was done through literal isolation. Using "solitary" in this way was meant to entice prisoners to inform on friends and allies. In opposition to this compounded social death, inmates engaged in hunger strikes, with varying success.

If this shows a literal resistance to social death expressed paradoxically by invoking the specter of physical death, more conceptually a hunger strike involves prisoners taking on erasure as the primary strategy of incarceration. Put differently, in the hunger strike, the erasure of oneself through intensive and seemingly permanent incarceration is dramatized through protest. Even as the body of the hunger striker literally shrinks in size through their actions, their social presence becomes even more outsized. It is as if death is made their own, transformed into a more challenging form of self-erasure. What, it forces prison authorities and broader publics to ask, would make someone choose something so extreme, so very painful and harmful, to protest their imprisonment?

As anthropologist Allen Feldman puts it, with reference to inmates incarcerated as part of "the Troubles" in Northern Ireland: "Starvation of the flesh in the hunger strike was the inverting and bitter interiorization of the power of the state. Hunger striking to the death used the body of the prisoner to recodify and to transfer state power" (1991, 237). Feldman here refers to the power of the British state, which imprisoned people they labeled as "terrorists" or "criminals," but who often saw themselves and were seen by supporters as political prisoners or even prisoners of war (Caesar 2017). There are close parallels but also stark differences between contexts like Northern Ireland and Guantánamo Bay. People like Moath were quickly known not to have committed any act of violence, while some of those arrested during the Troubles had committed violence but for politically specific reasons.

There are also ways in which very different humanitarian assumptions about letting people die or forcing them to live came into what these different states did during hunger strikes.[6] In some instances, hunger striking inmates died, where this was not allowed to happen at Guantánamo. And yet Feldman argues that such tragedy could at the same time add new energy to the overall struggle: "The act of self-directed violence interiorized the Other, neutralized its potency, enclosed its defiling power, and stored it in the corpse of the hunger striker for use by his support community" (1991, 237). The Other, for Feldman, is his name for the state and its ability to seemingly control all things. His point is that it made it harder for the British state to claim a moral high ground when mere "criminals" were willing to die for a cause. That might be no consolation for those who were socially disconnected from people they loved and now gone in an act of protest, but it can make that loss seem like something other than State control, something politically productive for that reason, even if troubling. That is, perhaps, what the American state may fear happening in a very different location, with very different prisoners, when they do not allow hunger striking prisoners to die.

Modern, liberal prisons are generally meant to suspend social or public existence, not threaten outright destruction. Through the hunger strike, inmates arguably confront the social death of separation and threaten to turn it into a real death, one that they and only they can control. They do so using one of the only powers they have: their ability to refuse food. Prisons can and often do respond by force-feeding prisoners, in an effort

[6]Thank you to Elizabeth Swanson for helping me to make this point.

to take away their power of refusal, as they have so many other forms of political and expressive agency. In doing so, they harness the power to make people live, forcibly, if necessary, in the name of humane treatment. In the words of Guantánamo's head of public affairs, Captain Robert Durand, in response to criticism of force-feeding:

> Obviously if the men were not eating for six months none of them would be alive. We preserve human life on solid legal and ethical grounds. ... Most of them are compliant ... it's a process designed to be pain free. (AFP Guantanamo 2013)

As a result, a force-fed prisoner is not only kept alive, fulfilling the prison's bare minimum mandate, but made invisible again by being denied political agency, that is, being refused the ability to express a valued goal (Dougherty et al. 2013). That goal can take many forms, but at Guantánamo it included reclaiming media narratives about their supposedly "humane" and fair treatment. With hunger striking, prisoners use what incredibly limited power they have to protest specific actions by prison authorities and compel them to change, as well as to attract audiences and allies beyond the prison who might intervene on their behalf. Arguably, to reduce the hunger striker from a protester actively wasting away to a patient in need of a medical or humanitarian intervention, under the control of doctors and aides, is to attempt to depoliticize their act of resistance by reinscribing it within neutral-seeming biomedical categories surrounding the power to keep one alive; to make one live.

Hunger strikes and force-feeding represent a struggle over prisoners' bodies, which as a result become concentrated zones of political expression and resistance, as well as domination and silencing. It is therefore not surprising that hunger striking became central in early efforts to resist the massive force of state power by prisoners at Guantánamo Bay. In a state of amplified or extreme carceral absenting, inmates had been stripped of nearly all other forms of resistance and political recognition. As Reecia Orzeck writes:

> Like other prisoners before them, the War on Terror detainees at Guantánamo Bay have used hunger strikes as a way of challenging the material and legal conditions of their detention. While the strikes have often been triggered by particular events—a camp guard removing a makeshift turban from a praying detainee, the beating of a young detainee, the transfer of

detainees to Camp 6, a maximum security complex—they have lasted because of the more general demands that animate them: better medical care, greater respect for the Koran, an end to the hierarchy of detainee privileges, an end to the indefinite nature of the detainees' detention, and the application of the Geneva Conventions to the camp. (Orzeck 2016, 31)

For Orzeck, and many other scholars, activists, and critics, Guantánamo prisoners differ from others in that they are represented as a "geo-political resource" by the US Department of Defense and intelligence agencies.[7] In such a context, hunger strikes allow inmates to turn their bodies into a different political resource, one that challenges the efforts to extract security value (Orzeck 2016, 45). At Guantánamo, hunger striking amounted to a radical form of political speech in a situation of seemingly total domination (Vicaro 2015). While bodies do not speak for themselves, they can become a powerful symbol (recodified as a "free-floating signifier," in Feldman's terms above). In that sense, they can be used by others (lawyers, activists, politicians, artists, etc.) as a way to challenge more literal, but dubious speech acts that come from the powerful, that is, those who work for the state and routinely claim, as we have seen, that what they are doing is humane or claim that the people they are doing it to are inhuman.

Moath al-Alwi was among the first to be unjustly detained in the early years of the War on Terror and one of those actively involved in hunger strikes. In an opinion piece published on aljazeera.com in June of 2015, he explains this in his own words:

I protest th[e] injustice [of detention] by hunger striking, refusing food and sometimes water. One of Guantanamo's long-term hunger strikers, I am a frail man now, weighing only 96 pounds (44kg) at 5'5″ (1.68m). Recently, my latest strike surpassed its second year. My health is deteriorating rapidly, but my intention to continue my strike is steadfast. I do not want to kill myself. My religion prohibits suicide. But despite daily bouts of violent vomiting and sharp pain, I will not eat or drink to peacefully protest against the injustice of this place. My protest is the one form of control I have of my own life and I vow to continue it until I am free. (al-Alwi 2015)

[7] Though Price 2015 shows how even in ordinary domestic prisons, there are similar efforts to transform inmates into security assets who can inform policing strategies, as mentioned above.

Hunger striking belies the bare minimum care that prisoners at Guantánamo Bay otherwise receive. This bare minimum care keeps them alive as merely living animals and nothing else. This is what Agamben calls, following Arendt, "bare life," where all legal rights are suspended and a person is not recognized as capable of creative or productive action, whether in the form of artistic self-expression or political self-representation. Similarly, Moath writes that being a prisoner there meant being "trapped, rotting in this endless horror." Vomiting, pain, and "wasting away" are in a sense embraced in order to resist that "rotting" and to expose it. Such rotting, caused by extreme political repression, differs from that of the emaciated body, and is difficult to visualize because of the subtle, even invisible way that it eats away at one's humanity, even if one is kept otherwise healthy, well fed, and nourished. A hunger strike takes this invisible rotting, the rotting of social death, and makes it radically, horribly visible, in the form of a dying but not yet dead body.

Visibility is key here. Agamben followed Arendt in identifying what he called "bare life" with the concentration camp primarily as having no law, that is, it is a place where "anything is possible" because all sovereign laws are suspended (Weber 2012, 9). While scholars have used bare life in just this way to discuss the inhumane treatment and torture of prisoners at Guantánamo Bay, one clear difference of many between other "camps" and this one is that human rights activists, lawyers, and politicians have been directly challenging such suspensions, in courts and in public spaces, from the beginning. It is not guaranteed, in other words, that no law holds. Such challenges of invisibility and erasure take work at the same time. Only some things can be made visible, and one of the best sources has been interviews done with former prisoners after their hard-won release.

In such a context, where erasure is continually reasserted and contested, hunger striking offers a direct challenge that immediately calls to mind images of emaciated bodies, indeed not unlike those subjects of bare life in the concentration camps that Arendt and Agamben used for their arguments about total power today. In this sense, social death becomes a living death chosen by the hunger striker themselves, strategically embraced to make the more abstract social death visible, to enflesh it in and through the afflicted, wasting body.

In what follows I would like to use Moath's act of resistance as a hunger striker in part to rethink his sculpture. Specifically, I want to partly reframe his sculpture as an alternative way of challenging carceral presence and

absence, imprisoned life and social death. This is especially so, I want to argue, when prison art draws upon waste. As political acts, hunger striking in prison and prison art share more in common than it might at first seem. If the former calls attention to inhumane imprisonment and bodily refusal by allowing oneself to waste away, creating art from rubbish serves to make visible in a radical way creative practice, allowing a way with waste. Moreover, the paradox of in/visibility at play in incarceration can be productively incorporated in prison art itself, especially through its humble yet unusual ingredients.

This is easier to see, I argue, by borrowing from Hannah Arendt's (1958) study of the human condition.[8] While more famously drawn upon by Agamben and others to understand the expression of totalitarianism through concentration camps, Arendt's work is also useful for thinking through the arts of prison resistance because of its central concern with representations of and impediments to freedom. Specifically, Arendt's understanding of art is explicitly political in nature and yet, at the same time, offers clear ideas about the material practices behind art. Art, in her understanding, is not political or not, but always connected to some worldliness that takes into account where and how it was made, including under what circumstances but also with what means. Indeed, for Arendt the best art could be said to be the very embodiment of freedom from constraints, whether material, social, political, or otherwise. As she writes, "[the durability of artworks] is of a higher order than that which all things need in order to exist at all; it can attain permanence throughout the ages" (Arendt 1958, 167). Art, for Arendt, is about transcendent ideals but also a highly material, embodied affair. It is for this reason that her approach is more easily put into conversation with the very fleshy, corporeal politics of hunger striking.

What, then, might we make of art that not only comes from a site of such extreme unfreedom, but that also highlights such unfreedom as the condition of its production? With Arendt's help, it becomes clear how art, waste, and life are productively entangled in the interstices of empire and ordinary materials.

[8] I use Arendt to think through art from waste elsewhere in more detail (Reno 2019).

IMPRISONMENT AND ART (WITH SOME HELP
FROM HANNAH ARENDT)

In this chapter, I am more interested in the materials that are thought to make these moves possible. Different media have a large role to play in challenging or reasserting carceral processes of separation and erasure. To put this differently, the logic of absence in prison life is also about permanence and impermanence. Those things that are permanent (walls, bars, fences, cots, cells) are typically not under inmates' control. The lack of political agency of prisoners is partly reaffirmed in daily life through their lack of control over the unchanging material conditions of imprisonment.

This fits closely with Arendt's approach to human life as "world-building," and moreover, "the degree of worldliness of produced things, which all together form the human artifice, depends upon their greater or lesser permanence in the world itself" (1958, 96). Not all types of human activity in the world serve to further senses of human freedom; most obviously things like eating, cleaning, breathing, sleeping, since they are highly impermanent or fleeting. Indeed, these kinds of unglamorous actions can only gain deeper levels of significance when, for instance, in a hunger strike a prisoner refuses to carry on living as normal. Even here, though, the broader reach of hunger strikes is also limited for this reason, since they do not leave behind durable material traces of having been accomplished. Indeed, the only material trace that can result is when, tragically, hunger strikers die and, as Feldman (1991) describes, leave a symbolically powerful corpse behind: "If space, time, and the specular body as corpse and ghost appear as detached from customary constraints, it is not an exaggeration to assert that they have been converted into free-floating signifiers" (Feldman 1991, 68). I see Feldman's idea of the corpse transcending "customary constraints" as not so different from the conditions that also surround art practice from an Arendtian point of view, as I will turn to below. What is key for Feldman, though, is the notion that the body of a hunger striker is not only a body, but has a power all its own precisely because it escaped the power of the much more powerful state. That state does not only try to control people's bodies through erasure, by taking and hiding them far away, it also tries to control the meanings behind this control, the moral narrative of why it is necessary and good. This is where hunger striking and art can take on a form of protest that can be similarly challenging. While Feldman does not directly discuss prison art, there can be a shared reliance on drawing upon the material

conditions of incarceration in creative ways. For instance, both hunger striking and artistic practice may make use of abject or wasted media (a starving body, a discarded object) in ways that, more or less, explicitly contest their generic devaluation by prison authorities and the state.

That said, generally speaking, successful hunger strikes do not leave behind durable works, a material record of having been done. Very different from hunger strikes in this regard is the material productivity of artwork:

> Because of their outstanding permanence, works of art are the most intensely worldly of all tangible things; their durability is almost untouched by the corroding effect of natural processes, since they are not subject to the use of living creatures, a use which, indeed, far from actualizing their own inherent purpose—as the purpose of a chair is actualized when it is sat upon—can only destroy them. (Arendt 1958, 167)

This raises some interesting questions when it comes to prison art. It would seem, for instance, that prison art is the most capable of being tangible, permanent, enduring, if it leaves the confines of the prison entirely and can circulate "throughout the ages" (Arendt 1958, 167). This is perhaps clearest in the form of prison writing. The written word, due to its sheer iterability (Derrida 1988), may begin in scribbles on toilet paper, notebooks, or walls, but it ultimately lends itself to being translated into published works. And yet—and this is critical—if this broader circulation of prison writing happens, it does not necessarily challenge carceral absenting. By this I mean that printed books by imprisoned authors may actually give the false impression that prison conditions are rather free, or at least may not show the challenges of thinking and writing in prison that make it materially distinct from thinking and writing on the outside. In this way, the conditions of prison writing's production are erased even as the incarcerated "self" may appear to become more visible. For instance, Gramsci's "Prison Notebooks" appear as such in name only. They are not typically reproduced in a way that highlights what the act of writing under these circumstances entailed.[9] In this way, the conditions of prison writings'

[9] This might include, not only the Italian cell that Gramsci was in, but the challenges of writing he faced as a person undergoing twenty years' political imprisonment in a distant island, who had been physically disabled his whole life and was unable to walk by this time (see Forgacs 2016).

production are erased even as the incarcerated "self" may appear to become more visible.

Very different are alternative forms of prison art that involve reusing materials, which then become more permanently associated with carceral conditions as they gain the aura of art objects for public display. One well-known example, in the Southwestern US, are the pañ009, pen and pencil drawings that emerged in the 1930s, primarily by incarcerated and formerly incarcerated Chicanos. One characteristic dimension of pañ008 is their creation on impermanent, everyday fabric media that were available to inmates, like pillowcases, bed sheets, and handkerchiefs (see Ibarra 2021). One advantage to this method of production is that it makes not only the content but also the form of art speak to the realities of incarceration, conveying these conditions in another, arguably more affective register. It is not just that prison fabrics are used in the art, but that the kind of fabric used in prisons is foregrounded. One not only sees the beauty inscribed on the paño but imagines the feel of it on the skin when sneezing or laying down to rest (as if it had been your pillow, your bed sheet). This leads to yet other thoughts, the realization that no matter how this feels, whatever the sensation on the skin, that is all one has, there is no other option. The realization that the artist instead saw in this extraordinary yet everyday unfreedom (lack of choice in bedding) an opportunity for self-expression. In the process, absenting and erasure are potentially challenged in a more powerful way than occurs, for instance, with prison writing.

MOATH AL-ALWI'S *VIVA ACTIVA*

It is with this distinction in mind that I begin a consideration of Moath's sculpture. Specifically, I want to call attention to this question of materials that artists have to work with and what their use adds to the work of art. In Moath's case, these are not only found objects, but wasted ones: leftovers, scraps that were offered to him to work with, and so on. So the question is not only what prison art carries with it, as prison art; nor is the question what is embodied in prison art that appropriates and displays tools of incarceration. The question is rather how matter and meaning are combined in prison art in ways that challenge erasure and social death, just as Moath's well-known hunger strikes did and do, manifesting his sculpture as an alternative but linked approach to the prison aesthetics of visibility/invisibility. If the hunger strike calls attention to inhumane imprisonment and bodily refusal through wasting away, creating art from

rubbish serves to make visible in a radical way art as a creative practice. This I term *a way with waste* to suggest that what Moath has done is move from manipulating his bodily form through material refusal (hunger striking) to what might be considered an equally compelling material acceptance; that is, a reassessment of ordinary objects around him as having hidden value, an altered sensibility that enabled him to artfully collect and fashion these materials into imitation sails, ropes, planks, and masts.

The website Art from Guantánamo[10] is where I first encountered Moath's work as that of an artist. Specifically, the site displays three sculptures, all ships, all made with found materials recovered from the environment that served to keep him alive and imprison him indefinitely. *GIANT* (2017) is the most recent, with *The Ark* 2015 and *Gondola* (2016) completed the two years before.

Upon initial viewing, all three sculptures share a rather ordinary appearance as model ships. This is true only from a distance, though. By this I mean that they do not strike one, in color or design, for instance, as particularly expressive. The closer one gets, the clearer it becomes that they are not from some pre-fabricated kit, but assembled with care from nothing and with what was ready at hand. *Gondola* looks like a basic form of a gondola from afar. Closer up, it is slightly irregular in shape, yet beautiful in a form that challenges assumptions about what might be seaworthy. *The Ark* is the same and *GIANT* a much bigger version. If one studies more carefully, it is clear that the components are partly what lend this sublime sense of irregularity of form. One might not know of what they are made and still recognize that, on some level, these materials were not manufactured for the purpose of forming a model ship, and yet have been carved and arranged and bent by the artist in order to do so.

All of this changes when one looks closely and sees familiar objects—clothing, toiletries, cardboard, thread—creatively chosen and molded to imitate the shape of each object. This more durable object, more durable than transient food at any rate, only comes together and assumes the form it does as a result of the careful assembly of the sculptor, whose discerning eye and steady hand selects and readies materials for use, cleans and shapes them, fitting them together like finishing a puzzle. Where the materials available for art may be inadequate, new materials must be sought out, imagined in new ways. Thus, to create the appearance of "lamps" for

[10] https://www.artfromguantanamo.com/moath-alalwi

Gondola in 2016, Moath repurposed the plastic covers for razors he was given to shave.

Once again, one's assessment of the boat sculptures changes. These found materials were used, showing that a clever hand and eye were at work in their construction, belying their rather ordinary initial appearance and titles.

And all of this changes again, more radically now, when one becomes aware—as the Art from Guantánamo website places front and center—that the art was created in a state of imprisonment, the found materials recycled and transvalued to make these objects. It shifts yet again when one realizes the prison itself is an island, separating the artist from their home by an ocean. The use of found materials, as in the paños mentioned above, is different from other forms of prison art, such as writing about or from within prisons. Using such ready-at-hand materials to write, draw on, or build with does not conceal the material conditions of its production. Rather, prison art like the paños or Moath's sculptures use the materials and tools of carceral discipline as art materials in such a way that they appear, along with the finished product, as part of the final artifact. If hunger strikes take an impermanent, relatively common action—eating—and transform it into something with transcendent power (however temporary), then prison art made of prison materials do the same thing in an even more physically durable way. Moreover, all of this is done under incredibly restrictive conditions, where it can be difficult to maintain the energy to work while routinely underweight and underfed when on hunger strike, from the material and psychic conditions of indefinite detention without charge, and where prison rules do not allow one to work when and how one wishes at any rate. Indeed, consider the challenge of believing that one can *say what one wants* through art in a context where free expression is formally disallowed and occasionally met with rubber bullets. Just a few years before the sculptures were completed, prisoners had been fired upon by guards during a protest against their mistreatment and, more broadly, their unlawful and unending imprisonment (Stainburn 2013).

Yet another dimension to Moath's art practice that is worth noting, both for what it shares with hunger striking and how it radically differs, is its ability to detach from the artist and travel more broadly, entering places and encountering people he cannot. As has been widely reported, these sculptures were not given to a museum for display but offered as gifts to friends and family. For Arendt, one way that art could seemingly become eternal, transcendent, or permanent was through the communities of

critics and circuits of value that designate some pieces as "priceless," that is, as somehow both within and beyond the art economy altogether. By contrast, Moath's sculptures move in smaller networks, part of more intimate chains of assessment and possession. It was only by word of mouth that the artwork of prisoners was made public at all, though now that it has been made more broadly available those networks have grown exponentially into ever more shows and written pieces of appreciation and analysis (including this one). But that explosion of interest in Moath's work had humble beginnings. Erin L. Thompson who helped curate "Ode to the Sea: Art from Guantánamo" from 2017 to 2018, puts it:

> Last year, a lawyer, a friend of a friend, asked if I would curate an exhibition of paintings made by her client, a Guantánamo prisoner. When I said yes, word spread among the lawyers who volunteer to help prisoners, and then among the prisoners themselves. Soon, my office in Manhattan filled with the tang of acrylic from hundreds of paintings, and the floor was crowded with model ships, sails made from old T-shirts, and rigging unraveled from the lining of prayer caps. (Thompson 2017)

From lawyers to friends of friends of lawyers to collectors, the trajectory of prisoner art was unexpected, accidental.

Crucially, the release of these artworks not only extends connections through lawyers, curators, professors, gallery visitors, and buyers; on a still deeper level, following what I have argued, they also serve to reconnect the prisoner with those who have also suffered from his extra-legally mandated social death. In this sense, prison art such as this actually extends Arendt's understanding in new directions, by presenting a fundamental challenge to experience, to existing ways of thinking. It is hard to think of a more apt response to the subtractive work of extreme incarceration than giving a gift of one's prison, transvalued as a work of one's creative imagination, to those it has endeavored to separate you from. Taking all of this into account—not only the object, but its miraculous production and alternative paths of circulation—seemingly humble models become not only more affecting but the artist himself all the more incredible for having done this. Moath's plight and continued imprisonment then become that much more of an affront to everyone's freedom, insofar as people like me are moved to look at the boats, and then to look again ... and to wonder about the conditions that produced such detritus in the first place. For a Guantánamo prisoner, in particular, those conditions are not merely

about imprisonment *tout court*, but bespeak the American carceral empire and its longstanding practice of freely robbing persons of their freedom, going back to the slave ship (Hartman 2008) and continuing on with a ship-sculpting forever prisoner.

In this way, not only the practice of recycling found materials into extraordinarily ordinary art works but also the practice of gift-giving associated with it, Moath flirts with a transcendence that only freedom from Guantánamo Bay can actually give him. In the midst of the hunger strike, one holds onto the promise of eating again by choice, of being free to eat or not eat or, put differently, of being re-enchained in networks of kith and kin where familiar obligations now dictate how and with whom one eats. As a curator of prison materials and a sculptor of prison art, one is instead holding onto the promise of one day making art free from such constraints or, put differently, of choosing new constraints more freely, new media, new materials, and new subjects to depict. Until that moment, Moath challenges his erasure, his planned social death, with the freest tools at his disposal: his hands, his mouth, his imagination, and his will.

CONCLUSION

Conceptually, when a hunger strike is carried out, all food becomes like waste, inconsumable. Indeed, insofar as the hunger striker refuses the food offered to them, they make others see it as waste as well, since in many cases the prison workers might have no choice but to throw it away as food waste. In fact, wasting is redoubled, insofar as hunger striking means making food into waste, but also seeing value in the body's gradual loss of physical mass, its "wasting away" through deliberate starvation.

Similarly, prison art often makes use of waste, meaning that engaging in alternative and subversive aesthetic actions means revaluing materials in unexpected ways. Prison artists often depend on and revalue humble, forgotten, and found materials to use as materials for artistic expression. Here, once again, prisons resemble landfills where workers routinely make use and reuse of materials they find cast about. I do not want to overstate the similarities here, except insofar as in both sites, absence is not only a negative condition, or privation, but one that can be made use of in politically suggestive ways.

In terms of purely temporal sequence, Moath had been hunger striking periodically for years before the sculptures were completed. While he had been striking off and on at least since 2005, just three years after his

wrongful imprisonment—Moath weighed less than 100 pounds by 2013—his first sculptures were not completed until almost a decade later, when they were given to his lawyer. Rather than a shift in strategy, from more intimate, bodily resistance to more conceptual, artistic resistance, I think there is clear continuity between the nearly two decades of periodic hunger striking and the artwork of the last decade, beyond the fact that the same material body engaged in both projects.

There are obvious physical limits on both hunger striking and artistic production when both are conducted from within a prison. These limits trouble the apparent freedom otherwise indicated by bodily resistance and artistic creativity, respectively. In the case of the former, even if the strike is not broken through force-feeding, it is constantly threatened by the absolute limit of possible death, which for Moath is disallowed as an adherent of Islam. But this is where Arendt's model is worth complicating, though in Maslin's reading it might be merely extending what is already in Arendt's theory of art. It is actually in the interest of the imprisoned political and/or artistic subject to call attention to this limit even as their acts of resistance seek to transcend them entirely. Wasting away into less than 100 pounds is exactly such an impossible act of coming up against and nearly crossing over the limit dividing life from death.

In the context of imprisonment, it is not ordinary artistic transcendence through sculpture or political revolt through hunger striking that is the primary goal, but a more focused one of achieving recognized presence against the work of subtraction or absenting that prisons engage in above all others. Only time will tell what becomes of political art, as a record of confinement, when forever prisoners are hopefully, finally released. Will they be considered artists, or forever remembered as having been prisoners once through the enduring traces they leave behind, the food uneaten, the found materials remade?

Works Cited

AFP Guantanamo. 2013. Force-Fed Torture Or Humane Treatment at Guantanamo? *Alarabiya News.* https://english.alarabiya.net/perspective/features/2013/08/12/Force-fed-torture-or-humane-treatment-at-uantanamo-. Accessed 15 October 2022.

Agamben, Giorgio. 1995. *Homo Sacer: Sovereign Power and Bare Life.* Stanford, CA: Stanford University Press.

al-Alwi, Moath. 2015. If the War Is Over, Why Am I Still Here? *Al Jazeera* archive. https://www.aljazeera.com/opinions/2015/6/23/if-the-war-is-over-why-am-i-still-here. Accessed 31 March 2022.

Arendt, Hannah. 1958. *The Human Condition*. University of Chicago.

Bales, Kevin. 2012. *Disposable People: New Slavery in the Global Economy*. University of California Press.

Brown, Michelle. 2019. Transformative Justice and New Abolition in the United States. In *Justice Alternatives*, ed. Pat Carlen and Leandro Ayres Franca, 73–87. Routledge.

Burns, Devin, Lauren Dominguez, Rebekah Gordon, Laura McTighe, Lydia Moss, and Gabriela Rosario. 2020. The Ground on Which We Stand: Making Abolition. *Journal for the Anthropology of North America* 23 (2): 98–120.

Caesar, Samantha Anne. 2017. Captive Or Criminal? Reappraising the Legal Status of IRA Prisoners at the Height of the Troubles Under International Law. *Duke Journal of Comparative & International Law* 27: 323–348.

Derrida, Jacques. 1988. *Limited, Inc*. Northwestern University Press.

Dillon, Stephen. 2012. Possessed by Death: The Neoliberal-Carceral State, Black Feminism, and the Afterlife of Slavery. *Radical History Review* 112: 113–125.

Dorf, Michael C. 2013. Legal Limits on the Forced Feeding of Hunger-Striking Guantanamo Bay Detainees. *Verdict*. https://verdict.justia.com/2013/05/08/legal-limits-on-the-forced-feeding-of-hunger-striking-guantanamo-baydetainees. Accessed 15 October 2022.

Dougherty, Sarah M., P. Jennifer Leaning, Gregg Greenough, and Frederick M. Burkle. 2013. Hunger Strikers: Ethical and Legal Dimensions of Medical Complicity in Torture at Guantánamo Bay. *Prehospital and Disaster Medicine* 28 (6): 616–624.

Feldman, Allen. 1991. *Formations of Violence: The Narrative of the Body and Political Terror in Northern Ireland*. University of Chicago Press.

Forgacs, David. 2016. Gramsci Undisabled. *Modern Italy* 21 (4): 345–360.

Hartman, Saidiya. 2008. *Lose Your Mother: A Journey Along the Atlantic Slave Route*. Macmillan.

Human Rights Watch. 2004. *Guantanamo: Detainee Accounts*. https://www.hrw.org/legacy/backgrounder/usa/gitmo1004/index.htm. Accessed 15 October 2022.

Ibarra, Alvaro. 2021. *Sueño en paño*: Texas Chicano Prison Inmate Art in the Nora Eccles Harrison Museum of Art Collection, Utah State University, and the Leplat Torti Collection. *Latino Studies* 19: 7–26.

Ibrahim, Yasmin, and Anita Howarth. 2019. Hunger Strike and the Force-Feeding Chair: Guantanamo Bay and Corporeal Surrender. *EPD: Society and Space* 37 (2): 294–312.

Maslin, Kimberly. 2020. *The Experiential Ontology of Hannah Arendt*. Lexington Books.

Orzeck, Reecia. 2016. Hunger Strike: The Body as Resource. *Body/State* 8: 31–50.

Paik, A Naomi. 2016. *Rightlessness: Testimony and Redress in U.S. Prison Camps since World War II.* University of North Carolina Press.

Price, Joshua M. 2015. *Prison and Social Death.* Rutgers University Press.

Reno, Joshua O. 2016. *Waste Away: Working and Living with a North American Landfill.* University of California Press.

———. 2019. Underwater, Still Life: Multispecies Engagements with the Art Abject of a Wasted American Warship. In *Repair, Brokenness, Breakthrough: Ethnographic Responses*, ed. Francisco Martínez and Patrick Laviolette, 24–40. Berghahn Press.

Reyes, Hernan. 2007. Force-Feeding and Coercion: No Physician Complicity. *Virtual Mentor: AMA Journal of Ethics* 9 (10): 703–708.

Rumsfeld, Donald. 2002. Transcript: Rumsfeld Calls Detainees Treatment 'humane.' *Washington Post* archive. https://www.washingtonpost.com/wp-srv/onpolitics/transcripts/rumsfeld_text012202.html. Accessed 15 October 2022.

Schept, Judah. 2022. *Coal, Cages, Crisis: The Rise of the Prison Economy in Central Appalachia.* NYU Press.

Smith, David. 2016. Abu Zubaydah, Detainee Tortured by CIA, Makes Case for Guantánamo Release. *The Guardian* archives. https://www.theguardian.com/us-news/2016/aug/23/abu-zubaydah-guantanamo-bay-cia-torture. Accessed 31 March 2022.

Stainburn, Samantha. 2013. Guantanamo Bay Prisoners Fight Back Against Guards in Clash. *GlobalPost.* https://theworld.org/stories/2013-04-14/guantanamo-bay-prisoners-fight-back-against-guards-clash. Accessed 15 October 2022.

Thompson, Erin. 2017. Art from Guantánamo. *The Paris Review.* https://www.theparisreview.org/blog/2017/10/02/art-from-guantanamo/. Accessed 15 October 2022.

Vicaro, Michael P. 2015. Hunger for Voice. *The Guardian* archives. https://www.theguardian.com/us-news/2016/aug/23/abu-zubaydah-Guantánamo-bay-cia-torture. Accessed 24 March 2022.

Weber, Samuel. 2012. Bare Life and Life in General. *Grey Room* 46: 7–24.

Ships of Scraps: Moath's Model Ships in Islamic Art and Prison Histories

Mira Rai Waits

Moath Hamza Ahmed al-Alwi has been detained without charge in Guantánamo Bay Detention Camp since 2002. Established first as a temporary structure on the southeastern shore of Cuba after the attacks of September 11, 2001, twenty-first-century Guantánamo, at the height of its use as a space of detention for roughly 779 prisoners, comprised seven purpose-built detention camps (The Guantánamo Docket 2023). This multistructure camp epitomizes the US Government's architectural expression of its "War on Terror." The land that Guantánamo occupies has been leased domain since the early twentieth century, when the Cuban Senate ratified the Platt Amendment, which allowed the US to establish a naval base in the bay in 1903 (Walicek and Adams 2019). Under US governance this land has been shaped into a space for containing "undesirable" individuals; in the 1990s Haitian refugees and people living with AIDS were warehoused in detention facilities in Guantánamo Bay, and

M. R. Waits (✉)
Appalachian State University, Boone, NC, USA
e-mail: waitsmr@appstate.edu

© The Author(s), under exclusive license to Springer Nature Switzerland AG 2024
A. S. Moore, E. Swanson (eds.), *The Guantánamo Artwork and Testimony of Moath al-Alwi*, Palgrave Studies in Literature, Culture and Human Rights,
https://doi.org/10.1007/978-3-031-37656-6_6

today there remains a site for the detention of Haitian and other migrants. In 2002, this land adjacent to the Windward Passage—the space between Cuba and the island of Hispaniola through which enslaved people and migrants were transported in the years before—was rhetorically christened "the least worst place" to hold "enemy combatants" by the then-Secretary of Defense for the US Government, Donald Rumsfeld, who subtly implied through this double negative that Guantánamo would in fact be an ideal site to incarcerate perceived terrorist/prisoner bodies (Rosenberg 2021b).

Moath was one of the first prisoners to be brought in January 2002 to the temporary structure dubbed "Camp X-Ray," which consisted of concrete and chain-link fence enclosures and 8-foot square open-air cages. It was abandoned in April 2002, and prisoners were resettled in the camp's first purpose-built structure, Camp Delta. Subsequent purpose-built camps were constructed in the years that followed, with various punitive spatial features built in.[1] Most Guantánamo camps were conceptualized as high-security facilities, designed to support the use of solitary confinement as punishment for the many men and boys detained without charge. Camps 5 and 6, the two camps that the US government says are currently in use at Guantánamo, were both built or retrofitted with solitary cells (Moath has spent time in the solitary cells of both camps). The camp's cellular spaces are concrete enclosures with limited furnishings—toilet-sinks and shelf beds; prisoners have spent as long as 22 hours of a single day in these always-lit windowless or opaque-windowed cells (Human Rights Watch 2008, 9–13).

In the 20 years Moath has spent at Guantánamo, he has been in and out of solitary confinement. The design of the solitary cells was intended to impede the formation of community, preventing prisoners from communicating with each other unless they yelled through the cracks of the iron doors. Solitary confinement, as it is framed in Lisa Guenther's work, can be understood as a "living death," predicated on both "civil death," the "[deprivation] of the legal status of a person with civil rights," and "social death," the exclusion of people or a group of people from society so that their lives "no longer bear a social meaning" (2013, xii, xviii–xxiv). In

[1] Camp 4, for example, was designed with more communal prisoner space, while the US government has endeavored to keep the built space of Camp 7 a mystery to the public. Although as recently as 2018, the Pentagon requested funding to retrofit Camp 7, which was been described as "broken down" and "[inefficient]," it was closed in 2021 (Rosenberg 2018, 2021a).

addition to this punishment of living death, Moath has described his experience at Guantánamo as one of "endless horror"—he has endured unimaginable cruelties that include torture, which has taken the form of force-feeding in response to his hunger strikes, and physical assault, which in one instance consisted of being fired at with guns that shot rubber bullets (Moath 2015). Nevertheless, it is in this "least worst" prison, equipped with solitary cells designed to dehumanize individuals through social and civil death, where Moath has turned to making art. At the edge of a body of water that Guantánamo officials have actively labored to prevent prisoners from seeing, Moath builds model ships out of found and salvaged materials.[2] While making these ships of scraps, he forgets that he is incarcerated within a prison, and through art-making, he "[fills]" the "emptiness" of prison time (Moath [in Thompson 2017], 33).

Moath's model ships belong to a category of art known as "prison art," which Phyllis Kornfeld defined in *Cellblock Visions: Prison Art in America* as "the nonprofessional art of criminals and convicts" (1997, xvii), although it is crucial to note that Moath has never been charged with a crime, much less convicted. Kornfeld's work offers an important intervention in recognizing the unique experiential conditions that influence an imprisoned person and inform their art-making, while at the same time noting that prison art represents an artistic subculture wherein access to materials, spaces of art distribution and consumption, and art audiences are limited (xx–xxi). Moath did not train as an artist before being sent to Guantánamo; rather, along with other prisoners, he had access to art classes beginning in 2009, and arrived at art-making as an everyday practice to endure the living death perpetuated by his indefinite detention without charge. While Moath has often been confined in solitary cells with no social contact, in or out of solitary he labors on his ships for hours on end, appropriating found materials to construct miniature maritime worlds.

Prison art-making also belongs to a history of resistance within modern carceral spaces that includes tactics such as protest, hunger striking, and prison writing. Nicole Fleetwood's groundbreaking *Marking Time: Art in the Age of Mass Incarceration* understands prison art as a resistant and

[2] Mansoor Adayfi, a contributor to this volume and a former prisoner at Guantánamo released in 2016, has written about the great lengths Guantánamo officials took in preventing prisoners from viewing the Caribbean Sea. Even though Guantánamo 's camps were in close proximity to water, officials used tarps to obstruct prisoners' sight lines to the sea (Adayfi 2017).

"relational practice" that allows the incarcerated to forge community within and outside of prison, engage with family and friends, and contest both the dehumanizing experience of incarceration by "[cultivating] subject positions that cannot be eviscerated or fully managed by the carceral state" (2020, 255). Prior to 2017 (when the Trump Administration banned the removal of prison art from Guantánamo), Moath's ships made their way into the world beyond the prison as gifts, first seen by lawyers, friends, and family, and then as objects of display in the exhibit "Ode to the Sea: Art from Guantánamo" (2017–2018) in the President's Gallery at John Jay College of Criminal Justice in New York (Gunter 2022). The importance of viewing these works in a New York gallery, as Rosalyn Deutsche argued, was particularly poignant as it reminded viewers that citizens in the United States "[benefitted] from the violent injustices" of the "war on terror," while prisoners such as Moath survived abject conditions to assert their humanity through art (2020). The ban on art removal at Guantánamo was a harsh blow for the prisoners who remain; the unique intervention of prison art—artistic expressions that challenge the prescribed dehumanizing experience of the carceral state—is weakened without a larger community to view and receive prisoners' works, which is why the January 2023 reversal of the ban is welcome news.

Building from the recognition that Moath's model ships are part of an artistic subculture that resists the horrors of Guantánamo, this chapter expands critical approaches to Moath's work with two additional lenses: considering his ships as part of an Islamic visual tradition, and as part of broader histories of model ship making by prisoners. Moath, a Yemeni national who grew up in Saudi Arabia, is a devout Muslim. Works like *GIANT* (2017), Moath's large (26 × 26 × 7 in) model ship of a galleon—the ship that emblematizes maritime exploits during the Age of Exploration, benefit from an examination that considers the work within a longer history of Islamic visual production. This history recognizes how Islamic art objects share a common functionality that connects them to aspects of life such as faith. Additionally, this chapter explores how the model ship and the modern prison have been intertwined since the late eighteenth century, when French prisoners of war (POWs) began to manufacture ships from memory in English prisons, passing their time in detention by making objects that had a market value (Coughlin 2018, 62). In examining what Moath's ships have in common with prisoner-made ships throughout the prison's modern history, as well as how Moath diverges in his art

from this extant tradition, this chapter explicates the significance of Moath's model ship as a challenge to the spatial logic of the prison's built form.

MOATH AND ISLAMIC VISUAL TRADITIONS

In the Islamic collection of the Metropolitan Museum of Art in New York there is an eighteenth-century Turkish image of a galleon composed of calligraphy, known as a calligram (Fig. 6.1). At the time of this calligram's making, the Ottoman Empire's Navy was sailing newly-commissioned

Fig. 6.1 'Abd al-Qadir Hisari, "Calligraphic Galleon," A.H. 1180/1766–67 CE. Ink and gold on paper, H. 19 in. (48.3 cm) W. 17 in. (43.2 cm). © The Metropolitan Museum of Art. (Image source: Art Resource, NY)

galleons (Teece and Zonis 296). In the background two smaller galleons drawn in ink flank the central ship on both sides, suggesting a fleet. Unlike Moath's galleon *GIANT* that delights the contemporary viewer as an anachronistic maritime object, the Turkish image, drawn by the calligrapher 'Abd al-Qadir Hisari, must have seemed to be a beautifully modern image of a ship in the eighteenth century. Nevertheless, despite this temporal divide, it is worth considering Moath's model ships alongside works such as the Turkish calligram in order to expand our engagement of Moath's work by approaching it as part of a longer history of Islamic art-making.

As a specialty within the larger discipline of art history, scholars in the field of "Islamic art" have grappled with the very expression "Islamic art" (Grabar 2006, 335–337). Originally an Orientalist construction, the expression seems to suggest that religion is the only lens for characterizing the art and modes of art-making in spaces and times that have a connection to Islam and Muslim peoples. The expression "Islamic Art" has been applied to religious art, but also art made for Muslim patrons, by Muslim artists, and in Muslim-controlled spaces. There remain compelling reasons for considering works of art under this shared history, including the idea that there is a culture of Islam "with its own unique artistic language" (The Metropolitan Museum of Art 2000). While acknowledging care and nuance in our use of the expression "Islamic art," Oleg Grabar reminds us that works of art we call Islamic share a common purpose in that they "were meant to be used and not simply looked at; they all entered into the life of the ones who came into contact with them" (Grabar 2006, 354–355). Grabar here alludes to a history of Islamic visual production wherein art has always been produced not just for the purpose of creating something visually pleasing, but to be utilized by people. In other words, unlike other artistic traditions where art-making starts first with the goal of being looked at or with aesthetic ends, the aesthetics of the Islamic art object connect to its functionality. Therefore, while the making of model ships certainly provide Moath with a means of survival and as art objects display his resistance to Guantánamo, the ships can also be read as Islamic works of art with a use value that corresponds to Moath's experience as a Muslim detained without charge who has found ways to practice his faith in horrific prison space. Consequently, his model ships connect Moath and those who view his art to the materiality of Islamic prayer, the idea of pilgrimage, and a broader history of Islamic imagery.

In returning to the comparison of Moath's model ship to the Turkish calligram, both works take the sea and its navigation by ships as the focus. Numerous references to ships sailing the seas appear in the Qur'an (the literal Word of God for Muslims). The ship and its passage through water are taken as a sign of Allah in this holy text. The Qur'an notes, for example, that "It is God who created the heavens and the earth, and sent down out of heaven water wherewith He brought forth fruits to be your sustenance. And He subjected to you the ships to run upon the sea at His commandment; and He subjected to you the rivers," and "And of His signs are the ships that run on the sea like landmarks" (Qur'an, trans. by Arthur Arberry 1955, 14:32 & 42:32). Since the emergence of Islam in the seventh century, Muslim sailors have forged maritime trade routes through the Red Sea, Indian Ocean, and Mediterranean Sea, to name a few. Recent projects have taken the sea as lens of engagement for understanding Islamic art history, not only because of descriptions within the Qur'an, but also because a study of the seas helps to explicate the movement of religious ideas and visual traditions across the Islamic world (Dalal et al. 2019). The ship is the vessel of this movement, and, as an object that reflects the power of Allah, it offers itself for contemplation. Both the calligram and Moath's model ship afford the viewer the opportunity to use the ship as an object of religious reflection through the contemplation of beautiful writing and the materiality of prayer, respectively, gesturing to a visual tradition wherein the ship is configured as a divine object.

The calligram reveals the importance of the ship's use value as a form of visual contemplation. Calligraphy has been a venerated artistic medium within Islamic visual culture for the past 1400 years (Blair 2006, 3). Beautiful writing, particularly the writing of religious texts, is viewed as mode of spiritual expression. Upon careful reflection of the Turkish ship, one observes that the hull and the deck are formed through golden inscription, while script in black ink produces a border for enclosing the ship. A mix of Ottoman Turkish and Arabic, the text includes blessings to the Prophet Muhammed, a discussion of navigation and the sea, the *tughra* (seal) of the Ottoman sultan, and the names of the Seven Sleepers and their dog (the names of the sleepers comprise the inscription of the central gilded image) (Denise-Marie Teece and Karin Zonis [in Ekhtiar et al. 2011], 296). The story of the Seven Sleepers, significant in both Christian and Islamic traditions, recounts how persecuted Christians took refuge in a cave in what would be modern-day Turkey around AD 250, awaking hundreds of years later unharmed, having received divine protection.

Reference to the story can be found within the Qur'an, and since the seventeenth century, the act of writing the names of the Seven Sleepers on vessels like ships was viewed as a protective act within Ottoman society (296). The calligram reflects the calligrapher's religious feeling and a beautiful text is produced, but an image of a ship is also generated through words that house the calligrapher's spiritual expression. The ship, which invokes Allah's power in the Qur'an, here too reflects divine protection as a calligraphic image and in the recollection of the story of Seven Sleepers.

Moath's ships also materialize religious practice, albeit through the appropriation of religious objects—prayer beads and prayer caps—as opposed to the act of beautiful writing. Practicing Muslims must pray in the direction of Mecca five times a day. The US government has claimed that it supports the practice of Islam at Guantánamo by supplying prisoners with religious objects such as the Qur'an along with prayer caps, beads, oils, and mats, ensuring that solitary cells have arrows that signal direction of Mecca, and broadcasting the call to prayer over camp loudspeakers (Gahagan 2003). However, the right to pray has not been guaranteed at Guantánamo. The Qur'an was routinely desecrated in cell searches and the call to prayer mocked by Guantánamo officers (Taub 2019). James Yee, a Muslim who formerly served in the US Army as chaplain and attended Guantánamo prisoners, observed in his memoir that "Islam was systematically used as a weapon against the prisoners" (Yee 2005, 217). Furthermore, communal prayers—an important religious practice during the holy month of Ramadan—were historically prevented by the US Government in the prison (Victor 214). And yet despite the weaponization of faith, prisoners found ways to form an Islamic community through their religious practices.[3]

Given the challenges Muslim prisoners have faced in the practicing of their faith, Moath's utilization of prayer beads and caps—some of the only material connections that one can have with prayer in Guantanámo— aligns his model ships with religious practice. *Subha* (Islamic prayer beads) consists of 33 beads that facilitate recitation during prayer, and a *kufi* (prayer cap) is worn to cover the head as a sign of respect during prayer. Moath unravels the beads and the threads comprising the caps, putting them to use when constructing the rigging on model ships like *GIANT*. This appropriation of the material objects of prayer and subsequent

[3] Adayfi recalls that the relaxing of the punishment of solitary confinement in 2010 enabled the prisoners "to pray collectively in rows like we would in mosques" (Adayfi 2022).

repurposing in the making of a model ship is a gesture that guides our viewing. Part of what makes Moath's ships so fascinating is the detail that one sees when one looks closely—this looking is a visual discovery to see how disparate objects are joined together to create the unexpected. Like the calligram, where the text reveals itself upon careful reflection, when the viewer moves around the model ship, the nuances of the objects and their former uses are revealed. In this way, Moath's mining of prayer materials is similar to how the Turkish calligram relies on words to come into existence. Both ships, signs of Allah when considered in relation to the Qur'an, are constructed from spiritual practices (writing/prayer) that connect the artists to Islam.

A work like *GIANT* is, therefore, both an Islamic and carceral spatial-temporal product. The carceral will be discussed in greater detail in the following section, but in looking at the label Moath provides for the work, he reminds us of this doubling. The ship model's nameplate, written in both Arabic and English, is complemented by the signature nameplate that offers Moath's name, Guantánamo, and two calendar dates, the Georgian "30/7/2016" and Islamic "25/10/1437." This labeling not only situates *GIANT* within a curatorial tradition that recognizes both calendars in the dating of Islamic art objects but also suggests that *GIANT*—a model ship made in a prison space—belongs to two different times, a time of living death and a time of faith. It is the ship, the divine man-made artifact, which has been granted the power of mobility, that can be used to move between these times.

When curating the exhibition "The Sea is the Limit," which explored the contemporary experience of migration through art, the artist Varvara Shavrova described the "mythological connotation of boats as symbols of transition from the material into the spiritual realm, and as carriers of our dreams, as well as vessels for adventures, escapes, and journeys" (Shavrova [in Dalal et al. 2019], 282). Moath's model ships have also been contextualized as carriers of his dreams. Erin L. Thompson, who curated "Ode to Sea," the exhibition where Moath's ships were first displayed to the public, shared an interview with Moath where he described how when making the ship, he "imagined [himself] on the ship in the middle of the ocean" (Moath [in Thompson 2017], 33). This imagined freedom in art-making signifies how art served as a form of resistance to the horrors of Guantánamo and as a means of mental escape; importantly, Moath also imagines specific destinations for his ship.

GIANT's portholes have hidden images—major Islamic monuments in the holy cities of Mecca, Medina, and Jerusalem, which are pilgrimage sites for Muslims. Indeed, the fifth pillar of Islam is the *hajj* or pilgrimage to Mecca that all adult Muslims of physical and financial ability must make in their lifetimes. Moath fixes images of the Great Mosque of Mecca that enshrines the Kaaba, the Prophet's Mosque in Medina with its iconic green dome, and the Dome of the Rock in Jerusalem—the martyrium-style building that encloses the site where Muslims believe the Prophet Muhammed ascended to heaven. It is a labor for the viewer of Moath's work to see these images of monuments, just as the act of pilgrimage itself is a labor undertaken by the devout. These monuments are largely hidden when a cursory glance of the model ship is all that is undertaken, but in the discovery of such details—Islamic pilgrimage sites and the spectacular monuments that consecrate them—Moath again provides a use value for his model ship offering it as an object of contemplation and even perhaps as a proxy for pilgrimage, which connects the ship to a long Islamic visual history.

There are other details of *GIANT* that invite an Islamic perspective. Moath's cardboard eagle's wings, perched atop the model ship as figure-heads that simulate flight, are multidimensional symbols. Of the use of eagles (another set of eagle wings appears on Moath's *Gondola* 2016), Moath has said that the eagle represents flight, which to him symbolizes freedom. He describes having seen an eagle from a tiny window in Camp 5 at Guantánamo as a guiding experience in his decision to include eagles' wings on his ships. Since the Trump administration's ban on art removal, Moath's artworks, including more than one ship, have been incarcerated with him, but he has continued to engage with the symbolism of the eagle; his largest ship to date is named *Eagle King*, and on this ship there is another cardboard eagle perched atop the bow rigging (Gunter 2022). The ship's storage case, which Moath also constructed, repeats the imagery of an eagle in flight. Moath painted gilded two-dimensional eagles on the case, and his choice of gold paint, a historically luxurious pigment, works to reinforce the importance of the eagle as a prominent symbol within his *oeuvre*.

Moath's explanations touch on a shared global vocabulary concerning the symbolism of eagles as majestic birds that reflect freedom. The eagle has been a prominent symbol since antiquity, perhaps most famously as a standard in the ancient Roman army. Meanwhile, the largely US audience that encountered Moath's work at John Jay College might have initially

made a nationalist association with the symbolism of his eagle, as bald eagles have been inextricably entangled with US identity since the late eighteenth century. However, within Islamic art history eagle imagery also features across hundreds of years and a range of media, which includes ceramics, metalwork, glasswork, textiles, and within architectural settings, to name a few. For example, the Dome of the Rock, one of Moath's monuments hidden in the porthole windows of *GIANT*, was constructed in the seventh century using spolia (repurposed building materials) that included column capitals with eagle imagery and brand new mosaics adorned with "dis-embodied wings, outspread, and decorated with jewel-like patterns" (Nees 2015, 124). At this early Islamic monument, the appearance of the eagle signifies the newly acquired power of the Umayyad Caliphate in its appropriation of extant materials and development of a new visual vocabulary. That eagles should be part of an Islamic visual tradition is not altogether surprising given how visual associations have been disseminated across time and space, but the act of recognizing the eagle as a multidimensional and multicultural symbol that holds diverse meanings is useful to our reading of Moath's eagles. For Moath the eagle symbolizes an imagined freedom that helps him survive the living death of Guantánamo. Moath's use of eagles also links his work to a historical artistic tradition that includes Islamic visual history, and these multiple points of belonging are a testament to the power of his work.

The "War on Terror" precipitated a rise in Islamophobia that was nurtured in popular Western media; images of prisoners at Guantánamo were mobilized across visual domains (official and non-official) to "establish and reinforce the notion of Western Christian superiority over a racialized Islam" (Coleman in Walicek and Adams 2019, 46). Acknowledging the Islamic connotations of Moath's work offers a means of refuting an Islamophobic visual culture. Within the solitary spaces of Guantánamo, Moath brought to life art objects connected to Islam that were meant to be contemplated, and then "[entered] into the [lives] of the ones who came into contact with them" (Grabar 2006). Our reading of his ships is enriched with the knowledge that the ships gesture to Islamic religious and visual traditions through materials and imagery, which in turn enables this prison art to uniquely contest the prison responsible for codifying a racialized understanding of Islam.

Moath and Prison Histories of Making

The t-shirt fabric comprising *GIANT*'s sails—fabric that Moath hardened into a windblown motion with glue—bears the export stamp "Approved by US forces," which marks the art object as "belonging" to the Guantánamo Bay Detention Camp. Belinda Walzer's chapter in this collection draws our attention to this stamp as a signifier of the long history of US violence against people of color. In branding the object as a part of a bureaucratic system of ownership, Moath's ship becomes conscripted within an archive of violence that extends far beyond the prison system. However, it is also worth returning to the history of making within the modern prison system when analyzing Moath's model ships, since, somewhat surprisingly, they are not the first set of ships made in prison that have come to "belong" to the carceral state and later to cultural institutions.

In the National Maritime Museum in London there is a display of model ships in the museum's "Sea Things Gallery." This is a lively section of the popular Greenwich museum; there are several interactive displays for viewers to engage. Numerous model ships are suspended in a see-through glass case, seemingly sailing through air. Within this case is a late eighteenth-century model ship of "Le Heros," identified by an inscription on the stern (Fig. 6.2).[4] The model is a richly detailed object made of wood with a complex rigging. Preserved model ships like this one provide some of the most important records of ship design available to scholars (Coughlin 2018, 62).[5] Gail Rothschild's contribution in this volume provides a succinct but rich exploration of the model ship's history; this chapter, in turn, picks up a thread introduced by Rothschild as it examines the model of "Le Heros" and the body of model ships it belongs to—the prisoner-made model ship.

The model ship "Le Heros" is one of hundreds of model ships that date from the French Revolutionary and Napoleonic Wars.[6] Crafted by French POWs held captive in British purpose-built prisons or decommissioned

[4] "Le Heros" was a large ship in the French Navy constructed in 1778 that sailed under the command of French Admiral Pierre André de Suffren de Saint Tropez. The ship was an active vessel in the French's Indian campaign, but was scuttled by the British Captain Sidney Smith in 1793.

[5] There are, however, some inaccuracies common to these model ships in terms of scale with the height of the masts and bowsprit.

[6] The British kept a quarter of a million French prisoners of war imprisoned in Britain from 1793 to 1815 (Davidson and Biddle 2022, 64).

Fig. 6.2 French prisoners of war, Le Heros, 1778. Overall model: 878 × 1144 × 355 mm; Base: 73 × 463 × 190 mm. © National Maritime Museum, Greenwich, London

and retrofitted war ships (known as prison hulks), these model ships were made from prisoners' memories of their time as sailors (Davidson and Biddle 2022, 65–55). In this way the French POW model ships—ships made from memories—align with Moath's ships that he describes as carriers of his dreams. As prison-made objects, these model ships also have much in common with Moath's ships in that the prison's materiality informs the construction of the model. Along with prayer beads, prayer caps, and t-shirt fabric, Moath repurposed scraps of cardboard, plastic from shaving razors, bottle caps, and dental floss—residue that testifies to the lives held captive in Guantánamo. The French POWs also mobilized prison scraps. Model ships were carved from animal bones, leftover from food rations, that were then boiled and bleached, and the wood was sourced from fragments laying around prisons that had been used for building repairs (Coughlin 2018, 66). Prisoners even used their own hair to weave the rigging for the models (Davidson and Biddle 2022, 66). These POW model ships were a collective enterprise made in assembly

lines and thus left unsigned (Coughlin 2018, 62). After completion, they were sold in nearby prison depots where prisoners would earn money to buy rations or additional materials for future model ship projects (Davidson and Biddle 2022, 66).

Model ships continued to be produced in other prisons around the world throughout the nineteenth and twentieth centuries. Museums and prison exhibitions retain the models, putting them on display as evidence of this making practice. In addition to its collection of French POW model ships, the National Maritime Museum also has a model ship made by German POWs during World War I at a military camp in Scotland (Fig. 6.3).[7] Across the Atlantic at Eastern State Penitentiary in Philadelphia—the gothic-styled prison that first articulated the US' commitment to solitary confinement as carceral punishment—archival records from 1835 mention a prisoner who spent his leisure time constructing a toy ship (Harmon 2021). By the twentieth century, the making of model and toy ships was an established prison industry at Eastern State, and this commitment to model ship making can be seen as part of a broader global investment in the idea of prison industries as rehabilitative, which prison officials in the nineteenth century had popularized as progressive carceral philosophy. The ships were sold or given as gifts, and examples can be seen at Eastern State, which is now a historic site and museum, as well as at the Independence Seaport Museum in Philadelphia (Harmon 2021). Another ship model was made in the twentieth century in a prison that has geographical commonalities with Guantánamo. In Argentina in 1902, a jail and military prison opened in Ushuaia, a small town in a bay on the southern coast of Isla Grande de Tierra del Fuego. The prison closed in 1947 and is now a museum, and within the museum's display is a model ship made of wood, paper, and string, and delicately decorated with wooden matches.

The global prevalence of prisoner-made model ships is clear evidence of a widespread interest in making models that miniaturize the massive forms of human ingenuity that ships have come to symbolize. However, this interest alone does not fully explain why model ships have become so entangled with modern prisons. Certainly, model ship making is a

[7] This model ship is a replica of the SMS "Scharnhorst," a German cruiser that was attacked by British soldiers and sunk in 1914 in the waters near the Falkland Islands. German prisoners from another cruiser, the SMS "Gneisenau," who had been captured in the same battle, made the model using wood from a British ship involved in the battle, the HMS 'Invincible.'

Fig. 6.3 Prisoners of war from *SMS Gneisenau*, SMS Scharnhorst, 1915. Overall model and case: 398 × 662 × 222 mm © National Maritime Museum, Greenwich, London

time-consuming activity. Moath's models have taken him months, and the prisoners who crafted model ships before him similarly harnessed the monotony of prison time with this detail-oriented and laborious act of making. There was also an economic reason for model ship making. With the sanction of the British Royal Navy who encouraged the French POWs to take "full liberty" to craft objects to sell, the French POWs drew from their maritime experiences to make model ships that had some exchange value in late eighteenth- and early nineteenth-century English markets (Davidson and Biddle 2022, 66). In this way model ship making was a literal form of survival, as prisoners confined on floating prison hulks parlayed their knowledge of ships into desirable commodities. The commodity appeal of the model ship at Eastern State in the twentieth century was so popular that guards and wardens were noted collectors of prisoners'

maritime craftsmanship (Harmon 2021). Model ship making even served as a path toward rehabilitation. In the 1920s two different Eastern State prisoners involved in prison model ship making opened woodworking businesses upon release and went on to employ the formerly incarcerated in their shops (Harmon 2021).

Proximity to water must have certainly played a role in prisoners' decisions to craft ships in their stationary enclosures even if they were not granted viewing access to the water. Many modern prisons were constructed near bodies of water as critical elements of state infrastructure. Two of the US' most famous prisons, Sing Sing Correctional Facility and the Alcatraz Federal Penitentiary, draw their punitive strength from their relationship to bodies of water—in the case of Sing Sing punishment was the experience of going "up the [Hudson] river" away from New York City, and in the case of Alcatraz the prison was hailed as escape-proof since it was surrounded by the cold waters of the San Francisco Bay. Like Guantánamo, which can trace its origin as the "least worst place" to build a prison to the US Navy and its desire for a base in the bay, modern prisons have relied on bodies of water to further the disciplinary experience of incarceration.

Given the entangled relationship between bodies of water and prisons, perhaps another point to consider in thinking through the ubiquity of prisoner-made ships concerns the spatial points of departure between a prison and ship. The modern prison, as Robin Evans taught us, is a "fabrication of virtue" realized as a purpose-built and permanent space of enclosure that aspires to serve as "a vessel of conscience and as pattern giver to society" (Evans 1982, 6). Conversely, the ship is a vessel of movement that delights in charting new and unexplored channels. For Foucault, the prison (panopticon) was not to be "understood as a dream building; [instead,] it is the diagram of a mechanism of power reduced to its ideal form." On the other hand, he saw the ship (boat) as the "greatest reserve of the imagination," and claimed that in societies bereft of these vessels, "dreams dry up, espionage takes the place of adventure, and the police take the place of pirates" (Foucault 1977, 205 and Foucault 1986, 26). Ultimately, the movement of the ship as spatial form can be interpreted as synonymous with freedom of thought, while the permanence of the stationary prison attempts to signal the foreclosure of resistant possibilities. Model ships in prison mediate this divide. When the police supplant piracy within the carceral state, the model ship in prison resuscitates imagination and celebrates adventure.

Where ought we to situate Moath's ships within this longer history of prisoner-made model ships? Through signing, Moath calls out his status as an artist in ways that diverge from the anonymous French POW model ships made in assembly lines for sale in English markets. Moath's ships were not made to be sold, but were gifts, and Moath sees these gifts as art. Indeed, as the preceding section argues, Moath's model ships should be considered within existing artistic traditions, such as Islamic art. However, other prisoner-made model ships were made by individuals, albeit anonymous, who also turned to making as a result of the unique temporal experience of carceral enclosure. The model ship from Ushuaia was made by a single prisoner, and though objects like it might have been sold in the town, the museum description marvels at how the prisoner found the patience and time to craft the model.

This history of model ship making in prison shares further similarities to Moath's work in that the models are imbued with the potential to delight viewers. Many of the toy model ships that left Eastern State Penitentiary found their way into the hands of sick children and orphans in the mid-twentieth century as joyous Christmastime gifts (Harmon 2021). Lastly, these model ships collectively disrupt the logic of the modern prison, certainly as prison art, but also in the repurposing of the prison's materiality through the appropriation of prison scraps, and as symbolic vessels that counter the prison's diagramming of power by claiming it as a space of creativity.

The Guantánamo Bay Detention Camp, with its chain-link fences and concrete solitary cells, is a space that should forever be linked to the US Government's abject failure to uphold international laws by committing egregious human rights violations. Like the thousands of prisons that have come before it in the modern era, Guantánamo was built to fabricate a virtue—the US' unwavering commitment to fighting "terror." Alongside Guantánamo prisoners such as Muhammad Ansi, Khalid Qasim, Ghaleb Al-Bihani, and Djamel Ameziane, who turned to ships or sea imagery in their paintings, Moath's model ships find common cause with the anonymous prisoners incarcerated in the years before him in the creation of ships that were of the prison, but, as portable objects, had the potential to leave the prison. To cherish Moath's ships is to cherish the anonymous incarcerated lives of those who came before him and also dreamt of ships sailing the sea.

CONCLUSION

Moath's work invites many readings. When sharing his work with students in my Islamic art and architecture course, several students were moved to tears. These art students, who were babies or not even born when Moath was first sent to Guantánamo, were invited to imagine art-making in a space that symbolizes the worst kind of state-sanctioned horror. His work not only touched on a semester's worth of studying Islamic visual traditions, but also taught these students about a prison history of which they had been largely unaware. Undoubtedly, the more people who encounter Moath's work, the more layers of meaning it will acquire; the two lenses offered here will be two of many future approaches. As a scholar of art and architecture, my thinking has been enriched by the opportunity to contemplate and reflect on Moath's work. I join my words to the work of the lawyers, activists, and Moath's friends and family who have worked on his behalf to advocate that he and his model ships may be released.

WORKS CITED

Adayfi, Mansoor. 2017. In Our Prison on the Sea. *The New York Times*, 15 September. https://www.nytimes.com/2017/09/15/opinion/sunday/guantanamo-early-years-sea.html.

———. 2022. The Brotherhood of Guantánamo Bay. *Al Jazeera*, 25 January. https://www.aljazeera.com/opinions/2022/1/25/the-brotherhood-at-guantanamo-bay.

al-Alwi, Moath. 2015. If the War is Over, Why am I Still Here? *Al Jazeera*, 23 June. https://www.aljazeera.com/opinions/2015/6/23/if-the-war-is-over-why-am-i-still-here.

Arthur J. Arberry. 1955. *The Koran Interpreted*. Trans. George Allen and Unwin. https://archive.org/details/in.gov.ignca.4296/page/n5/mode/2up.

Blair, Sheila S. 2006. *Islamic Calligraphy*. Edinburgh University Press.

Coughlin, Mary. 2018. Prisoner-of-War Ship Models Made in Britain: History, Manufacture, Materials, and Treatment. *Journal of the American Institute for Conservation* 57 (1–2): 62–72.

Dalal, Radha, Sean Roberts, and Jochen Sokoly, eds. 2019. *The Seas and the Mobility of Islamic Art*. Yale University Press.

Davidson, Benjamin, and Pippa Biddle. 2022. Ships of Bone and Hair: The Art of French Prisoners of the Post Revolution and Napoleonic Wars. *The Magazine Antiques*, March/April, pp. 64–67.

Department of Islamic Art. 2000. "The Nature of Islamic Art." In *Heilbrunn Timeline of Art History*. New York: The Metropolitan Museum of Art. http://www.metmuseum.org/toah/hd/orna/hd_orna.htm.

Deutsche, Rosalyn. 2020. Rosalyn Deutsche on 'Ode to the Sea: Art from Guantánamo Bay.' The Online Edition of *Artforum International Magazine*, 1 September. https://www.artforum.com/print/202007/rosalyn-deutsche-on-ode-to-the-sea-art-from-guantanamo-bay-83687.

Ekhtiar, Maryam, Priscilla P. Soucek, Sheila R. Canby, and Navina Haidar, eds. 2011. *Masterpieces from the Department of Islamic Art in The Metropolitan Museum of Art*. 1st ed. The Metropolitan Museum of Art.

Evans, Robin. 1982. *The Fabrication of Virtue: English Prison Architecture, 1750–1840*. Cambridge University Press.

Fleetwood, Nicole. 2020. *Marking Time: Art in the Age of Mass Incarceration*. Harvard University Press.

Foucault, Michel. 1977. *Discipline and Punish: The Birth of the Prison*. Trans. Alan Sheridan. Vintage Books.

Foucault, Michel, and Jay Miskowiec. 1986. Of Other Spaces. *Diacritics* 16 (1): 22–27.

Gahagan, Kendra. 2003. Behind the Wire: Life at Guantanamo Bay. *ABC News*, 23 September. https://abcnews.go.com/WNT/story?id=129401&page=1.

Grabar, Oleg. 2006. *Islamic Art and Beyond*. Ashgate Publishing.

Guenther, Lisa. 2013. *Solitary Confinement: Social Death and Its Afterlives*. University of Minnesota Press.

Gunter, Joel. 2022. The Sudden Silencing of Guantanamo's Artists. *BBC News*, 28 August. https://www.bbc.com/news/world-us-canada-62399826.

Harmon, Erica. 2021. *Eastern State Penitentiary: Nautical History*. Philadelphia: Presentation Seaport Museum.

Human Rights Watch. 2008. *Locked Up Alone: Detention Conditions and Mental Health at Guantanamo*. New York.

Kornfeld, Phyllis. 1997. *Cellblock Visions: Prison Art in America*. Princeton University Press.

Le Heros. 1778. Warship; Third Rate; 74 Guns. *Royal Museums Greenwich*. https://www.rmg.co.uk/collections/objects/rmgc-object-66491.

Nees, Lawerence. 2015. *Perspectives on Early Islamic Art in Jerusalem*. Brill.

Rosenberg, Carol. 2018. Pentagon Wants to Replace Guantánamo's Top Secret Prison. Price Per Prisoner: $4.6M. *The Miami Herald*, 13 February. https://www.miamiherald.com/news/nation-world/world/americas/guantanamo/article199832664.html.

———. 2021a. Military Closes Failing Facility at Guantánamo Bay to Consolidate Prisoners. *The New York Times*, 4 April [Updated 23 September]. https://www.nytimes.com/2021/04/04/us/politics/guantanamo-bay-prisoners.html.

———. 2021b. Recalling the First Guantánamo Detainees. *The New York Times*, 3 May. https://www.nytimes.com/2021/05/03/insider/first-guantanamo-prisoners.html.

SMS Scharnhorst. 1915. Warship; Cruiser; Armoured Cruiser. *Royal Museums Greenwich.* https://www.rmg.co.uk/collections/objects/rmgc-object-67330.

Taub, Ben. 2019. Guantánamo's Darkest Secret. *The New Yorker*, 22 April. https://www.newyorker.com/magazine/2019/04/22/guantanamos-darkest-secret.

The Guantánamo Docket. 2023. *New York Times*, 8 March. www.nytimes.com/interactive/2021/us/guantanamo-bay-detainees.html.

Thompson, Erin L. 2017. Ode to the Sea: Art from Guantanamo. *Postprint Magazine.*

Victor, Philip J. 2014. Gitmo Detainees' Lawyers Invoke Hobby Lobby Decision in Court Filing. *Al Jazeera America*, 5 July. http://america.aljazeera.com/articles/2014/7/5/hobby-lobby-guantanamo.html.

Walicek, Don E., and Jessica Adams. 2019. *Guantánamo and American Empire: The Humanities Respond.* Palgrave Macmillan.

Yee, James. 2005. *For God and Country: Faith and Patriotism Under Fire.* PublicAffairs.

Guantánamo Bay Ensigns: Material Rhetorics and Moath al-Alwi's Ships

Belinda Walzer

Moath Hamza Ahmed al-Alwi's model ships are elaborately and intricately designed. One is a model of a gondola with lanterns and gold accents. Several are models of seventeenth- or eighteenth-century galleons reminiscent of pirate ships or colonial and slave trade ships, each with an eagle on the prow. One of the largest, titled *GIANT*, has three masts with complex rigging, detailed crow's nests at the top of each mast, a squared off stern, and multiple levels. The pennant flags at the top fly green, symbolic of hope, Moath says, and none of the ships feature discernible weaponry. Moath's art is created entirely out of scraps of material he salvages from his everyday life as a Guantánamo Bay detainee, including cardboard, plastic from his razors' packaging, thread from his clothing and prayer cap, mops, and bottlecaps. As part of the 2017–2018 exhibition at the John Jay

B. Walzer (✉)
Appalachian State University, Boone, NC, USA
e-mail: walzerbl@appstate.edu

© The Author(s), under exclusive license to Springer Nature 113
Switzerland AG 2024
A. S. Moore, E. Swanson (eds.), *The Guantánamo Artwork and
Testimony of Moath al-Alwi*, Palgrave Studies in Literature, Culture
and Human Rights,
https://doi.org/10.1007/978-3-031-37656-6_7

College of Criminal Justice, "Ode to the Sea" curated by Erin L. Thompson, Paige Laino, and Charles Shields, the ships were displayed including a tag with Moath's handwritten name.

However, Moath's art also features another tag not of his design (Fig. 7.1). Each piece of work has been stamped by the US military. One galleon model has large text prominently displayed on the lowest sail in the front mast. Stamped in black, it reads "APPROVED BY US FORCES" with the US seal next to it featuring an eagle in the center. The date is in red on the next line and below that are the symbols "JTF/

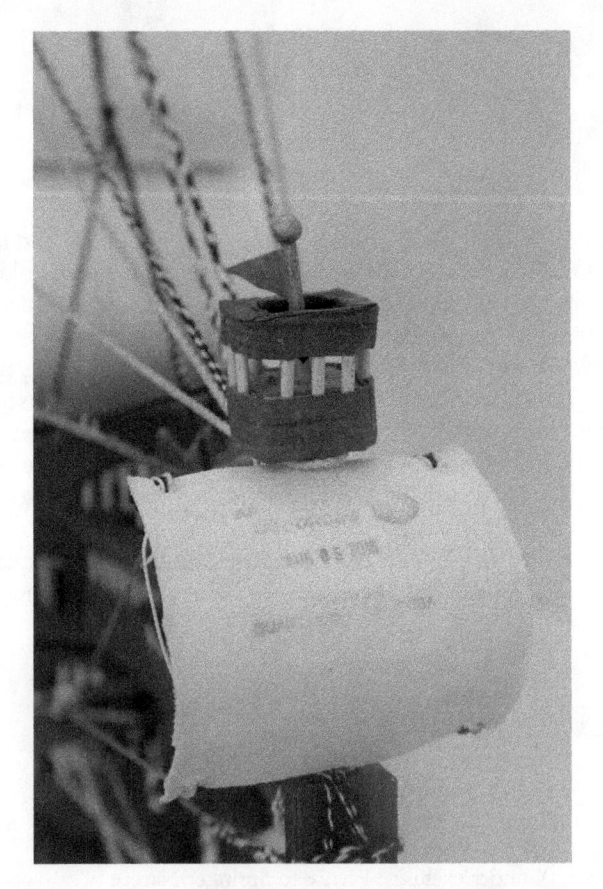

Fig. 7.1 Moath al-Alwi, *GIANT*, mixed media sculpture, 2017. Detail of approval stamp on sail. Courtesy of artist

JDG S-2." The last line has GUANTÁNAMO BAY, CUBA in bold capitals. The mast of another ship is stamped with "Cleared by JDG" and a series of numbers. JTF/JDG is an acronym for Joint Task Forces/Joint Detention Group who are "responsible for the safe, humane legal care and custody of law of armed conflict detainees; collection and dissemination of intelligence; and supporting Military Commissions, Periodic Review Boards, and Habeas review" (jtfgitmo.southcom.mil). After the artist completes the art, the art teacher sends the work to JDG where it is stamped with these marks, even if it will never see an external audience. The stamp is necessary for prisoners even to keep their own artwork. Although always heavily regulated and considered government property, art that once was sent to lawyers and contacts outside of Guantánamo became even more restricted in 2017 such that detained prisoners could "no longer give away their art to make room for more" (Rosenberg 2019). Although the US Department of Defense has recently reversed the ban on art leaving the prison (as of January 2023), the language regulating what can leave the prison with any released prisoners—a "practicable quantity"—is vague, and the art remains property of the US government (Rosenberg 2023). This is, according to UN Special Rapporteurs Alexandra Xanthaki and Fionnuala Ní Aoláin, a violation of the prisoners' cultural and human rights.

This chapter examines Moath's artwork through the lens of visual and material rhetorics[1] to consider how the art, produced out of the material conditions of detention, is simultaneously an archive of state violence as well as a testimony to and resistance to that violence. This argument rests on two premises: First, I argue that Moath's art is always already political because of the found nature of the objects that create his art. Moath's appropriation of common materials for aesthetic expression retains traces of his everyday carceral experience even as the ships themselves signal an imagined future outside of indefinite US custody. Second, I argue that through the US forces' property stamp, the scene of resistance that these ships manifest is also the scene of subjection to the very violence it represents. In other words, the stamp draws attention to the uncontainable nature of the art as resistance as well as to the impossible nature of that

[1] I'm using rhetorics here to signify the art of persuasion, but I also use it to signify the political stakes of Moath's ships within the context of their production and reception. Rhetoric, as a field of study, is interested not only in persuasion, but also the stakes and ethics of that persuasion.

resistance itself. I argue that the ships stage a claim to human rights outside of the law, which helps us understand human rights to be much more than just the legal discourse that circulates through normative institutions. Moath says (in this collection) of his ship art: "The most beautiful thing happened the first time I made the sails and tied the rope. I felt as if I were in the middle of the ocean ... and I felt I was rescuing myself. ... Yes, the ship itself is the rescue" (2023, 29). If we understand these ships to be an imagined alternative and resistance to his reality inside Guantánamo, the fact that this aesthetic imagining is still subject to the US government's ensign signals the difficulty of staging resistance to his detention, let alone claiming rights, out of the impossible rhetorical situation of his indefinite detention (despite having been cleared for release) in a forever war.[2]

Material rhetorics is an analytical approach and broad theoretical conversation that emerged in the latter half of the twentieth century in the field of rhetoric, literature, and feminist studies. It has long sought to ground abstract notions of agency and symbolic communication in lived realities and embodied experiences. A catch-all term for multiple theoretical conversations (e.g., Marxist feminism, new materialism, object orientated ontology, and actor-network theory, to name a few), material rhetorics examines the deeply contextual ways in which unequal structures of power condition the meaning and impact of language, the subject speaking, and the ability to persuade. Relatedly, it also seeks to understand that physical objects and matter also have the power of persuasion and are thus subject to the same structures of power that condition all meaning-making capacities. In other words, material rhetorics understands that both the material conditions that create marginalized populations as well as the means of resistance to that oppression are embedded in language. Thus, language and rhetoric have tangible material affects on the world and matter has agency beyond the cultural value granted by a social construct. As Arjun Appadurai says, theories of materialism demonstrate the ways in which the human is not the "sole repository of agency, intentionality, vitality, and purposiveness" (2015, 221). This can be seen in

[2] Indefinite detention is a euphemism that refers to the incarceration or detention of individuals, or what the US government calls "unlawful combatants," without a fair trial or sometimes without even a charge. Indefinite detention violates multiple human rights instruments. Indefinite war refers to the legal gray area that the US government exploits in its "War on Terror," such that it is not at war with a specific country, but rather against a non-state actor or ideology. Given these terms, a "War on Terror" can be waged indefinitely. (See, e.g., Luban *Torture, Power, Law.*)

everything from legal documents that affect action, for example the US Torture Memos, which authorized the torture and abuse of Guantánamo and other prisoners in the War on Terror, to the ways in which physical structures condition how bodies move through physical space in particular ways, for example, a building with accessible design has hallways wide enough for those with wheelchairs and doors that open automatically so those who speak American Sign Language can continue their conversation. A materialist approach is crucial to understanding the politics of human rights representation and recognition while also recognizing that the language of rights matters. The materiality of rhetoric, then, becomes its force in the world. It doesn't just represent the world, but mediates the world (Biesecker and Lucaites 2009, 3).

Material rhetoric is a useful analytical approach to the artwork by Guantánamo detainees because it understands not only the symbolic and aesthetic nature of the artwork as resistance, but it also understands the material nature of that resistance. Moath's ships would not "exist" as such for an audience without the US military stamp of approval. In effect, the approval seal marks both the ship as a product of Guantánamo prison as well as its release from the prison for external viewers. The US military ensign marks the ship as property of the US, representative of the US military system, much as a national ensign marks a naval vessel as a part of that state and thus subject to the laws of the flag state. However, if the ensign on a naval vessel signifies nationality and thus conveys the legal status and rights that come with citizenship for the bodies on board, what does the US government ensign suggest here, whether for the right of the object to travel or the rights of its maker?

Human rights lawyer to several Guantánamo detainees, Shelby Sullivan-Bennis says that the artwork that made it out of Guantánamo "is a small sampling that the government has deigned capable of being released ... artwork that's non-political in nature and ... doesn't depict their treatment whatsoever" (Imtiaz, 2021). Although Sullivan-Bennis' point is well taken insofar as none of the artwork that the government allows off the base any longer directly depicts the detainee's treatment, I argue that all of the art is political in nature, particularly Moath's, because it is constructed out of his everyday life in detention. Prison art is always already conditioned by the context and temporality experienced by its makers.

As Nicole Fleetwood argues in *Marking Time: Art in the Age of Mass Incarceration*, prison art cannot be divorced from the conditions of its production—even if the art is meaningful well beyond the fact that its

maker is incarcerated. She argues that most art "emerges in relation to institutions, be they entities commonly associated with art, like ateliers, conservatories, museums, and galleries" (2020, 2), or institutions like prisons, and, "like art made in other arenas, prison art exists in relation to economies, power structures governing resources and access, and discourse that legitimate certain works as art and others as craft, material object, historical artifact, or trash" (2020, 3). She coins the term "carceral aesthetics," which defines a mode of "envisioning and crafting art and culture that reflect the conditions of imprisonment" (2020, 2). This prison art is often created with improvised and experimental materials given the nature of the conditions of production. By using not just art supplies provided by the prison but rather found objects, Moath's art is direct evidence of his everyday experience and life in detention that remains otherwise invisible or illegible to those not granted access to the prison. Each crow's nest retains signification as a former bottle cap and each sail rigging retains signification as a former string from a mop.

Carceral aesthetics and prison art also often engage and challenge notions of "inside" and "outside" (Fleetwood 2020, 6). For example, much of the subject matter of the art in the "Ode to the Sea" exhibit features the ocean, which the Guantánamo detainees often cannot see except on unusual occasions, like a hurricane or a transfer. This juxtaposition of being detained on an island but without access to the sea is, I argue, one of the most political aspects of the aesthetic subject matter in "Ode to the Sea." Access and even views of the water are restricted for detainees and many of them, especially those coming from landlocked countries, had never seen an ocean or sea before. They would steal glimpses of the water, for example, when hurricanes damaged the fencing restricting their view or through small tears or holes in the infrastructure, as Moath describes doing in his essay published in this collection. Another former Guantánamo detainee, Mansoor Adayfi, writes about the sea, "Everyone who could draw drew the sea. ... I could see the detainees put their dreams, feelings, hopes and lives in them. ... Each of us found a way to escape to the sea" (Adayfi 2017). In depicting the sea or the maritime infrastructure as Moath does with his ships, detainees are drawing direct attention to their incarceration. The fact that the art is an "ode" to the sea but uses no materials that are found in or around the sea (sand, shells, driftwood, etc.) indicates their restrictive experience and lack of access to the sea by omission. By using found objects, and further, only human-made found objects (including trash) from prison life, the art reflects "the material limitations

and scarcity of art supplies inside, constraints that some transform into innovative experiments with found objects, ephemera, and state property" (Fleetwood 2020, 7), and which thus "materializes the conditions out of which prison art emerges" (Fleetwood 2020, 8).

The original prison art program in Guantánamo, as Thompson articulates in this volume, may have been "more meaningful to the authorities than the detainees" (2023, 59). As Rosenberg reports, "Guantánamo prison introduced art classes a decade ago to reduce friction between bored, angry or isolated detainees and their guards. Inmates who behaved were taken, in shackles, to a cell block [where they were] chained by the ankles to the floor and got to color, paint or sculpt" (2019). Color copies of the early artwork were also displayed on the base for visiting lawyers and media. Largely created as a behavioral mediation tactic and utilized in their own public relations campaigns, at first the program required detainees to undergo invasive searches in order to gain access to paper and crayons and a teacher who wasn't allowed to talk to them (Thompson 2023, 59). However, by 2011 the program included more sophisticated materials and actual instruction in drawing and painting mediums. Perhaps most significant to Moath, by this time the detainees were also allowed to keep their art in their cells. Although ultimately an incredibly valuable program for the detainees—detainees have described their art as if it were a piece of their soul (Gunter and Moath in this volume)—the art program reveals the government's own hypocrisy. Detainees were provided with poor materials and made to undergo humiliating circumstances to use them to produce artwork that the military was happy to exhibit to visitors when it benefitted the military's own ends. However, once the art was exhibited outside the museum and generated negative publicity for the base, the military censored the arts' ability to be seen by the public.

Although art had always undergone censorship and restrictions in leaving Guantánamo, after the 2017 "Ode to the Sea" exhibit, the government changed its policy to ban further releases (this ban was reversed in January 2023). Detainees were no longer permitted to give the work to their lawyers, bring it to meetings, or even leave the base with it when they were released, which suggests that the art was restricted because of the negative publicity about Guantánamo generated by "Ode to the Sea" (see Thompson in this volume). As the curator for "Ode to the Sea," Thompson claims that, "The ban, which was meant to bury this art, ironically enough brought it to the attention of millions of Americans" (Rosenberg 2019). Since the prison can't store all of the art the prisoners produce and

prisoners are only allowed to keep a certain amount in their cell and in storage, the government is at worst threatening to destroy the art detainees are making and at best ambiguous about whether any detainees approved for transfer would be able to take their artwork with them (see Thompson and Introduction in this volume). The military, perhaps rightly, claims it is not in the business of storing or curating art. Spokesperson for the prison, Navy Cmdr. Adam Bashaw, told Rosenberg that "the military has an undisclosed limit on how much artwork a captive can keep in his cell. Overflow goes to a storage facility. Once a limit in both sites is reached, the detainee can 'choose which artwork to discard.'" First, he said, the artwork is photographed and the captive is given "a printed copy" (Rosenberg 2019). It is unconfirmed how much, if any, of the art has been destroyed. Even the photographs of artwork were refused release.

Both Adayfi and Moath write about artwork that was destroyed prior to 2017, specifically in the 2013 raids on their cells, but this threat of destruction for lack of storage, even as the prison refuses to release any of the art to detainees leaving the prison, suggests that the art itself is threatening to the institution. Moath describes in this volume the grief he felt when artwork he created was taken from him to be locked away in its own "prison" (allegedly it was locked in another empty cell) and the importance of his art being seen by others (2023, 38, 43–4). The concept that the art produced in prison belongs to the prison, not the artist, is not new policy. There are extensive guidelines issued by the US Federal Bureau of Prisons that regulate prisoners' arts production and distribution. In Ohio, for example, the prison takes a 20 percent cut of all art sales, and it is at the wardens' discretion whether or not prisoners can distribute their art outside of the prison. In Louisiana's Angola prison, the sale of prisoner art at the annual Rodeo is a significant moneymaker for the prison (Fleetwood 2020, 9). However, it's worth noting here that Guantánamo is not a part of the US penal system under the US Federal Bureau of Prisons (FBP) even if Guantánamo's three main camps (and to a certain extent the art policies) are modeled on Federal prisons.[3] Instead of being part of the FBP, Guantánamo is under military purview precisely so that prisoners of Guantánamo are not subject to the same status and laws

[3] For example, there is one camp "where 'compliant' detainees live in a communal setting; one where noncompliant detainees are isolated to single cells; and the top-secret Camp 7 that house[d] 15 high-value detainees who were formerly held in CIA custody" (Leopold). When Moath made his ships, he identifies that he was mostly housed in Camp 5 or 6, either in communal settings or in a windowless solitary cell.

granting them rights as federal prisoners.[4] This means that even the right of prisoners to artistic expression that Fleetwood references is not a guarantee for Guantánamo detainees.[5]

When the art is produced by marginal figures, the context of production often becomes more important to its reception than the aesthetic value (Fleetwood 2020, 12). For example, the carceral aesthetics and conditions of production of the Guantánamo art (rather than its aesthetic value alone) are the primary focus of this essay and this collection. The political context of production and reception seems to be the central story of the art produced in Guantánamo, and that generates its value. A military spokesperson said in 2017 that one of the reasons the Department of Defense restricted the movement of art outside of Guantánamo was because of how popular sales were, which of course had the opposite effect and made them even more popular (Rosenberg 2019). After the 2017 exhibit, several celebrities bought art produced by detainees, and the Department of Defense allegedly worried about where those proceeds were going, even though according to the exhibition catalogue for "Ode to the Sea," any art for sale was created only by former detainees (Gunter 2022). As Carol Rosenberg reported, "The lawyer for one captive said her Yemeni client assigned the money to his mother's medical care and others have used it to support their family as they try to navigate life after sometimes decades of illegal detention given the often-continued severe restrictions on their movement and lifestyles" (2019). In this volume, Thompson details the varied reception of the prisoner artwork from angry family members of people who died in 9/11, one of whom called the exhibit "absolutely outrageous and reprehensible," to thankful 9/11 widows who said it had given them hope, to veterans with complex reactions (2023, 64–5). Thus, in material rhetoric terms, it's clear that certain kinds of rhetorical frames of recognition condition the art's production and specific frames of recognition condition its reception by any public.

[4] In fact, in a report commissioned by Diane Feinstein in 2008 and released in 2012 on the feasibility of closing Guantánamo, multiple detention facilities were identified within the US and they were all operated by the Department of Defense and the Department of Justice, not by the US Federal Bureau of Prisons (Leopold). This is in order to maintain the detainees' status of "unprivileged enemy belligerents" (Leopold).

[5] In a letter to military officials, lawyers argued for the rights of prisoners to have the ban overturned using federal prison as an example, "pointing out that convicted US state and federal prisoners were permitted to make, send out, exhibit, and sell their art" (Gunter). To date, the military has not responded to the letter.

I read the Guantánamo artwork as a site of resistance to the conditions of its production.

Hannah Arendt argued at the inception of modern human rights doctrine that the law initiates personhood, or recognition as a person-before-the-law, and thus the protections that the law affords. Guantánamo detainees have been and continue to be denied this kind of legal category of personhood: tortured, and held without charge, due process, or trial, and for indefinite amounts of time. The threat that the artwork poses to the government is that it makes visible a subjecthood for the prisoners that the government cannot contain. In particular, that the art is made out of found objects, which is an appropriation of the purpose of each material object, subverts the control of the prisoners' subjecthood by the US government. But, the scene of resistance that these ships manifest is also the scene of subjection to the very violence it represents. The artwork is significant precisely because it was created under violent conditions and detention without charge. This begs the question, as Saidiya Hartman asks about the archives of slave ships crossing the Atlantic, "how does one revisit the scene of subjection without replicating the grammar of violence?" (2008, 4). And for viewers of the art, what does it mean to bear witness to these objects as resistance?

This question hangs heavy when faced with the "Approved by US forces" stamp front and center on *GIANT* because it carries the signifier of not just incarceration, but a deep history of abuse at the hands of the US military in the forever war and its other imperial activities. In other words, we must also question how to understand and interpret this art when its maker is still sitting in a cell in Guantánamo having been cleared for release but with no transfer date in sight. As Moath has said, "I wanted the prison stamp to be clear on the sail so people would know the ship comes from Guantánamo" (Gunter 2022). Add to this the political context of the legal policies that led to the detainees' imprisonment and that stretch back into the long history of US atrocities, including the slave trade and the War on Terror. Although Darryl Li rightly cautions against untheorized "invocations of Blackness and slavery in broader discourses around the prison" (2021, 21), Hartman's argument about the archives of the transatlantic slave trade that represent the racialized history and contemporary politics of captivity in the US helps us understand the ways in which the art produced in Guantánamo Bay bearing the stamp of the US military signifies a kind of structural violence that extends beyond even the violent conditions the artist must endure for its production—violent both

because of strip-searches and other everyday intrusions, but also structurally violent because of their overall lack of rights.

Hartman argues that materials that represent history and violence can never be removed from the context of their production and audiences must always attend to what is not there or what is not visible—what haunts the material with its spectral or ghostly nature. To do so is fraught because representations can never do justice to the violence experienced; thus, recognition of that violence is already complexly mediated by the challenges of representation. However, this impossibility of recognition is precisely what Hartman advocates for—to recognize the spaces of resistance by "listening for the unsaid, translating misconstrued words, and refashioning disfigured lives ... intent on achieving the impossible goal: redressing the violence" (2008, 3), meaning both the *violence of representation* and the *violence being represented*. Although Hartman's argument about representing, recognizing, and redressing violence inflicted on captive women in the slave trade and their omission in the archives is quite different from the context of understanding the art being created and curated for display by Guantánamo detainees, it is relevant to understanding the politics of representation, recognition, and resistance of/to certain kinds of violence that the artwork materializes.

I have argued elsewhere that understanding the rhetorical frames of recognition and reception are key to understanding resistance since some forms of resistance may not be recognizable within larger material and rhetorical contexts (Moore and Walzer 2018). Rhetorical frames of recognition, or the normative patterns of communication as determined and predetermined by rhetorical conventions, are explicitly conditioned by rhetorical temporalities. For example, we all know there are right and wrong times to make arguments based on any number of contextual circumstances that accrue over time or occur in the moment of argumentation. Simultaneously, violence and the ability to recognize that violence are also conditioned by the same circumstances of temporality (Walzer 2020).

Decades of habituation by the media have made audiences better able to understand violence that is temporally bounded by a particularly spectacular event, whether battles in a war, or natural disaster events like an earthquake, a mudslide, or a flood. Traditionally, these events erupt out of, disrupt, and throw the status quo into crisis. However, what audiences find difficult to recognize on a large scale are the kinds of violence that are born out of structural conditions and that are temporally "slow" (Nixon 2011). For example, the climate change that caused the mudslide,

the rising sea water that caused the flood, or the poverty that meant the earthquake disproportionately affected certain populations. In other words, audiences fail to recognize violence that is, itself, the status quo. I argue elsewhere that this kind of slow violence, what I call "everyday violence," rather than crisis-oriented violence, is particularly difficult to recognize as a human rights violation within legal contexts.

Art produced in prison is conditioned not only by the materials needed for production but also by the time and conditions (e.g., art programs) needed for production. Prison art also redefines notions of labor, time, and productivity in captivity given the time it takes to plan, prepare, and produce intricate works of art like Moath's ships.[6] This temporal nature of prison, what Fleetwood calls "penal time," works two ways: time in prison is both highly regulated and controlled, but also time is often the resource of which detainees have the most. For some artists, this penal time enabled them to produce works they would not normally have the time to produce outside of incarceration (Fleetwood 2020, 12). As former Guantánamo detainee, Mohamedou Ould Slahi (author of *Guantánamo Diary*) says in his essay "My Guantánamo Writing Seminar," "time as a steady, uniform flow doesn't exist in prison, especially not in solitary confinement in a windowless cell. An hour is only an hour if you have a measuring device" (2022, 402). For prisoners in Guantánamo who were kept in solitary confinement, time is also wielded for torture. For Slahi, "prison didn't just slow things down: it stopped everything," and the past, present, and future existed simultaneously (Slahi 2022, 402).

Incarcerated detainees in Guantánamo (and, arguably, even those released, given the ongoing restrictions on their movement and freedom) exist in multiple overlapping and sometimes conflicting temporal frames of recognition and violence. For example, they fall into the category of everyday violence because they are often no longer bound by a temporal relationship to the original logic of their detention, given the long durée of the forever war, regardless of how suspect or weak that logic was originally, and regardless of the fact that by now, any threat they pose to the US government has been essentially constructed by the detention itself. This notion of everyday violence helps us recognize structural violations that fall outside the purview of the law and are not perceived in traditional terms as violent. For example, as Alexandra Moore and I argue (2018), the

[6] This is especially true when set alongside the kinds of labor that many formally charged and incarcerated individuals are required to do in factory settings for little to no wages.

conditions of Slahi's detention made any arguments for his own innocence rhetorically impossible, since how does one argue for innocence when one has never been charged with a crime, but is indefinitely detained? However, even everyday violence as a frame of recognition cannot contain the multitudes of violence committed against the detainees—from the spectacular violence of rendition, torture, strip-searches, force-feeding, and so on, to the structural and legal violence of being denied personhood and rights (not to mention the slow violence caused by global geopolitical conflict that may have contributed to their detention in the first place), to the everyday violence of prolonged detention. In other words, the conditions of prolonged detention need to be read through multiple frames of recognition and categories of violence. Thus, the challenge of reading the art produced in Guantánamo as resistive to these forms of violence becomes even more complex. What does it look like to resist multiple genres of violence, some of which fall outside of traditional frames of recognition?[7] And, how do audiences viewing the art on exhibit recognize it as resistance?

As Nicholas Mirzoeff argues about the images that emerged out of the war in Iraq, including the horrific Abu Ghraib photographs,[8] visual representations of war had, it seemed, become "banal." This follows Hannah Arendt's famous argument about the banality of evil and Susan Sontag's articulation of the oversaturation of images from conflict. As Mirzoeff says, "it seemed that visuality had become a weapon for authority, not against it" (2011, xiv). Given this larger context of the lack of impact that images revealing spectacular violence have, how do we make sense of the perceived threat the art created in Guantánamo poses to the US government, especially when it does not depict spectacular violence? Similarly to the release of Slahi's memoir *Guantánamo Diary*, the first edition of which was allowed to be published but with over 2500 redactions in large black stripes across the text (some of which redacted obvious material like gendered pronouns and publicly available information), why at once release the book, but under such absurdly restrictive regulations, if even

[7] Although there are many groups protesting the existence of the prison, there are pockets of the US public who believe detainees either deserve the treatment they received, or that they have been treated too well. In this sense they do not see their treatment as violent even if it was considered a violation of human rights law.

[8] For their part in the Abu Ghraib abuse depicted in the photos that made headlines in 2004, 11 officers were convicted of prisoner abuse (McKelvey). A lawsuit, brought by four former prisoners, remains open against the private contractor, CACI Premier Technology, who "provided interrogation services at the prison" (Bierman).

photographic evidence of torture and human rights violations mean so little in the larger scheme of repercussions and justice for violating human rights law in the War on Terror? Why draw attention to the censorious capacities of the government if not only to perform power? Why is this "depoliticized" art of intricate ships that don't even depict any weapons seen as potentially more threatening by the government than actual images of torture? Because, as Mirzoeff argues, visual art can be used to represent subaltern histories and voices formally left out of traditional, colonial historical temporalities because it enacts the "right to look" (2011).

The right to look refers to both the rights of the audience to view the artwork being produced in Guantánamo as well as the rights of the detainees to "be seen" (Mirzoeff 2011, 4). The right to look, claims Mirzoeff, is a right to engage in the mutuality of recognition, even if that recognition is so contingent and in-the-moment as to be unrepeatable. The right to look challenges the authority who says, "Move on, there's nothing to see here" (Rancière qtd in Mirzoeff 2011, 1), even as both those doing the looking and those being looked at recognize that there is, indeed, something to see. This brings Mirzoeff to the ultimate conclusion that "the opposite of the right to look is not censorship, then, but 'visuality,' that authority to tell us to move on, that exclusive claim to be able to look" (2011, 2). This concept of visuality as an exertion of power over looking is precisely what the "approved by US Armed forces" stamp represents. Visuality is the right to classify through naming, mapping, and identifying; what Foucault called "the nomination of the visible" (Foucault qtd in Mirzoeff 2011, 3). It threatens to restrict the ability to look, but rather than completely censoring, it instead exerts its authority by stamping a reminder that we look, but only by permission: "The autonomy claimed by the right to look is thus opposed by the authority of visuality" (Mirzoeff 2011, 3). In this way, audiences, viewers, spectators, witnesses, become implicated in the same scene of authority that allows for the visuality in the first place. This concept of visuality begs the question: who has the right to look at the artwork produced in Guantánamo? And what does that ability to view activate in terms of recognition?

This concept of the "right to look" is significant for Moath's artwork because it encapsulates what is so threatening to the government. To see Moath's and other detainees' artwork, is to *look at them*; to acknowledge their existence in Guantánamo and to be implicated in that indefinite detention. The ships both materialize and symbolize the violence and suffering they experience. According to Moath, "If *GIANT* could talk, it

would answer your questions about how I suffered and stayed up exhausted until I created it from nothing. Every part of this ship has a story and a challenge that comes with it" (2023, 37). "The right to look," says Mirzoeff, "claims autonomy, not individual as in voyeurism, but the claim to a political subjectivity and collectivity" (2011, 1). The right to look means that the artists' precarity is recognized, as is their right to have rights: "It means requiring the recognition of the other in order to have a place from which to claim rights" (Mirzoeff 2011, 1).

In 2020, Moath's ships (the ones that have already been released from Guantánamo) were featured again in another exhibition of current and former Guantánamo detainees' artwork titled "Guantánamo [Un]Censored: Art from Inside the Prison" at CUNY School of Law's Sorensen Center for International Peace and Justice. This exhibition, in the aftermath of the Department of Defense's crackdown on the release of the artwork after the 2017 exhibition, was even more explicit about fore-grounding the visuality of the detainees through their art and sought to expand on the scope of the 2017 "Ode to the Sea." One of the organizers of the 2020 exhibit was lawyer Shelby Sullivan-Bennis. She said of this exhibit: "The objective—of the entire exhibition—is to provide a platform for the men to be heard, on their own terms, rather than through the words of others, and to combat the purposeful silencing and identity-erasure that GTMO perpetuates" (quoted in Worthington). In 2023, as we mark the twenty-first anniversary of the opening of Guantánamo prison, Moath, although cleared for release, remains in the prison.

One of Moath's most recent ship sculptures is called *Eagle King*. As of this writing it is still in Guantánamo. Moath began creating *Eagle King* just before the government cracked down on releasing artwork in 2017, and he describes the challenges he faced completing the project in his testimony in this volume. All of his ships feature eagles or eagle wings in some capacity, usually on the prow. Viewers of Moath's ships, especially American audiences, must reckon with the dissonance of the different eagles on Moath's ships: one of Moath's design, and one on the Department of Defense seal that accompanies the "Approved by US forces" stamped on the sails. The Department of Defense eagle, meant to represent the military's strength (Department of Defense brand guide), depicts an eagle with three arrows in its talons and "crowned by 13 stars ... [that] represent the original 13 states. The arrows represent the Departments of the Army, Navy, and Air Force, which stand ready to defend the freedoms won by those 13 states" (dfas.mil). Under the DoD

eagle are wreaths of laurel and olive symbolizing honor and peace (Department of Defense Brand Guide). Contrasted with the DoD seals are the eagles that Moath calls "his symbol." In his essay in this volume, Moath describes sitting in his cell and imagining an eagle flying outside his window: "I could see an eagle freely flying up high. My mind would wander away far from prison and the narrow cell. The wings on the figurehead of my ship symbolize flying, which is freedom. When I saw an eagle flying, I felt it was me flying. I wished the eagle could pick me up and carry me away" (2023, 31). If the eagle on the DoD seal is meant to represent the military's symbolic defense of an ideological freedom through securitization, the eagles that adorn Moath's ships represent a desire for material freedom. Given the complex and fraught nature of the context of production for the art, but also its frames of representations and recognition, it is literally and rhetorically impossible to view Moath's art without the US government stamps. If ensigns signal the legal apparatus under which a vessel operates, the government ensign gives the ship its ability to exist as such. But ironically, these stamps also enable the ships to be visible as a scene of resistance. The artwork simultaneously stages a resistance to the conditions of Moath's detention as well as a proxy claim to recognition, even if that recognition is mediated by the government's stamp.

WORKS CITED

Adayfi, Mansoor. 2017. In Our Prison on the Sea. *New York Times*, 17 September.

al-Alwi, Moath Hamza Ahmed. 2023. Artmaking at Guantánamo. In *The Guantánamo Art and Testimony of Moath al-Alwi: Deaf Walls Speak*, ed. A.S. Moore and E. Swanson, 23–46. Palgrave Macmillan.

Appadurai, Arjun. 2015. Mediants, Materiality, Normativity. *Public Culture* 27: 221–237.

Arendt, Hannah. 1951. The Decline of the Nation-State and the End of the Rights of Man. In *The Origins of Totalitarianism*, 266–298. Harcourt, Brace and Company.

Bierman, Noah. 2015. Few Have Faced Consequences for Abuses at Abu Ghraib Prison in Iraq. *Los Angeles Times*, 17 March.

Biesecker, Barbara A., and John Louis Lucaites, eds. 2009. *Rhetoric, Materiality, & Politics*. Peter Lang.

Coole, Diana H., and Samantha Frost, eds. 2010. *New Materialisms: Ontology, Agency, and Politics*. Duke University Press.

Defense Finance and Accounting Service. dfas.mil.

Fleetwood, Nicole R. 2020. *Marking Time: Art in the Age of Mass Incarceration*. Harvard University Press.

Gunter, Joel. 2022. The Sudden Silencing of Guantánamo's Artists. *BBC News*, 29, August.

Hartman, Saidiya V. 2008. Venus in Two Acts. *Small Axe: A Caribbean Journal of Criticism* 26: 1–14.

Imtiaz, Saba. 2021. Footprints: Artworks from Guantánamo. *Dawn*, 7 September.

Leopold, Jason. 2015. These are the 6 US Prisons That May Soon House Guantánamo Detainees. *Vice*, 26 August.

Li, Darryl. 2021. Captive Passages: Geographies of Blackness in Guantánamo Memoirs. *Transforming Anthropology* 30 (1): 20–33.

Luban, David. 2014. *Torture, Power, and Law*. Cambridge University Press.

McKelvey, Tara. 2018. I Hated Myself for Abu Ghraib Abuse. *BBC News*, 16 May.

Mirzoeff, Nicholas. 2011. *The Right to Look: A Counterhistory of Visuality*. Duke University Press.

Moore, Alexandra, and Belinda Walzer. 2018. Precaritization in the Security State: Ambient Akairos in Mohamedou Ould Slahi's *Guantánamo Diary*. In *Precarious Rhetorics*, ed. W.S. Hesford, A.C. Licona, and C. Teston, 21–40. Ohio State University Press.

Nixon, Rob. 2011. *Slow Violence and the Environmentalism of the Poor*. Harvard University Press.

Rosenberg, Carol. 2019. Did Pentagon Ban on Guantánamo Art Create a Market for It? *The Miami Herald*, 2 January.

———. 2023. Pentagon Lifts Trump-Era Ban on Release of Guantánamo Prisoners' Art. *The New York Times*, 7 February.

Slahi, Mohamedou Ould. 2015. *Guantánamo Diary*. 1st ed. (Ed. Larry Siems). Little, Brown and Company.

———. 2022. My Guantánamo Writing Seminar. *Humanity: An International Journal of Human Rights, Humanitarianism, and Development* 13 (3): 402–410.

Sontag, Susan. 2003. *Regarding the Pain of Others*. Picador.

Thompson, Erin L. 2017. Art Censorship at Guantánamo Bay. *International New York Times*, 27 November.

———. 2023. "APPROVED BY US FORCES": Showing and Hiding Art from Guantánamo. In *The Guantánamo Art and Testimony of Moath al-Alwi: Deaf Walls Speak*, ed. A.S. Moore and E. Swanson, 53–69. Palgrave Macmillan.

U.S. Department of Defense Brand Guide. defense.gov.

Walzer, Belinda. 2020. Novel Violence. *Philosophy and Rhetoric* 53 (3): 344–350.

Worthington, Andy. Photos and Report: The Launch of '[Un]Censored: Art from Inside the Prison' at CUNY School of Law in New York. AndyWorthington.co.uk.

Xanthaki, Alexandra, and Fionnuala Ní Aoláin. 2022. *Mandates of the Special Rapporteur in the Field of Cultural Rights and the Special Rapporteur on the Promotion and Protection of Human Rights and Fundamental Freedoms While Countering Terrorism*. AL USA 22/2022. 29 Nov.

A Sea Without a Shore: Toward Building an Alternative Visual Archive of Guantánamo Bay

Safiyah Rochelle

> *Art's transformative potential … does not recede with time; it banks up like storm clouds; it deepens like a coastal shelf.*
> —Manderson *(2018, 15)*

In this chapter, I explore the role that art made by Guantánamo Bay detainee Moath al-Alwi plays in building an alternative visual archive of the detention camp. I begin by foregrounding my exploration against the existing visual archive of Guantánamo Bay—an archive I imagine as both emerging from and productive of the logics and processes of visuality and state violence (legal and otherwise) that form the camp. Those logics and processes work to frame our apprehension (or non-apprehension) of the

S. Rochelle (✉)
York University, Ottawa, ON, Canada
e-mail: srochell@yorku.ca

A. S. Moore, E. Swanson (eds.), *The Guantánamo Artwork and Testimony of Moath al-Alwi*, Palgrave Studies in Literature, Culture and Human Rights,
https://doi.org/10.1007/978-3-031-37656-6_8

131

camp, its violences, and of detainees themselves. I then examine how art created within carceral spaces bears a particular and revelatory relationship to the law, where prisoner art both resists and unveils the legal processes through which carceral subjects are rendered as such. Moath's art, and detainee art more broadly, can be seen as creative expressions and acts of self-representation, but also of *counter-visualization* created amidst the most abject and vulnerable of carceral conditions; in this, they also disrupt the state's authority and monopoly of the visual ordering and archiving that is so central to the structures and forms of violence that characterize the detention camp, and call attention to the ways in which the camp both encapsulates and exceeds boundaries of law, violence, and authority. The ban introduced by the American state on detainee art (reversed in January 2023, but with conditions that can still restrict its release or circulation at the discretion of military authorities), wherein art could still be produced but could never be shown, nor described, nor leave the confines of the camp, can be seen as a tactical maneuver to undo the effect of the *breaking in* and *breaking through* of state power that occurs through the building of an alternative visual archive. However, I explore it as a self-reflexive gesture that, treated as such, may sharpen our understanding of the state's dependence on a mastery of the visual. This mastery produces subjects that are themselves constructed via a violent visuality, as well as images that function as a constituent and continuing part of state violence. I end by considering the possibilities of Moath's aesthetic interventions into the intertwined and interdependent relationship between state violence and its visual archiving, even as such interruptions materialize and take shape within and through the spatial, temporal, and legal confines of indefinite, perpetual detention. How can art made under such circumstances—art that may yet "bear[] the marks of [the] ligatures" (Gregory 2006, 411) of the relationship between state power, violence, and their archiving—both reveal and challenge the conditions of possibility that both form and sustain these relations, and the camp itself?

THE VISUAL AND THE ARCHIVE

I begin from the premise that state-produced images, imagery, and visual practices are central to the workings of state violence. *Visuality* is a key concept offered by a host of critical visual theorists that captures the interwoven and interdependent relationship between power and the construction of visual fields. According to theories of visuality, things, and people,

are produced and made visible and invisible—or unseeable—within particular fields of mediated and authoritative vision (Rose 2007, 143). Visuality is a form of discursive power; it understands the visual as fundamentally embedded in power relations and authority which both produce an array of visual materials (media, photographs, imagery, and aesthetics), and are articulated through them. In other words, while power relations construct visual fields, mediate legibility and illegibility, and produce visual materials which function as systems of classification, visual materials themselves also work to construct, mediate, separate, aestheticize, and classify (Mirzoeff 2011a). As Nicole Fleetwood notes, "the power of the state to arrest and capture, to make visible and invisible, underscores the significance of visuality as a tool of state authority that structures who sees and what can be seen" (Fleetwood 2020, 55). Given the imbrication of authority and vision that underwrites and flows through visuality, it is no wonder that close attention has been paid to the relationship of visuality to carceral conditions. Fleetwood, for instance, names this relationship as "carceral visuality," a particular form of visuality that "make[s] incarcerated people both invisible and hypervisible, but also unseeing and unseen" (Fleetwood 2020, 16). In carceral spaces then, visuality encounters and is expressed upon a well-traversed terrain carved out by the disciplinary power of the state that categorizes and indexes prisoners, while also producing spaces and enacting practices that disappear them from view. By categorizing and indexing, I refer to the ways in which states produce (and visualize) prisoners *as such* and in doing so, arrange and fix meaning and certainty around this figure. The ordering and cohering work of criminal and racial indexes (Campt 2012, 33)[1] alongside governmental surveillance practices thus produce excesses of criminality, illegality, and culpability that inform political and social death and invisibility, inscribing all of these onto and through prisoner bodies.

Elsewhere, I have explored the connection between visuality, state power, violence, and the detainees of Guantánamo Bay (Rochelle 2022). In this space, the state-produced photograph figured greatly in both building interpretations of the camp and of detainees, and in explicitly formulating, validating, and renewing political and legal categories (or non-categories). The visuality of the camp is further particularized in

[1] Within carceral confinement, Tina Campt refers to "the racialized index" as producing prisoners as "subjects to be seen, read, touched, and consumed as available and abject flesh objects and commodities, rather than as individual bodies, agents, or actors" (33).

images of this space that comply with strictures set forth by military—and, by extension, state—forces. Taken by military personnel and provided to media sources by order of the Pentagon, the genesis and impetus of these images formed and directed the interpretative force of the photographs (Rosenberg 2008). Given their origins, and given this force, I suggest that they can also be conceptualized as forces in and of themselves. In other words, they were not artifacts or documentary materials awaiting narrative structure to give meaning beyond the immediate viscera or sensorial data they offered. Rather, they "actively, even forcibly," build and disseminate an interpretation that is "compelled and enacted by the visual frame" (Butler 2005, 823, 827). Judith Butler points to the state-mediated "seeing" that occurred in Guantánamo as producing and productive of images that were framed with a forcible interpretation in mind—to "make known that a certain vanquishing had taken place, the reversal of national humiliation, [and as] a sign of successful vindication" (Butler 2004, 77–8). Prior to their unveiling in public spaces, the ability to "see" the images was further mediated by state forces that decided what could and could not be included in fields of vision, and, ultimately, what and who could and could not be apprehended as viable political and legal subjects. In the context of this mandated and regulated visual image, disseminated by state forces during times of war, attention must then be paid to how these images occur within visuality as a relation that sutures authority, power, and interpretative force in specific and stubborn ways.

Images of the camp and of detainees functioned to allow for a tracing of the trajectories, rationales, and expressions of state violence, as articulated through and upon the bodies of detainees. Indeed, Guantánamo itself, as a detention camp for War on Terror detainees, can be understood as a visual event, wherein its initial unveiling to the world saw the logics and aims of this "War on Terror" embedded within and rationalized through the first images of the camp. We may consider here the meanings produced through mediated and authoritative images of racialized and subjugated detainees, indistinguishable from one another and yet wholly recognizable as an enemy deserving of consignment to the geographical, political, and legal outer limits of state power, and violence (Anden-Papadopoulos 2008, 9).[2] These images may also be approached as a scopic

[2] Anden-Papadopoulos refers to such visuals as "'pegs', not to [a] particular event but to larger stories that reflect[ed] and reinforce[d]" narratives around the narratives of the War on Terror.

system within a broader scopic regime. As Derek Gregory and others note, scopic regimes (Metz 1982, 62), or the "variable fields that structure what is seen," entail ensembles of practices and discourses that mediate and develop sight, and in the process, conceptions of both self and "other." Scopic regimes reign in historic and modern war projects that are "inflected by the visual codes of [O]rientalism," and mediate "the triangulations of modernity, [O]rientalism and war that frame [a] still profoundly colonial present" (Gregory 2012, 153). The visual archive of state violence in Guantánamo suggests that the detention camp's images can be thought of as a scopic system within this broader scopic regime that draws upon racial and visual codes to structure what and who is seen, and how, in times of war.

Within accounts of visuality, the relationship between what (and who) is made visible and what (and who) is rendered invisible also bears close scrutiny, as "absences can be as productive as explicit naming; invisibility can have just as powerful effects as visibility" (Rose 2007, 165). Indeed, visual practices in Guantánamo sought to both make visible and to disappear the violence of the state: on the one hand, highlighting the retributive power of the state through the display of captured enemy bodies and making "prisoners legible as enemies" (McClintock 2009, 59), while on the other, imbuing these images with the sanctioning and invisibilizing power of the American military. And so while the violence of detention, particularly indefinite detention, may be read in and through images of bowed and shackled detainees, the presence of military personnel in these same images works to sanitize, if not erase, at least part of the force of this violence, offering it as contained, occurring within certain bounds, and subject to a certain level of scrutiny. Similarly, those images voided of detainees—for instance, those which show Guantánamo as a place of mundane, almost parochial detention—can be seen as a tactic of the state to both conceal its violences and to actively engender others, including the violence that accompanies the almost total occlusion of detainees from the norms of law.

We may trace this work of visuality in the very first released images of the camp, where photographs captured (and cemented in public consciousness) orange jumpsuit-clad figures, huddled and kneeling, as military officials loomed over them. Bent at the knees, in supplicating, penitent positions, with their bodily senses dulled by hands covered in unwieldy black mittens, medical masks, and thick goggles, detainees were and appeared as utterly abject, and as utterly subject to state force. Conversely,

in images published later in the life of the camp, and accompanying news stories detailing a US Supreme Court decision that declared the habeas corpus rights of detainees as constitutionally guaranteed, detainees are entirely absent. Instead, what is shown are the materials that form indefinite detention—intricate barbed wire fences, watchtowers emblazoned with the United States, and distant military figures silhouetted against the foreground and surveilling this ostensibly emptied space. These elements work to convey carceral caging and surveillance, but work discursively as well, in visualizing detainees as bodies "hermetically sealed" within the camp, even as they are extended a measure of legal protections.

Taken together, these images demonstrate how visuality shaped both the material and legal limits of who could be seen before the law, as well as the legitimation of (il)legal categories such as "unlawful enemy combatant." In so doing, the legibility and authority of legal processes and visual practices employed by the state were mutually reinforcing and made possible through the functioning of the other. Fundamental, then, too to processes of law that surrounded the camp was a visuality that worked to legitimate (non)legal categories, findings of (ill)legality, and processes of legal inclusion and exclusion, while simultaneously shaping the limits and scope of what counts as recognizable both within the visual frame and within and outside of law (Rochelle 2022).

In Guantánamo, the visualizing impulses and encoding practices of state violence therefore do not just document this violence—they are a part of its reach and limits, the porous and ever-expanding boundaries of which are further structured through what emerges as a visual archive of the camp. I understand this visual archive in the vein of Ann Laura Stoler's conceptualization of the archive as a form of colonial governance. As such, archives are not merely "sites of knowledge retrieval, but of knowledge production, as monuments of states as well as sites of state ethnography" (Stoler 2002, 87). Archives, rather than being static documentations (or documents) of events, people, and places, should thus be approached as processes, as "active and generative," and as relying upon and producing knowledge which is both "productive and responsive" (Stoler 2009, 4). As a "force field that animates political energies and expertise, that pulls on some 'social facts' and converts them into qualified knowledge, [and] attends to some ways of knowing while repelling and refusing others" (Stoler 2009, 22), archives are "both transparencies on which power relations were inscribed and intricate technologies of rule in themselves" (Stoler 2002, 87).

Stoler's conceptualization provides the framework necessary for identifying an archive of Guantánamo Bay's images, and for approaching them as materials both shaped by and productive of the reflexive, entangled, and sometimes contradictory practices of state power and violence. The use of the possessive here is purposeful, for these are indeed not just images *of* the detention camp. They belong to, emerge from, and are embedded within the governing logics of this space, and together build an archive that is generative of meanings of not only Guantánamo and its detainees but also our own understanding of what it is that constitutes violence and suffering, and who it is that can be seen as its target. Guantánamo's visual archive thus structures the conditions of possibility for what and who can be seen or unseen, "what warranted repetition [and] ... what stories could not be told, and what could not be said" (Stoler 2002, 87). Moreover, this archive highlights the continuities and specificities of the visuality that runs throughout the camp. Indeed, Guantánamo's violence can be bound in both form and function to modern-day domestic penal techniques, and can be further embedded within a long history of racial logics that rationalized the subjugation and incarceration of largely racialized populations (Daulautzai 2007, 139). The very history of this space indicates also that its transformation into a repository for the "detainee" is far from a singular event. As a colonial outpost and naval base leased in perpetuity by Cuba to the United States, it has also been used to warehouse Haitian and Cuban refugees seeking entry into America. Detained in some cases for years, many of these refugees were not only denied entry within the borders of the USA, but also access to rights of asylum or habeas corpus rights, as afforded by the Constitution. Here too, images captured warehoused, racialized, and abandoned bodies within the camp, and function to draw the figure of the refugee, the asylum seeker, and the detainee in close relation to each other: they inhabit not only the same physical spaces of detention, but appear also as similarly "racially marked bodies in an imperial system" (Kaplan 2005, 840). Considering the history of the camp alongside photographs of detainees, the visual archive that emerges thus underscores visuality as a discursive power that is both distinctly organized and embedded within broader visual and scopic regimes, while providing stark instances of "how the visual becomes a way of arriving at particular types and layers of knowledge or ways of knowing" (Pink 2012, 5).

ART, VISUALITY, AND THE LAW

There is risk of a certain degree of discursive closure that follows from such an account of visuality and the archive as they manifest within Guantánamo Bay. This sense of closure may arise from how intimately the camp's images are bound to and framed through the lens' state power. It seems that we are limited, in trying to understand and come to terms with these images, to the perspective of power. And yet, the visual itself, despite its proximity to power, enjoys a "mysterious plasticity," wherein meanings embedded within and through even the state-mandated frame may always exceed origin and intent (Manderson 2018, 15). Given this, just as the archive as a process renders it equally subject to authoritative forms of knowing as to the fits and starts of shifting knowledge and authority, the visual practices and materials entailed by visuality, including art, aesthetics, and images/imagery, may also play a vital role in "attempts to expose, critique, and unsettle"—to break through—the entanglements of vision, knowledge, and state power and violence (Manderson 2018, 14). In this, art offers itself as a "crucial mode of self-representation," particularly within a context that seeks to both visualize and erase detainees as subjects of power and violence; in doing so, it can also craft a "shadow archive" (Fleetwood 2020, 236). This shadow archive, beyond resisting the legal, political, and social disappearances that form the lives of prisoners, intrudes into the visual mastery of the state. In doing so, it plays upon the tension that lies at the heart of prisoner art—the "tension between the artist as a symbol of autonomy, and law as a symbol of power" (Manderson 2018, 15).

The relationship between art and law has been taken up by a number of theorists who focus on the ways in which art ironically juxtaposes itself against legal orders, and in the process, "elevate[s] to visibility the legal order that passes unnoticed" (Manderson 2018, 16). Drawing on Shoshana Felman's generative work, Desmond Manderson points out that there is an aesthetic edge to irony itself, wherein it stages the "unintended effects of juxtaposition and contrast" though an "aesthetics of ambivalent and excessive meaning." In so doing, irony unpicks the threads of intention from mastery, and "seizes on imaginal law's indeterminacy or remainder to challenge, to undermine, and even to transform the legal system" (Manderson 2018, 15). The unveiling and ironic power of prisoner art thus reveals the occlusions of law, not just through affirming that prisoners "still exist, that they are still alive, [and] that they are *there*" (Gregos 2020,

130), but also by highlighting the ways in which law seeks to maintain visual mastery through the artful management of its appearance and disappearance (Manderson 2018, 16). The potential and power of art to do so have indeed been seized by prisoners within carceral spaces, as they seek to deploy "strategies of representation that humanize and politicize their existence" (Brown 2014, 176) against the abjectness that characterizes their status before the law and their depictions as subjects of the carceral state. As Fleetwood so powerfully states, "through artistic practices and creative communities inside prison, incarcerated artists fight the punitive isolation and severance of relationships that prisons impose. They work to undermine the carceral indexes … that mark people as criminal and incarcerated subjects, and the stigma of being a prisoner. Prison art is part of the long history of captive people envisioning freedom—creating art, imagining worlds, and finding ways to resist and survive" (Fleetwood 2020, 6).

In speaking—or in looking—back to the visuality of the state, such artistry is also "shaped by penal limitations"; indeed, "to make art in prison is to create under the conditions of scarcity of resources, lack of control over one's environment, immobility, constant surveillance, and a combination of sensory deprivation and sensory overload" (Fleetwood 2020, 58). For Fleetwood, the thoroughness with which prison institutions govern and control the lives and bodies of prisoners means also that art that emerges from such confines bears evidence (apparent or hidden) of the "artist's attempt to manipulate and work within or around penal constraint" (Fleetwood 2020, 58). In a very real and material sense, prison art is often itself constructed from the offal of "penal matter," as prisoners transform the physical material that surrounds them to serve different purposes, subjecting these objects to transformations that both materialize the conditions out of which prison art emerges" (Fleetwood 2020, 7) and "produce new aesthetic formations and social relations" (60). Moreover, "temporal and spatial elements [both] structure the carceral experience" and are in turn structured by the long expanses of time that pass and are experienced within the close confines of the prison cell. In other words, extended prison sentences and the prison cell within which they must be served shape the experience of the prisoner. But time and space themselves also take on different meanings, and experiences, when they are lived within and through the confines of cells and the prospect of prolonged detention. This means that prison art may also embody the particular spatial and temporal deprivations of detention (McKay 2018, 261). Drawing

attention to the conditions under which such art is made is not to undermine the force and effect of "'carceral aesthetics,' which refers to ways of envisioning and crafting art and culture that reflect the conditions of imprisonment" (Fleetwood 2020, 60); rather, it is to highlight the ways in which the aesthetic and creative strategies of prisoners to harness the "right to look" (Mirzoeff 2011b) and the very materials through which they do so are framed, quite literally, by state power and its detritus. But this does not mean prisoner art cannot escape the imaginal confines of the prison; indeed, the shadow archive that is prisoner art, precisely through its embeddedness in the carceral conditions that give it life, draws the eye to what, and who, the law would wish to occlude from sight. Furthermore, the inherent autonomy of the artist, which may arguably find even greater expression through the transformation of the very materials of confinement rendered to express something in excess of the limits drawn by law, breaks through the visual mastery of the state in powerful and profound ways.

"To get [a] soul out of prison": The Art, the Stamp, and the Ban

> Despite being in prison, I try as much as I can to get my soul out of prison. I live a different life when I am making art; it makes me live within my soul. It makes me feel free. (Moath, qtd in Gunter 2022)

As is befitting a space that both calls upon and exceeds colonial histories, carceral practices, and legal norms, art in Guantánamo is both similar to and distinct from the broader conceptualization of prisoner art or carceral aesthetics that has been sketched thus far. At various times over the life of the camp, it has unfolded both secretly and openly; it has emerged from the transformation of the mundane materials comprising confinement and from under the tutelage of sanctioned teachers bearing paints and canvases; it has been subjected to strict censorship regimes while also evading the eyes of military officials to circulate publicly, only to be removed once again from public sight, denied an owner and a status as art at all (indeed, what is a piece of art with neither owner nor audience?).

Moath's art, created over the years of his confinement in Guantánamo, is remarkable not only for the ingenuity required to craft his sublime renderings of model ships from the most ordinary, yet also personal, of sources (dental floss, wooden skewers, prayer beads, mop yarn) and from within

the most restrictive of environments. His works, and the emancipatory themes that run throughout them, intervene in and disrupt Guantánamo's existing visual archive to construct an alternative, resistant archive of the camp. To be sure, art in general has both liberatory impulses and effects, achieved through acts of creation that, in their intensity and focus, free—if not literally, then figuratively or spiritually, and if not permanently, then temporarily and transcendentally—bodies from their surroundings and circumstances. Indeed, art cannot begin and cannot come to be except through acts or gestures of removal and separation; the artist steps back, they observe, their eyes see and their hands move to consider, interpret, transform, unravel, and make anew. Such work demands a comprehensive kind of mastery, achieved through choices and intentions known only to the crafter as they work diligently to materialize their vision. And yet, what emerges from these deeply personal efforts is as much a part of them as it is something born to be independent, free to roam and to perhaps shift; in its exposure to audiences, it may retain the original intents (conscious or otherwise) of the artist just as easily and rapidly as it may accrue layers of alternative meanings and potentialities. This is part of the fundamental danger and threat of art—its inherently evasive nature, borne of the excesses of meaning that cannot help but slip past frames, leak beyond confines, and bare themselves to multitudes.

What, then, of art that visualizes and reconstructs in meticulous detail the very vessels that would bear a soul away from the most precarious of lives? Boats that seem to belong to the endless waters that surround the camp, but that also conjure visions of ceaseless movement, of open air and shoreless seas, of anticipation and hope for what surely must lie just over one's line of vision? Given the slippages of meaning that inhere to art, Moath's boats are open to interpretation; "one has to wonder whether the artists see the ocean as an escape route to which they have no access to, a constant reminder of a world outside, or a force of nature" (Imtiaz 2018). It is clear, however, from his own writing in this volume that for Moath, his model ships and his hopes for freedom are inextricably intertwined.

Given its transformative and emancipatory potentials, it seems a wonder that Guantánamo detainees were ever allowed to create art, let alone have their work travel beyond the confines of the camp to be publicly displayed and encountered *as* art. And yet, from the first days of the camp, and prior to being officially granted access to art classes, art was present in Guantánamo. Detainees transformed the material around them, from the very walls of their cells to toilet paper and food waste, to create something

from nothing. Such creation had to be undertaken surreptitiously, and often their efforts were destroyed or confiscated by camp authorities. Denied an audience, this art could not be seen in the ways the artist would desire, nor in ways that would even name it as such; as Erin L. Thompson notes, for years, detainee art was made for "no one at all"—the work couldn't be shared with the world" (Grant 2022).

When, in 2009, detainees were granted access to art classes, it appeared that they could at last create openly, and in the open. "No longer did we have to hide our writings, paintings, poems, and songs—which had meant hiding parts of ourselves. No longer were we punished for painting or singing. We could reveal parts of ourselves that were missing" (Liu 2022). Moreover, their works could circulate; they could be shared with lawyers and they could be publicized, culminating in the 2017 John Jay College of Criminal Justice exhibition of detainee art entitled "Ode to the Sea: Art from Guantánamo," an exhibition that prominently featured Moath's model ships, alongside other works by both former and still-incarcerated detainees (Fig. 8.1). By definition, however, art that was able to be

Fig. 8.1 A model ship created by Moath Al Alwi. (Photo Credit: Elana Harris, *Mace & Crown*)

publicly displayed was also censored art, as every piece that left the camp was subjected to rigorous examination process and approval by military officials; hence, the words "approved by U.S. forces" stamped on the white sails of Moath's ships (Fortin 2017; see also, Walzer in this volume). This censorship regime means that for all we see (or saw) of detainee art, there is likely far more occluded, both from eye and from being named as art at all. What was eventually seen by the public was but a fraction of what had been created, submitted to the authoritative eye of the state, and deemed unsuitable for public viewing. For some, this means that the art that managed to leave Guantánamo was, by virtue of its ability to exist publicly and to be seen at all, inherently non-political, sanitized, and redacted—hence the plethora of public detainee art that depicted ostensibly parochial and placid scenes of nature (Imtiaz 2018). Others, including Moath, found instead that the existence and display of this art rendered it as inherently political, bearing as it did the physical evidence of its submission to the state's visual regime. According to Katherine Biber, the paradox to state redaction lies in what it unveils through its very existence—the presence of a secret, a thing to be hidden and unveiled, if not betraying its contents: "These are secrets that are hiding in plain sight; they are open secrets. Open secrets capture the tension between knowledge and discretion, operating in a zone between what is public and what is private, known yet hidden" (Biber 2018, 288). While Moath's boats are not redacted, per se, the stamp of approval acts as a signifier of the processes of state redaction, and the very act of submitting it to the gaze of the state reasserts both the existence of what power would seek to conceal and the ways in which concealment, and exposure, unfold through visuality. As Moath stated, "I wanted the prison stamp to be clear on the sail so people would know the ship comes from Guantánamo" (Gunter 2022). Indeed, this seems precisely a central point of his work. Without erasing the always-present possibility of resistance that persists in even the most oppressive of circumstances, but also taking seriously the totalizing nature of Guantánamo's confinement, to view his art as free from the camp would be to view a part of him as free from it too. At the same time, while art that bears the seal of the state conveys the power and force of its ever-watchful eye, the stamp, and later the ban, can also be construed as an attempt to maintain visual mastery over the camp. So entwined is the visual to the violence and logics of the camp, it cannot bear another master, especially when such supremacy is achieved through both gestures of concealment

and exposure that highlight the interplay between presence and absence, visibility and invisibility, that lies at the heart of these entanglements.

Given the possibilities present in art, it seems no surprise at all that the state would move to restrict detainee art in the aftermath of "Ode to the Sea." Shortly after the exhibition, and with the purported concern that such displays would allow detainees (past and present) to benefit monetarily from their art, the Pentagon set down a new policy that prevented art from being shown or from leaving the camp, and detainees from being able to take their works with them if they were ever released (Gunter 2022). As noted above, the denial of ownership casts the category of art itself into question. It also points to the ways in which visual materials, found to be lacking the proper "fealty to law found in an authentic or legitimate image" (Young 2018, 325) can be transformed and mediated by law into mirror images reflecting non-scenes, where, "by working to regulate the visual economies of … state power, state visual practices produce '(non)scene[s]—a state-crafted image where there is simply "nothing to see"'" (Wall 2014, 138).[3] And so, while detainee art exists and circulates in public spaces and within the public imagination, they are mediated also by the contradictory array of prohibitions and permissions that govern the camp and that would deny that there is something (or anyone) to see, even as we are confronted with visual evidence of *something*, and of *someone*.

It is a particularly fruitless endeavor to try and rationalize the ban by looking to other regulatory mechanisms that govern carceral spaces. For one, we may draw a distinction between carceral spaces and the camp as a repository for enemy subjects—in the case of the latter, as Thompson notes, "the idea of trying to dispirit someone by destroying what they've made, even if the subject is, on its surface, innocuous, is very common in warfare" (Fortin 2017). In keeping with the extra-legal and non-normative nature of the camp, there is no requirement on behalf of its military authorities to adhere to laws that govern US prisons, where the production and ownership of art by prisoners is de rigueur and inmates are typically allowed to keep their works both while they are imprisoned and after they are released. The ban, Thompson further states, thus emerges from this exceptional circumstance, and from "whatever law the government

[3] In his use of the term (non)scene, Wall draws on the work of Dylan Rodriguez, who coined this phrase. See Dylan Rodríguez, "(Non) scenes of captivity: the Common Sense of Punishment and Death," *Radical History Review* vol. 96 (2006), pp. 9–32.

wants to apply, [as] no rule concerning Guantánamo Bay is ever explained" (Grant 2022). Similarly, for Viva Moffat, the Pentagon's reasoning is disconnected from any analysis of relevant law, and is instead an expression of pure power (Grant 2022). This again seems befitting a space of exception, wherein detainees are seemingly consigned to the expressions of force that accompany a total abandonment from the law and in a space unmediated by any element other than power (Agamben 1998; Agamben 2000). And yet, as I have sketched in this chapter, Guantánamo is both exceptional and outside of legal and political norms *and* comprehensively mediated by both law and visual practices, and the configuration of the two. The state's visual archiving of the detention camp, as well as the excess of legal documentation, cases, and government edicts that work within the law to categorize it as outside of the law suggest that the camp as fundamentally devoid of any force besides pure power is shortsighted. Instead, visual practices and laws exist alongside and in consort with state power in Guantánamo, mediating the camp to configure our understanding of it, and of its detainees.

From one perspective, the ban may be viewed as a strike from power against the threats implicit in art—its power (see Miller 2017) and potential and the ways in which these accrue as art circulated beyond the reach of the camp and traveled through and between media environs, exhibit spaces, and spectating publics. From another, the ban can also be conceptualized as highlighting what Alison Young calls the "co-implicative relationship between the image and law," as well as the equal measures of excesses and voids that lie at the heart of it. In this relationship, the law both desires and abhors the image. On the one hand, it relies upon the symbolic and literal forms of meaning and authority that are produced by and expressed through the coming together of word and image(ry). On the other hand, law also works diligently to censor, prohibit, and subject image(ry) to its regulatory power and processes, and "does not hesitate to intervene when an image, such as an artwork, contravenes its regulatory protocols" (Young 2018, 311).

The ways in which law responds to the unauthorized, unsanctioned image reveal, ironically, precisely what it would seek to conceal. The ban, although now lifted, in what it redacts and removes nonetheless "becomes the mesmerizing black hole that lures us towards it" (Biber 2018, 288). The ban, like the stamp, thus also operates as an instructive, albeit brief, moment that betrays the "subterranean machinery of government [and] reluctantly exposes itself to public view" (Manderson 2018, 15). It is a

strike against the aesthetic intervention and countervisuality so powerfully conveyed by Moath's boats and both the perils and promises they hold. Stamped indelibly as belonging to and emerging from the camp and constructed from the materiality of confinement, his boats also carry promises of open waters and shoreless seas, of movement and freedom, of vessels subject not to the whims of power but to boundless winds.

Moath's boats and other forms of art produced by Guantánamo Bay detainees, in mapping the camp's "legal and political terrain," expose it as "characterized by obfuscation and concealment" (Biber 2018, 288). In doing so, they hasten the ban, which further unveils the visuality that is so integral to shaping the camp and its particular forms of violence, and the self-reflexive paroxysms of power that would seek to maintain a total mastery over the visual. Moath's boats mount and build an alternative visual archive of the camp that ruptures the complicity of the visual with power, and in doing so, seizes a right to look, to see, and to be seen. They both invert and look back to the gaze of state power, crafting an archive that carries visions and claims to freedom, even amidst the very conditions that would render them unheard and unseen.

Works Cited

Agamben, Giorgio. 1998. *Homo Sacer: Sovereign Power and Bare Life*. Trans. Daniel Heller-Roazen. Stanford: Stanford University Press.
———. 2000. *Means Without End: Notes on Politics*. Minneapolis: University of Minnesota.
Anden-Papadopoulos, Kari. 2008. The Abu Ghraib Torture Photographs: News Frames, Visual Culture, and the Power of Images. *Journalism* 9 (1): 5–30.
Biber, Katherine. 2018. The Art of Bureaucracy: Redacted Ready-mades. In *Law and the Visual: Representations, Technologies, Critique*, ed. Desmond Manderson, 286–310. University of Toronto Press.
Brown, Michelle. 2014. Visual Criminology and Carceral Studies: Counter-Images in the Carceral Age. *Theoretical Criminology* 18 (2): 176–197.
Butler, Judith. 2004. *Precarious Life: The Powers of Mourning and Violence*. Verso.
———. 2005. Photography, War and Outrage. *PMLA* 120 (3): 822–827.
Campt, Tina. 2012. *Image Matters: Archive, Photography, and the African Diaspora in Europe*. Durham, NC: Duke University Press.
Daulautzai, Sohail. 2007. Protect ya Neck: Muslims and the Carceral Imagination in the Age of Guantánamo. *Souls* 9 (2): 132–147.
Fleetwood, Nicole R. 2020. *Marking Time: Art in the Age of Mass Incarceration*. Cambridge, MA: Harvard University Press.

Fortin, Jacey. 2017. Who Owns Art from Guantánamo Bay? Not Prisoners, U.S. Says. *The New York Times*, 27 November. https://www.nytimes. com/2017/11/27/us/guantanamo-bay-art-exhibit.html.

Grant, Daniel. 2022. US Government Withholds Art Made by Detainees at Guantánamo Bay. *The Art Newspaper*, 31 October. https://www.theartnewspaper.com/2022/10/31/guantanamo-detainee-art-withheld-us-government.

Gregory, Derek. 2006. The Black Flag: Guantánamo Bay and the Space of Exception. *Geografiska Annaler: Series, Human Geography* 88 (4): 405–427.

———. 2012. Dis/Ordering the Orient: Scopic Regimes and Modern War. In *Orientalism and War*, ed. Tarak Barkawi and Keith Sthanski, 151–176. New York: Columbia University Press.

Gregos, Katerina. 2020. The Transformative Power of Art in the Prison Context and Its Perception. *The Art of Crime*, November. https://theartofcrime.gr/ the-transformative-power-of-art-in-the-prison-context-and-its-perception/.

Gunter, Joel. 2022. The Sudden Silencing of Guantánamo's Artists. *BBC News*, 29 August. https://www.bbc.com/news/world-us-canada-62399826.

Imtiaz, Saba. 2018. Footprints: Artworks From Guantánamo. *Dawn*, 2 January. https://www.dawn.com/news/1380170/footprints-artworks-from-Guantánamo.

Kaplan, Amy. 2005. Where is Guantanamo? *American Quarterly* 57 (3): 831–858.

Kell, Dara, and Veena Rao. 2021. A Ship from Guantanamo. *The New York Times*. https://www.nytimes.com/video/opinion/100000007783198/a-ship-from-guantanamo.html.

Liu, Jasmine. 2022. Guantánamo Detainees Ask Biden to Free Their Art. *Hyperallergic*, 13 October. https://hyperallergic.com/769470/ Guantánamo-bay-detainees-ask-biden-to-free-their-art/.

Manderson, Desmond. 2018. Imaginal Law. In *Law and the Visual: Representations, Technologies, Critique*, ed. Desmond Manderson, 3–23. University of Toronto Press.

McClintock, Anne. 2009. Paranoid Empire: Specters from Guantánamo and Abu Ghraib. *Small Axe* 13 (1): 50–74.

McKay, Carolyn. 2018. Video Links from Prison: Court 'Appearance' Within Carceral Space. *Law, Culture & Humanity* 14 (2): 242–262.

Metz, Christian. 1982. *The Imaginary Signifier: Psychoanalysis and the Cinema*. Trans. Celia Britton et al. Indiana University Press.

Miller, James. 2017. Art Made in Guantánamo is Now US Property. *Art Newspaper*, 4 December. https://www.theartnewspaper.com/2017/12/04/ art-made-in-guantanamo-is-now-us-property.

Mirzoeff, Nicholas. 2011a. The Right to Look. *Critical Inquiry* 37 (3): 473–496.

———. 2011b. *The Right to Look: A Counterhistory of Visuality*. Duke University Press.

Pink, Sara. 2012. *Advances in Visual Methodology*. Sage.

Rochelle, Safiyah. 2022. This is What It Looks Like: Searching for Law's Afterlife in Guantánamo. *Humanity* 13 (3): 378–398.

Rodríguez, Dylan. 2006. (Non) Scenes of Captivity: The Common Sense of Punishment and Death. *Radical History Review* 96: 9–32.

Rose, Gillian. 2007. *Visual Methodologies: An Introduction to the Interpretation of Visual Materials.* Sage Publications.

Rosenberg, Carol. 2008. Photos Echo Years Later. *Miami Herald.* https://www.miamiherald.com/news/nation-world/world/americas/guantanamo/article1928720.html.

Stoler, Ann Laura. 2002. Colonial Archives and the Arts of Governance. *Archival Science* 2: 87–109.

———. *Along the Archival Grain: Epistemic Anxieties and Colonial Common Sense.* Princeton University Press, 2009.

Wall, Tyler. 2014. Staring Down the State: Police Power, Visual Economies, and the 'War on Cameras'. *Crime Media Culture* 10 (2): 133–149.

Young, Alison. 2018. Illicit Interventions in Public Non-Spaces: Unlicensed Images. In *Law and the Visual: Representations, Technologies, Critique,* ed. Desmond Manderson, 310–330. University of Toronto Press.

Assemblage by Necessity: The Maritime Sculpture of Moath al-Alwi

Gail Rothschild

"Will you write about Moath al-Alwi's work as artwork?" the editors asked me. It seemed straightforward enough; I have known and admired it for years. But the more I thought about those intricate ships and the artist who made them, the more challenging it became. Can you look at a work of art and not think about the artist? What if the artist is a violent murderer like Caravaggio?[1] What if the artist is an enslaved person like the poet Phyllis Wheatley? Should we see imprisonment as a kind of disability to be overcome, like the great deaf percussionist, Evelyn Glennie? Does the artist's story overwhelm the way we experience the work? Can we ever divorce the two? And should we even try?

[1] Caravaggio was known for his "volatile temperament"; on May 29, 1606, he killed a man, allegedly over a bet on a tennis match—or a prostitute (Leader 2018).

G. Rothschild (✉)
New York, NY, USA
e-mail: gail@gailrothschild.com

© The Author(s), under exclusive license to Springer Nature
Switzerland AG 2024
A. S. Moore, E. Swanson (Eds.), *The Guantánamo Artwork and
Testimony of Moath al-Alwi*, Palgrave Studies in Literature, Culture
and Human Rights,
https://doi.org/10.1007/978-3-031-37656-6_9

We don't look at Caravaggio's *Bacchus* in the Uffizi and think, darn good painting for a criminal. Moath, however, became an artist because of his circumstance. He began making art to escape the horror of his imprisonment. The question becomes, how do his model ships transcend obsessive craft and become art? A number of detainees at Guantánamo have produced remarkable works, but I see Moath's ships as something altogether different.

Moath's sculpture is indeed artwork. It can be appreciated in a number of different ways. But is it prisoner art? Is it outsider art? Is it maritime art? Is it assemblage or bricolage? And what makes these pieces transcend the long history of model ship building? I will look at the three pieces that have been permitted to leave Guantánamo and have been exhibited in the US—*GIANT*, *The Ark*, and *Gondola*—from each of these perspectives, exploring the significant historical, mythical, spiritual, and religious parallels and traditions that inform my reading of Moath's ships by comparing him to Noah, Daedalus, and other figures, real and imagined. I will look at the ships, ultimately, as not perfect, not scale, not models. While Moath's ships are real enough and have historical precedents, I see them mostly as imagined, as vehicles of transcendence and magic. As an artist, I think of Moath and his process of making his sculptures as an act of escape and survival. But as an artist who shudders trying to imagine the challenges and horrors of his lived experience, I must see these vessels he creates as something more: they are Moath's victory over carceral time and space. I first saw Moath's artwork in the midtown office of my cousin, Beth Jacob, an attorney who represents him. "Do you think we can get this work exhibited?" she asked. I looked at the intricate model of a ship. It was as beautiful as its appearance on her desk stacked with legal briefs was incongruous. The delicately curved sail, as if filled by a sea breeze, was stamped US Military. "He calls the piece, *The Ark*," she said.

If he calls the piece *The Ark*, perhaps we should identify Moath with Noah. The ark is a ship of rescue and escape. The myth of an ark rescuing humans and animals from a flood dates as far back as (and probably further than) ancient Babylonia. By following the specific measurements and instructions given by the deity and rather miraculously interpreted by Irving Finkel of the British Museum after "a member of the public brought a battered clay tablet with 60 lines of neat cuneiform text to Finkel—one of the few people in the world who could read them" (Kennedy), Noah would have built a gigantic coracle, or round boat. As a Muslim, Moath might imagine his ark as it is described in the Qur'an where Noah is

referred to as the prophet Nuh. Allah's instructions to Nuh are quite clear about rescue:

> Construct the Ark within Our sight and under Our guidance. Then when comes Our command, and the fountains of the earth gush forth, take on board pairs of every species, male and female, and your people except those of them against whom the Word has already been issued: and address Me not in respect of those who are unjust; for verily they shall be drowned (in the flood). (Holy Qur'an, 23:27)

Interestingly, Moath talks about his own sculptures as ship "models." In creating representations of boats, he takes part in a tradition as old as humans venturing upon the water. Among the earliest to craft model boats, the Phoenicians were the great seafarers of the ancient world, while the Egyptians were intimately tied to the Nile, and the Greeks, as island peoples, depended on ships.

I have spent many hours at the Metropolitan Museum of Art in New York, enthralled by the small model boats from the Egyptian Middle Kingdom tomb of Meketre (2061–2010 BCE). Carved from wood, they were seen as magical substitutes for the boats used in real life and would be placed in tombs so that the typical activities along the Nile—fishing, bird-hunting, and pleasure-boating—might be continued in the afterlife. I was recently at the Museo Egizio in Torino where I noted that the scale of these boats is comparable to Moath's sculptures and show in similarly exquisite detail oars and rudder and the curves of the hull. I'd like to share those with Moath.

There is something inherently intriguing about this telescoping of the very large to the very small. The Victorians were obsessed by miniaturization. Alice in Wonderland shrinks in size and her perception of her world explodes. The epitome of this paradox of the container and contained is the model ship in the bottle. It is fragile and impossible and, like Moath's sculptures, we might hold it in our hands and wonder that it exists at all.

Whether we look at traditional ship models or at Moath's sculptures of ships, they all share a curious paradox: a ship is large, we climb aboard and—contained within its hull—we are carried away. But a ship model is small enough for us to pick up and carry in our arms. Instead of containing us, we cradle it. In Moath's case, he has made small ships that can be transported as he cannot.

Model ships have served many purposes. Until the early eighteenth century, virtually all European small craft and many larger vessels were built without formal plans being drawn. Instead, builders often made small models to work from. Shipwrights would construct models to show prospective customers. Admiralty models were intended for investors in the construction of a big ship.

Some of the oldest European ship models dating from the twelfth century have been found in churches, where they were used in ceremonies to bless the ships and those who sailed in them, or as votive offerings for a successful voyage, or simply to survive the perils of a long journey at sea. Setting out upon the ocean was always a risky undertaking. I can see the risk of Moath's endeavor: creating ship sculptures that he hopes to send into the unknown, not knowing if the military authorities will even permit them to leave or if he will ever see them again. But, for Moath to remain where he is does not represent the safety of home. As he describes in his contribution to this volume, every day he spends at Guantánamo is filled with fury and power and helplessness.

There is actually a historical precedent for prisoners making model ships. According to Melanie Pitkin (2010), during the Napoleonic Wars, jailed French and English seamen made model ships out of scraps of wood and bone from their rations of beef and mutton. With their sailor's knives they carved from memory the forms of the ships they knew so well. Then they covered these hulls with a decorative veneer of bone. The rigging was made out of human hair, horsehair, or whatever they could get. Bone was used for the masts and spars. They became known as bone ships and surviving examples can still be found in museums.

Constructing model ships remains a popular hobby today. Online markets advertise "Hard To Find Model Building Tools & Supplies," "Small Tool Specialists," "Over 240 Wooden Model Ship Kits & Wooden Model Boat Kits To Choose From," and "Order Online For Fast Delivery From The World's Largest Model Ship Store." I think of Moath cutting a piece of plastic coffee cup lid for an anchor. Model boat kits will provide all the materials. A little glue and enough hours and you too can create "your maritime vision with one of our satisfaction-guaranteed model ship kits." Like the Egyptians' boats and the Admiralty models, they are above all precise scale reproductions, perfect in detail. Moath's goal is not accuracy, and his sculptures, whether he refers to them as 'models' or not, truly transcend all model boats. I think it is Moath's intention that raises his work to the level of conceptual art as opposed to a preplanned "model."

They are fantastical vessels in both meanings of the word. As Moath writes, they are containers for his deepest aspirations.

And yet, Moath's sculptures aren't completely fantastical: he has seen pictures of boats, and there are aspects of the shape of the hull and rigging that suggest without representing actual historical ships. Of the artwork that has left Guantánamo, *GIANT* is Moath's masterpiece. It is clearly modeled on a galleon, the four-masted, multi-decked vessel that ruled the oceans during the Age of Sail from the mid fifteenth until the nineteenth century. Galleons could be used either for trade or for war. Moath's sculpture has no cannon; clearly this is not a battleship. But, if it is a trade vessel, then I am drawn again to the dual meaning of the word and wonder what precious cargo is it carrying? All of the artist's hopes, all of his dreams?

The craftsmanship is exquisite. Moath paints the hull a rich luminous auburn that suggests a precious wood, like mahogany, and not the painted cardboard from which it is actually made. Tiny lifeboats hang from the sides. *GIANT* is a rescue ship, literally a lifeboat. The railings on the deck form a rhythm that Moath continues in the bars on the portholes. I wonder how much symbolism to read into these bars. Can *GIANT* be at once a lifeboat and a prison ship?

Moath is neither a shipwright nor a historically accurate model-builder. He is an artist, and his ships are inventions that he sculpts alone. Still, every craft has its terminology, and naming the parts of the ships that inspire him can only add to their poetry. So here, for the record—and perhaps for Moath too—is a galleon's rigging: first, from the rear is the Bonaventure Mizzenmast, (typically lateen-rigged and shorter than the main mizzen), second is the mizzenmast (shorter than the foremast and lateen-rigged), then, the mainmast, and finally the foremast ("Sailing Ships: How to Tell Them Apart").

The challenge of writing this, of course, is that I don't have access to Moath. There are so many things I wish I could ask. I'd like to show him my paintings and ask his interpretation of them. It might put us more, if you'll pardon the pun, on even keel.

"I didn't have the material I needed," says Moath. "I improvised with what I had. Guards and other detainees were surprised that I could make something out of nothing."

This statement situates Moath's sculptures in the context of art created with limited or found materials. How might our perception of these pieces change if we place them alongside the improvisational assemblages of Picasso or Ai Weiwei, El Anatsui or Rauschenberg?

We might place *GIANT* within "The Art of Assemblage" in New York's Museum of Modern Art. Let's think about Moath's practice alongside that of other participants in that seminal 1961 exhibition that defined assemblage in Western art. Marcel Duchamp was one artist. His famous Fountain is simply a porcelain urinal signed "R. Mutt" (Tate). The contemporary Chinese artist Ai Weiwei credits Duchamp as an influence in his *Snake*, composed of hundreds of children's backpacks found at the deadly 2008 Sichuan earthquake. While Moath certainly uses found and non-art materials, he does so not to make a political or aesthetic point, but rather out of necessity.

Still, we are delighted when we see the unexpected transformation of a quotidian material into an artwork. Picasso's Bull sculpture, for example, is no more than a discarded bicycle saddle to which the artist welded handlebars. We are amused and transported when we discover that a giant shimmering tapestry by the contemporary Ghanaian sculptor El Anatsui is made entirely of found liquor bottle caps. Similarly, our perception shifts when we discover that the taut lines of Moath's rigging are nothing more than unraveled shirts and mops.

As a young artist I remember being overwhelmed by the possibilities when I walked into an art store and saw shelves loaded with oil paint and acrylic paint, pastels and crayons, clay and balsa wood, matte knives, and every shape and size of paintbrush. But Moath has no such luxury. His materials are what he can find and cobble together. There is a moment in art school when you are told to work with a "limited palette" of only four pigments. As you paint, you discover with a shock that you can actually make more with less. The US military forbids the use of most materials and certainly many tools that might make Moath's task easier. He must deploy amazing ingenuity to transform the most quotidian scraps into art.

We might identify Moath's ships with bricolage, another art term from twentieth-century Western art history and defined as "the construction or creation of an artwork from any materials that come to hand" ("Bricolage"). But again, Moath's choice to bring together such disparate elements as cardboard, threads from a shirt, or a coffee cup lid are not really choices at all but incredible ingenuity. That he takes such ephemeral non-art materials and constructs a new meaning out of them gives his ships a power and purpose that no model ship of brightly painted balsa wood might have. I want to curate Moath's sculpture alongside Rauschenberg and Ai Weiwei, but without forgetting the matter of choice: Moath does not have artist's materials available to him. He doesn't *choose* to make work out of cast-offs

and junk; rather his work is assemblage by necessity. He takes the poorest and strangest of detritus and creates magic out of them.

I know this firsthand because a few years back, Beth asked if I could help to buy art materials that she could bring to some of the detainees at Guantánamo. I happily agreed but when I read the list of forbidden materials it was daunting. No pencils, no sharpeners, no paints; even a paint brush with bristles held in place by metal ferules was off the US military's list. At the art store I walked up and down the aisles, peering at the loaded shelves and trying to imagine how crayons could be weaponized. It takes courage and hope to make art in a prison.

And this is how Moath's work can be seen within a context of prisoner art. In *Marking Time: Art in the Age of Mass Incarceration* and in an exhibition she curated for MoMA PS1, Nicole R. Fleetwood presents "the work of artists within US prisons and the centrality of incarceration to contemporary art and culture" (Fleetwood 2020). These are artists who are concerned with state repression, erasure, and imprisonment. But Moath's sculpture is never overtly about imprisonment. I wonder if he does this knowing that such work would inevitably be censored? I find it interesting that many of the incarcerated artists Fleetwood features make art that is often laborious, time-consuming. As if the act of making and becoming immersed in it is a way of managing penal time and its psychological weight.

The art that Fleetwood refers to is by American prisoners working in American prisons. Moath, however, is not American, and he is detained in an off-shore but American military prison. The materials to which he has access, some even humorously like the plastic coffee cup lid, are US-determined.

Imprisonment on an island, and his ability to imagine himself away from it, is Moath's reality. He is not permitted to see either the land of Cuba or the omnipresent sea that surrounds him. He must hear the ocean and feel the wind. But how do you escape from a place that is no place? There is something mythic about the problem. I think of Daedalus, the consummate artist and engineer held captive on the island of Crete and forced to produce wonderful works for King Minos. Daedalus anticipates Leonardo da Vinci and crafts wings to escape from the island. He literally flies from his prison. Moath sculpts ships to sail from Guantánamo.

If you look up "prison art," you will find a number of websites devoted to the marketing and sale of art created by inmates. Moath has not tried to market his ships, as this has been forbidden. He intends them as gifts.

Moath was never a seaman like the prisoners making bone ships. His sculptures, while inspired by historical precedents, do not come out of his memory. Rather, in his island prison, he imagines a fantastical ship and brings it to life. "When I made the sails," says Moath "I felt like I was in the middle of the sea. I felt I was rescuing myself" (29). Every ship that he makes is a kind of lifeboat and suggests rescue from the island where he is imprisoned. His artmaking is an act of escape from an intolerable reality, and also an act of self-rescue, as he writes. His sails are billowing in the wind and the ships are well along on their journey.

Earlier, I talked about Guantánamo as a kind of no-place for Moath. And yet it is part of the island of Cuba. In this context, I see his work, *The Ark*, as somewhere between a galleon and a caravel. The caravel was a small, fast Portuguese or Spanish sailing ship of the fifteenth to seventeenth centuries. The caravel had broad bows, a high narrow poop, and usually three masts with lateen or both square and lateen sails. Of Columbus's three ships that landed on the island of Cuba, two were caravels. Looking at *The Ark*, I can't help but think of Columbus, who stumbled upon North America intending to locate a trade route to India. Instead, his landing led to destruction for the native population. I imagine the lost Taino who once inhabited the island joining Moath aboard *The Ark*, in their case forced to flee their homes to avoid impending genocide from Europeans, whereas perhaps he seeks a way home.

At first, I wondered at Moath's choice of galleons and gondola—why ships from someone who grew up in Saudi Arabia? I wondered about a connection. A little research uncovered the rich maritime history of Moath's birth country, Yemen. Positioned at the juncture between the Indian Ocean and the Mediterranean Sea, Yemen became one of the great traders of the ancient world. According to the Metropolitan Museum of Art Heilbrunn Timeline of Art History, during the early ninth century BCE, trade in spices and other luxury goods from India and Indonesia made the Abassid Caliphate wealthy. Traders from Yemen successfully guarded proprietary knowledge of the origins of their precious spices for hundreds of years. The tales of Sindibādu al-Baḥriyy (Sinbad the Sailor in Western versions of the tale) came from Arab and Muslim sailors exploring the world for new sources of trade goods. So, boats are very much a part of Moath's cultural past, and he does, indeed, belong to a proud history of seamen.

Moath is concerned with the presentation of his artwork and sharing it with the public. In *Gondola*, the artist has taken great care to represent

different materials and to carefully attach the sculpture to a base, sending his boat out into the world where he cannot go. The transportation of the artwork becomes a part of the piece. There is a carry handle so that one of his attorneys can convey the sculpture away from Guantánamo to the gallery where it will be shared with the public.

At the opening of "Ode to the Sea: Art from Guantánamo" at John Jay College (2017), there were crowds around each of the glass vitrines that held the precious cargo of Moath's ships. I watched the viewers enthralled by these sculptures. They were invited aboard and transported.

Because *Gondola* is based on a simpler craft than *GIANT* or *The Ark*, we are drawn to each significant detail. For instance, there are two lamps to light the way. I had been thinking to talk about these pieces as "ghost ships" that sail forever without crew or passenger, but I see that I am mistaken: there is a little hooded gondolier. Is this figure Moath himself? As gondolier, whom might he transport or where might he be headed?

A gondola is an unsteady craft. Weighted to one side so that a gondolier can always stand on one side and paddle on one side, it will not go very far. The gondola seems a curious choice for Moath. What is a gondola after all? I think of the cliché of the striped-shirted singing gondolier paddling tourists along the canals, or the workhorse gondolas that ferry passengers and cargo from place to place. The gondola was also the extravagant sports car of the Medieval Venetian, who could parade his status in this decorated luxury craft along the Grand Canal. The last leg of trade to Europe of spices and silks from the far East was held in monopoly by Italian traders, especially from Venice. But who controlled the first part of this trade, bringing goods from the Far East? Islamic traders, many of whom were from Moath's own native Yemen.

Maritime art is defined as figurative art that depicts ships and the sea. I think I'll play curator here and place Moath's *Gondola* alongside one of the luminous images Canaletto painted of gondolas on Venice's canals. And then I'll place *GIANT* next to one of JMW Turner's early career portraits of a great ship in harbor. Next to that can hang the famous painting of Abu Zayd and al-Harith sailing on a boat from thirteenth-century Baghdad. Also, the Calligraphic Galleon dated A.H. 1180/A.D. 1766–1767 from the Metropolitan Museum by the Turkish Calligrapher 'Abd al-Qadir Hisari. The hull of this sailing ship comprises the names of the Seven Sleepers and their dog. The tale of the Seven Sleepers, found in pre-Islamic Christian sources, concerns a group of men who sleep for centuries within a cave, protected by God from religious persecution. Both hadith

(sayings of the Prophet) and tafsir (commentaries on the Qur'an) suggest that these verses from the Qur'an have protective qualities ("Medieval Sourcebook").

Moath's *The Ark* should hang alongside the *Prayer Book* from A.H. 118/A.D. 1766 also by 'Abd al-Qadir Hisari, showing an image of an ark much like Moath's. *The Ark* can also have a dialogue with one of my favorite paintings by Pieter Brueghel, the Elder, *Landscape with the Fall of Icarus* (c. 1555), a painting that inspired the eponymous poem by William Carlos Williams as well as W. H. Auden's 1938 "Musée des Beaux Arts." Maritime artists historically painted from model ships they kept in their studios.

In *Landscape with the Fall of Icarus*, Breughel juxtaposes flying—or rather, the failure to fly, which is falling—with floating on the waves. Moath's boats are also craft for flight. "My whole life I wish I could fly," says he in the film *A Ship from Guantánamo*. An airplane or a helicopter might be a more practical means of escape, but it is the ocean that challenges Moath with its ever presence and he must address it directly, so he makes ships. His choices are surely romantic: a Spanish galleon and a Venetian gondola. No motor-propelled vessel for Moath. In my imagination, he is crafting an escape of the spirit, and we are invited to come aboard.

Flight is a recurring theme in Moath's artwork, both figuratively as escape from confinement and literally as soaring through space. "When I was in Camp 5, I looked through a small window and I saw an eagle flying," says Moath. Sailing is like flight and before the twentieth century racing through the waves was as close as humans could come to leaving the earth. It is interesting that while NASA may refer to spacecraft, in the popular imagination we call them spaceships, imbuing rocket ships with the romance once reserved for nautical vessels that took off into an equally intimidating unknown.

"The eagle's wing on the ship symbolizes freedom," says Moath (Kell and Rao). The other day, as I drove through rural Connecticut, I saw a bald eagle sitting on a branch overhead and I thought of Moath's ship with its eagle wing. I wondered if he was aware that the eagle is the symbol of the United States? Or that Ben Franklin famously preferred the resourceful wild turkey?

In thinking about Moath's work and concepts of flight, it occurs to me that the ship too is "a floating piece of space, a place without a place, that exists by itself, that is closed in on itself and at the same time is given over to the infinity [of the sea]" (Foucault 1986, 27). As Moath conflates

sailing and flying, he even gives us a clue to his destinations: *GIANT* contains tiny photographs of Mecca, Medina, and Jerusalem, the three holiest cities of Islam—but you can only see these pictures if you peer through the tiny porthole. The act of looking into the ship is an intimate experience at the same time as suggesting a spiritual destination; this aperture takes you to another place entirely.

Moath was not schooled in art; rather, he is compelled to make art. So, perhaps we should also see his ship sculptures in the context of outsider art...but what is outsider art and how does it relate to him? The term was first coined in 1972 by the publishers of a book by British art critic Roger Cardinal, who personally much preferred the name Art Brut, a concept which he wanted to present to an English audience. In the 1940s, the French artist Jean Dubuffet had used the term Art Brut—literally "raw" or "uncooked" art—to describe art created outside official culture, art that was not influenced by the market pressures and competition of the mainstream art world. Ironically, "outsider art" has now been coopted as a marketing tool. There is even an Outsider Art Fair. *Raw Vision Magazine* prefers the term 'Intuitive Art' ("What Is Outsider Art"?). I agree that once you slip into vocabulary like Outsider and Insider you are faced with the question of who decides? Inside the commercial art world? Outside of the gallery system and international art fairs?

The American Visionary Art Museum in Baltimore celebrates "art produced by self-taught individuals, usually without formal training, whose works arise from an innate personal vision that revels foremost in the creative act itself" ("About Us"). Intuit: The Center for Intuitive and Outsider Art in Chicago describes in its mission statement "artists who faced marginalization, overcame personal odds to make their artwork, or who did not or sometimes could not follow a traditional path of art making, often using materials at hand to realize their artistic vision...The museum's mission is grounded in the ethos that powerful art can be found in unexpected places and made by unexpected creators" ("History and Mission"). Truly Guantánamo is an unexpected place and Moath an unexpected creator.

I think that what Fleetwood writes about "reimagining...time, space, and physical matter" perfectly describes what Moath's ships do ("Marking Time"). They are transformative both in material and in their suggestion of the journey and the flight from prison. As for Moath's practice, it is truly immersive in a way that such detailed work must be; perhaps the intensity of the labor carries him away from an unbearable daily reality.

Identifying Moath's artwork with the history of model ships, with prison art and intuitive art, with maritime art and with mixed-media assemblage broadens how we see his unique enterprise. The transcendence of these pieces may best be summed up in one of Moath's anecdotes in this volume about making them: "The most beautiful thing happened the first time I made the sails and tied the rope. I felt as if I were in the middle of the ocean... One day I was tired and lay down on the floor next to the ship. The fan blew air onto the sails and the ship started moving!" (29).

WORKS CITED

About Us. n.d. American Visionary Art Museum. https://www.avam.org/about-us.
Bricolage. n.d. Tate Museum. https://www.tate.org.uk/art/art-terms/b/bricolage.
Cardinal, Roger. 1972. *Outsider Art*. Westport, CT: Praeger.
Department of Ancient Near Eastern Art. 2000. Trade Between Arabia and the Empires of Rome and Asia. In *Heilbrunn Timeline of Art History*. New York: The Metropolitan Museum of Art. http://www.metmuseum.org/toah/hd/ince/hd_ince.htm.
Fleetwood, Nicole. 2020. *Marking Time: Art in the Age of Mass Incarceration*. Cambridge, MA: Harvard University Press.
Foucault, Michel. 1986. Of Other Spaces. *Diacritics* 16 (1): 22–27.
History and Mission. n.d. Intuit: The Center for Intuitive and Outsider Art (Chicago). https://www.art.org/history-and-mission/.
Kell, Dara, and Veena Rao. 2021. Op-Doc. A Ship from Guantánamo. *The New York Times*, 6 July. https://www.nytimes.com/video/opinion/100000007783198/a-ship-from-guantanamo.html.
Kennedy, Maev. 2014. Babylonian Tablet Shows How Noah's Ark Could Have been Constructed. *The Guardian*, 14 January. https://www.theguardian.com/culture/2014/jan/24/babylonian-tablet-noah-ark-constructed-british-museum.
Leader, Annie. 2018. This Day in History: May 29. *Italian Art Society Blog*. https://www.italianartsociety.org/2018/05/on-29-may-1606-the-great-italian-baroque-painter-caravaggio-killed-ranuccio-tommasoni-in-rome/.
Marcel Duchamp: Fountain. n.d. Tate Museum. https://www.tate.org.uk/art/artworks/duchamp-fountain-t07573#:~:text=Fountain%20is%20one%20of%20Duchamp's,Mutt%201917.
Mardrus, J.C., and E.P. Mathers. 2013. *The Book of the Thousand and One Nights*. Abingdon, Oxon: Routledge.

Marking Time: Art in the Age of Mass Incarceration, September 17, 2020–April 5, 2021. n.d. Museum of Modern Art (New York). https://www.moma.org/calendar/exhibitions/5208.

Medieval Sourcebook: Chardri: The Seven Sleepers of Ephesus. n.d. Internet History Sourcebook Project, Fordham University. https://sourcebooks.fordham.edu/basis/7sleepers.asp.

Pitkin, Melanie. 2010. *Prisoner of War Bone Ship Model.* Museum of Applied Arts and Sciences. https://www.maas.museum/inside-the-collection/2010/02/15/prisoner-of-war-bone-ship-model/#:~:text=During%20the%20Napoleonic%20Wars%20(1792,staple%20diet%20of%20mutton%20stew.

Sailing Ships: How to Tell Them Apart. 1986. *New York Times,* 4 July, p. 33. https://timesmachine.nytimes.com/timesmachine/1986/07/04/472586.html?pageNumber=33.

What is Outsider Art? n.d. *Raw Vision.* https://rawvision.com/pages/what-is-outsider-art?_pos=1&_sid=7a876990a&_ss=r.

INDEX[1]

[1] Note: Page numbers followed by 'n' refer to notes.

© The Author(s), under exclusive license to Springer Nature 163
Switzerland AG 2024
A. S. Moore, E. Swanson (eds.), *The Guantánamo Artwork and
Testimony of Moath al-Alwi*, Palgrave Studies in Literature, Culture
and Human Rights,
https://doi.org/10.1007/978-3-031-37656-6

Printed in the USA
CPSIA information can be obtained
at www.ICGtesting.com
LVHW082240211123
764609LV00005B/75